Your Royal Highness

To Commemorate your visit

to the V&A, on Wednesday

XXIXth March, MMVI.

Fergus Cannan Esther Kedourjim

EUROPEAN SCULPTURE
AT THE VICTORIA AND ALBERT MUSEUM

EUROPEAN SCULPTURE
AT THE VICTORIA AND ALBERT MUSEUM

Edited by Paul Williamson

Victoria and Albert Museum

First published by the
Victoria and Albert Museum,
London, 1996

The Victoria and Albert Museum
London SW7 2RL

© The Board of Trustees of the
Victoria and Albert Museum 1996

ISBN: 1 85177 173 5

A catalogue record for this book is available from
the British Library

Designed by Bernard Higton

Printed in Hong Kong,
by South Sea International Press Ltd

Jacket illustrations
Front: *Neptune and Triton* (detail) by Giovanni Lorenzo Bernini. Marble, c.1620–22.
Back: *Angel* (symbol of St Matthew) attributed to Jan van Schayck. Sandstone, c.1497.

CONTENTS

FOREWORD

There has been a long-felt need for an accessible handbook to the National Collection of Sculpture at the Victoria and Albert Museum. Detailed scholarly catalogues of many parts of the Collection already exist – and more are in preparation – but no single publication has been devoted to the whole of post-classical European sculpture since 1964, when *Fifty Masterpieces of Sculpture* was published. The number of sculptures included has now been more than doubled, but it should be stressed that this is still only a very selective sample of the great Collection at South Kensington. For reasons of space and in order to give a balanced picture, it has been necessary to leave out some sculptures in particularly rich areas of the Collection – Italy, for instance – which would undoubtedly find a place in most histories of the subject. The absence of pieces by such pre-eminent sculptors as Tino di Camaino, Michelozzo and Cellini, all of whom are represented in the Collection with major works, reflects the strength in depth of our holdings.

Because of the comprehensive nature of the Collection it is possible to follow the development of sculpture from the Early Christian period through to the beginning of the twentieth century. The book has consequently been designed to place the sculptures in their art-historical context, and it is hoped that it might be used not only as a guide to the

Museum's Collection but also as a convenient introduction to European sculpture generally. The bibliography at the end should lead those interested to further reading in all the main areas of the Collection.

Every member of the Sculpture Department has contributed to the creation of this book: Marjorie Trusted, Peta Evelyn, Norbert Jopek, Lucy Cullen, Wendy Fisher, Fiona Leslie, Alexander Kader and Diane Bilbey. Their writing is initialled accordingly, the remaining unsigned entries and essays being the work of the editor. Special thanks are due to Alexander Kader, who supervised the photographic programme, and to Diane Bilbey, who assisted in every aspect of the book's production. It was a pleasure to work with Mary Butler and Miranda Harrison of V&A Publications and I am most grateful to Bernard Higton, who designed the book with great skill.

Paul Williamson
CURATOR OF SCULPTURE

INTRODUCTION

THE FORMATION OF THE COLLECTION

The Collection of European post-classical sculpture at the Victoria and Albert Museum is the most comprehensive in the world. It has the status of a 'National Collection', making it the sculptural equivalent of the National Gallery, although its chronological scope is wider than its pictorial counterpart. Classical sculpture is the responsibility of the British Museum, so the earliest pieces at South Kensington are from the Late Antique period, in the fourth century AD; and by formal agreement in 1983 with the Tate Gallery the Museum does not currently collect large-scale sculpture produced after about 1914, the date of Rodin's gift of his sculptures (see page 19). It does, however, retain an interest extending to the present day in certain types of small sculptural artefacts such as ivories and bronzes, which complement the historical collections and which are not covered by the Tate Gallery.

The Museum's European Sculpture Collection differs from that of most other major international museums in forming an integral part of a museum of applied arts rather than being an adjunct of a paintings collection. Its holdings therefore include far more than simply figure sculpture, and the links between sculpture and the decorative arts – especially Metalwork, Ceramics and Woodwork – remain an important consideration in decision-making about acquisitions and display. It is no exaggeration to say that the collection of sculptors' models in terracotta,

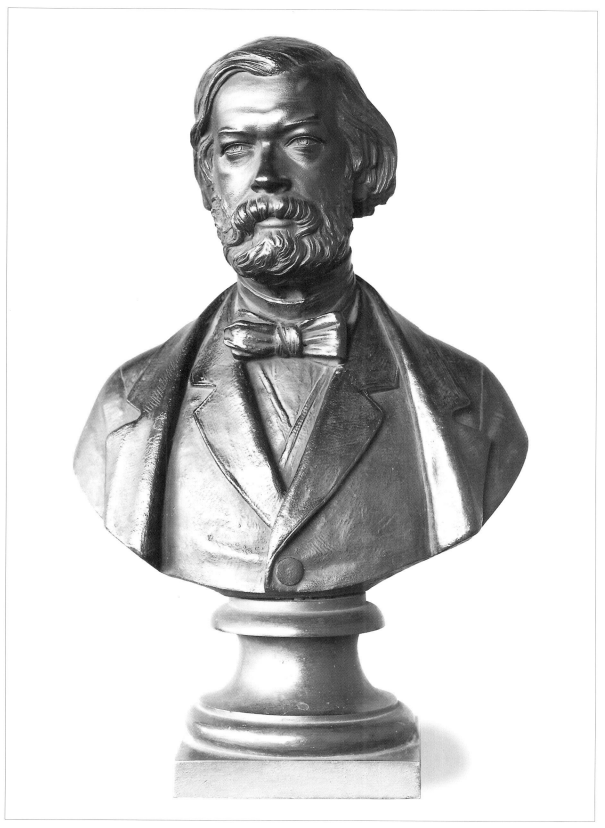

1. John Charles Robinson at about the age of 40.
Bronze bust by Carlo Marochetti; probably *c*.1864–65 (inv.no.A.202-1929).

2. The early sixteenth-century Netherlandish altarpiece (see page 102) displayed in the Museum of Ornamental Art at Marlborough House in 1856. Watercolour by W.L.Casey.

undoubtedly the finest and largest in the world, would not have come about outside the context of this particular Museum. By the same token there are historical idiosyncracies, such as the holdings of mosaics, which were allocated to the Sculpture Department at the creation of the dedicated departments in 1909 because it was then called the Department of Architecture and Sculpture. Medieval bronzes, on the other hand, are collected not by the Sculpture Department but by Metalwork, as at the beginning of the century pre-Renaissance bronzes were considered to be utilitarian objects rather than works of art. Thus the slightly bizarre system was created whereby a twelfth-century bronze crucifix figure from the circle of Renier of Huy, for example, was judged to be functional, and therefore assigned to the Metalwork Department, while its sixteenth-century Italian equivalent was seen as a work of art and allocated to the Department of Architecture and Sculpture.

The Sculpture Collection is as old as the Museum itself, the first acquisition dating to 1844. However, the Museum of Ornamental Art at Marlborough House, the precursor of the present Museum, was not set up to collect sculpture but rather to encourage excellence in contemporary design and manufacturing by the provision of exemplary samples from the present and earlier periods. The acquisition of sculpture in this context needed special justification, nearly always by referring to the relevance of the techniques to modern craftsmen, and even when the Museum moved to South Kensington in 1857 (becoming part of the South Kensington Museum) this notion continued to prevail. The longevity of this view is demonstrated in the words of Walter Crane, a celebrated figure of the Arts and

Crafts Movement, who when asked to comment on the advisability of purchasing seven small early sixteenth-century South Netherlandish wood sculptures in 1908, noted that they 'would be valuable acquisitions for the collection, as the study of such examples by craftsmen engaged in producing modern carved figures for church decoration would have a most beneficial effect in counteracting the conventional simpering figures which too often do duty in our ecclesiastical carving'.

Set against this background, the rapid development of the Sculpture Collection in the 1850s and 1860s is all the more remarkable, and its creation largely the achievement of one man, John Charles (later Sir Charles) Robinson (1824–1913). Robinson (figure 1) was appointed the first Curator of the Museum of Ornamental Art at Marlborough House in 1852 at the young age of 28 and quickly apprehended the potential in a situation where the British Museum had neglected to collect European sculpture other than Greek or Roman and had no immediate plans to do so. Determined to grasp the opportunities to build a first-rate collection of European sculpture Robinson at once sought out available pieces, both en bloc and individually, with extraordinary energy, intelligence and taste. Such was his single-mindedness, however, that it was not long before he was chafing at the constraints placed upon him by his immediate superior, Henry Cole, the Secretary of the Department of Science and Art, a friction which would combust a decade later. In between these dates the foundations of the present Collection – especially in the area of Italian sculpture – were laid.

The cornerstone was provided by the acquisition of the Gherardini Collection in 1854. This collection, which comprised mainly sculptors' models in terracotta and wax, had been discovered only a few years before in Florence. Having unsuccessfully offered the collection to the Tuscan and French governments in 1853, the Gherardini family moved it to London the following year, and after some negotiation the entire collection of 30 sculptures was bought for the nation for £2,110. At a stroke, the Museum of Ornamental Art was transformed from a collection which had one or two pieces of sculpture in marble and bronze to an embryonic systematic collection of Italian sculpture, where the creative process of the artist could be seen at an early stage. The Gherardini Collection was famed at the time for containing several wax models by Michelangelo, and although only one of these is still accepted as by the artist (see page 98) the collection was well-endowed with sketch models by Giambologna, Francavilla, Lorenzi and Duquesnoy. Robinson now had a base from which to expand the collection of sculpture; this important step forward was recognised retrospectively in 1883 in the *History of the Science and Art Department*, where it was stated that the acquisition of the Gherardini Collection, 'inasmuch as it referred to a branch of art not necessarily connected with manufactures, helped in extending the limit of the collections generally, which henceforth became 'Art Collections''.

So in the years immediately after the purchase of the Gherardini Collection, Robinson bought quickly and widely. The single purchases included such treasures as Rossellino's *Virgin with the Laughing Child* (page 82) in 1858 and a group of four marbles related to the workshop of Nicola Pisano (page 53) in 1859; and in 1860 followed Adriaen de Vries's signed and dated bronze relief of the Emperor Rudolph II (page 125) and Luca della Robbia's great stemma of René of Anjou in enamelled terracotta (inv.no.6740-1860). The acquisition of the Soulages Collection in 1856 (bought by private subscription and subsequently purchased in instalments up to 1865) also added some significant pieces, although this particular collection was richest in maiolica, furniture and other objects of the applied arts. Nor were non-Italian sculptures neglected. Early sixteenth-century South Netherlandish and French altarpieces were added to the Collection in 1855 and 1857 (pages 101-3 and figure 2); four important low-relief figures in oak of c.1360–90 which originally formed part of an altarpiece in the Johanneskirche in Lüneberg were acquired in 1856 (4845 to 4848-1856); and two French Virgins of the fourteenth century, one limestone and the other marble, were bought in 1860 (6964-1860, 6982-1860). Ivory carvings also flowed into the Collection from an early date, mostly through the

good offices of the collector and dealer John Webb, outstanding medieval examples from this period of purchasing being the fine mirror back showing the Storming of the Castle of Love (page 63) and the large early fourteenth-century Virgin and Child (4685-1858), both now displayed in the Medieval Treasury.

When the Museum was transferred to South Kensington in 1857 extra space became available for the Sculpture Collection, creating an environment even more conducive to the large-scale expansion favoured by Robinson. Shortly after, between December 1860 and January 1861, the Italian sculpture collection was enhanced by the acquisition of 84 sculptures from the so-called Gigli-Campana Collection in Rome, actually comprising two quite separate collections formed by the Marchese Campana and Ottavio Gigli, Campana's agent. Their availability had come about because the Marchese had been imprisoned by the papal authorities on fraud charges and his sculptures – including those in the process of being acquired from Gigli – seized. In these difficult circumstances, exacerbated by the civil war raging throughout Italy, Robinson's powers of persuasion, diplomacy and stamina were called upon to the full. He knew better than any other the great importance of the pieces he had selected from the Gigli-Campana Collection and must have considered their acquisition for a total price of £5,836 as one of his greatest coups.

When the sculptures arrived in London early in 1861 the Museum's holdings were enriched by the addition of such signal masterpieces as the marble Annunciation relief ascribed to Arnolfo di Cambio (7563-1861), Donatello's *Ascension with Christ giving the Keys to St Peter* (page 76) and *Dead Christ supported by Angels* (7577-1861), Luca della Robbia's roundels of the Labours of the Months from the Palazzo Medici (page 79), Verrocchio's terracotta *bozzetto* for the Forteguerri monument (page 84) and Jacopo Sansovino's *Descent from the Cross* model for the painter Perugino (page 94). In addition to the Arnolfo *Annunciation*, the early Italian collection was significantly strengthened by two curtain-drawing angels from a wall-monument by Tino di Camaino (7566 and 7567-1861), a marble Virgin and

Child by Alberto Arnoldi (7600-1861), a relief of the Virgin and Child with two angels by the so-called Master of the San Michele in Borgo pulpit (7564-1861), the very fine terracotta Virgin and Child produced in the milieu of Ghiberti and the young Donatello (7573-1861) and many other reliefs related to the Donatello workshop. Some of the attributions of the sculptures have, not surprisingly, changed in the 135 years since 1861, the most dramatic being the down-grading of the most famous of the Gigli-Campana sculptures at the time of the sale, the so-called Cupid, thought then to be a masterpiece of Michelangelo and bought for the high price of £1,000 (figure 3). It has subsequently been demonstrated that this sculpture should more accurately be identified as *Narcissus*, and that it is in the main a Roman copy of a Hellenistic original, restored probably by the Florentine Valerio Cioli in the second half of the sixteenth century – when the head was added – and again just prior to acquisition.

After the purchase of the Gigli-Campana Collection Robinson settled down to write the first catalogue of the Italian sculptures at South Kensington, a pioneering and seminal work which was published the following year. Although he must have been unaware of it at the time, this was to be the peak of his career in the Museum. He was to continue to acquire works of art energetically for another five years, travelling throughout Europe, but his powers to act independently were gradually diminished and his relations with Cole deteriorated in the face of constant rows over purchasing policy. In 1863 Robinson's appointment as Superintendent of the Art Collections was terminated, the position being downgraded to Art Referee, and this in turn was taken away from him in 1867-68, when the permanent post was abolished.

If the exceedingly high standard of acquisitions of Italian sculpture established by Robinson could not be maintained after the early 1860s, other areas of the Collection were nevertheless rapidly expanded. Nowhere was this more true than in the field of medieval ivory carvings; John Webb continued to be the main source, lending large numbers of ivories to the Museum until such funds as were necessary for

their purchase became available. Between 1865 and 1867 many of the greatest ivories were acquired, including the Symmachi Panel (page 30), the cover of the Lorsch Gospels (page 32), the Veroli Casket (page 37), the whalebone *Adoration of the Magi* (page 41), the St Nicholas Crozier (page 47), the Soissons Diptych (page 58) and Giovanni Pisano's *Crucified Christ* (page 56). A good number of these had belonged to Prince Peter Soltykoff, having been bought by Webb at the extraordinary sale of his collection in Paris in 1861 and held for the Museum for up to six years. Without Webb's goodwill in this matter the Museum would only have been able to afford a very limited number of the best pieces at the time of the auction.

The years between about 1870 and 1910 have been considered as at best mediocre, at worst disastrous, for the acquisition of sculpture at South Kensington. This is only partially accurate. In comparison with the 1860s the years following were inevitably less fruitful, but there was, of course, no question of being able to sustain the level of activity of that decade. Sights were set in other directions, and while it is true that the acquisitions of Italian sculptures were not in the main as significant as before, many important purchases were made in the field of German and Netherlandish wood sculpture, for instance. A very good-quality Upper-Rhenish winged retable, probably from the Carmelite church in Boppard (125-1873) was bought in 1873, Tilman Riemenschneider's *Mary Salome and Zebedee* (page 107) was acquired in 1878, the *St Peter* from Antwerp (page 100) in 1888, a *St Christopher* by the Master of Elsloo (374-1890) in 1890, and the remarkable small boxwood Virgin and Child by Veit Stoss (page 106) entered the collection in 1893. Two years later, in 1895, a large selection of woodwork, including 20 sculptures, was acquired from the collection of the Abbé Emile Peyre in Paris: probably the finest of these pieces is a French fourteenth-century polychromed wood figure of St Michael overcoming the Dragon (526-1895). The later French collection was increased in 1882 with the gift of the John Jones Collection, although it has to be said that Jones does not appear to have had a particularly good eye for

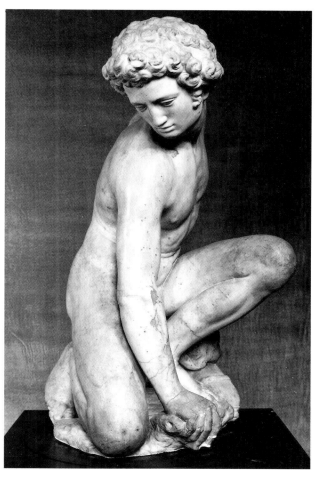

3. *Narcissus*. Roman marble figure restored by Valerio Cioli (*c*.1529–99) (inv.no.7560-1861).

sculpture. The ensemble of 86 pieces consisted principally of eighteenth- and early nineteenth-century terracottas, small marbles, bronzes and ivories, but no piece can match the interest of the furniture or ceramics from the same collection.

In addition, monumental ensembles of sculpture continued to be purchased, including the colossal roodloft from 's-Hertogenbosch (page 128), whose removal from the cathedral and acquisition in 1871 sparked debate in the Netherlands and led to the introduction of a policy for the protection of ancient monuments in that country. It was at first installed against the south wall of what is now the west Cast Court, facing the plaster cast of Trajan's Column, but

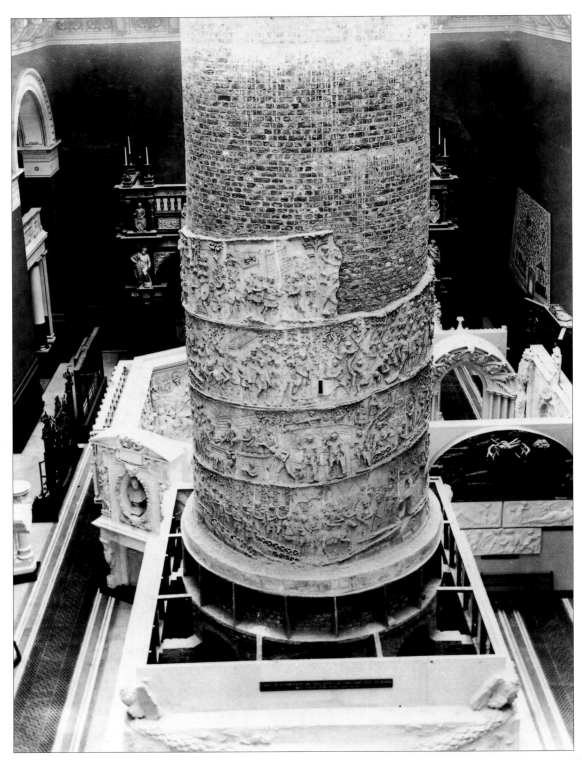

4. View of the west Architectural Court (Room 46A) in 1873, showing the roodloft from 's-Hertogenbosch (see page128) on the south wall, and the plaster cast of Trajan's Column in course of construction.

was moved in 1923–24 to the East Hall (Room 50), where it could be seen from both sides (figures 4 and 5). Other potentially controversial additions of this type were made to the collection in the decades immediately following. The most notable were the great *Madonna della Misericordia* relief by Bartolommeo Buon (page 74), tragically removed from above the doorway of the Scuola Vecchia della Misericordia in Venice and in the circumstances acquired almost reluctantly by Robinson – who was working for the Museum again temporarily – in 1881; the sixteenth-century wall-tomb of Gabriele (?) Moro from Santa Maria della Misericordia (455-1882), purchased at the same time; and the vast Malaspina monument from the deconsecrated church of San Giovanni in Sacco in Verona, bought five years later (page 72).

Although the Museum's record of acquisitions at the end of the nineteenth century was not as black as has sometimes been painted, Robinson's disengagement from a permanent position in the Museum probably did have a deleterious effect on acquisitions; this was aggravated by increasing competition from museums abroad, most notably that in Berlin, which was being driven forward by the erudition and energy of Wilhelm von Bode. The level of curatorial expertise at South Kensington had diminished so seriously by the early 1890s that responsibility for acquisitions lay almost entirely in the hands of the external Art Referees. Something had to be done, and following much public debate and slow-moving government endorsement the Museum as a whole was transformed, physically, administratively and even in name, becoming the Victoria and Albert Museum in 1899. The display space itself was greatly increased between 1899 and 1909 by the construction of Aston Webb's Cromwell Road and Exhibition Road façades and the galleries immediately behind them, including the large West and East halls which now house the Raphael Cartoons and the English and Continental sculpture gallery (figure 6).

In the year before, in 1908, an official committee of re-arrangement had deliberated on how the collections should be shown and what should be acquired. This committee, chaired by Cecil Harcourt Smith (who

became Director and Secretary almost immediately afterwards), had concluded that

at present the Victoria and Albert Museum is practically the only British metropolitan institution in which non-classical sculpture regarded as Fine Art finds a place. Although the scope of that institution, as defined by the Minute of 1863, does not properly embrace the collection of all such material, yet in view of the treasures which it already possesses of this class, and the indirect influence which fine sculpture exerts on all forms of applied art, it seems to be desirable that provision should be made in the Victoria and Albert Museum for the reception of works of art of this character. It is obvious that a certain amount of sculpture belongs to the category of applied art, and as such would naturally find a place in the Victoria and Albert Museum; it appears indeed to be essential that specimens of such work should be included, if the Museum is to fulfil its principal purpose. It would appear therefore that funds of the Museum may properly be devoted to the purchase of objects to which this description applies. On the other hand, while statues and reliefs which have no function as applied art fall outside this category, the dividing line is often difficult to define, and there are certain advantages to be gained for students if the division is not too strictly insisted upon, and if the juxtaposition of both classes can be conveniently arranged.

The committee also recommended that eight curatorial departments be set up, including that of 'Architecture and Sculpture'. Perhaps the most significant effect of this action was to create centres of excellence in which expertise could be developed and into which first-rate scholars would be attracted. The earliest of these to work in the Architecture and Sculpture Department was Eric (later Sir Eric) Maclagan, who went on to become an international authority on Medieval and Renaissance sculpture,

Overleaf

Left: 5. View of the East Hall (Room 50) in 1923, looking west towards the main entrance; the roodloft from 's-Hertogenbosch (see page 128) was installed below the first arch in the following year.

Right: 6. View of the East Hall (Room 50) in the final stages of construction in 1909, looking east towards the Santa Chiara Chapel (see page 86).

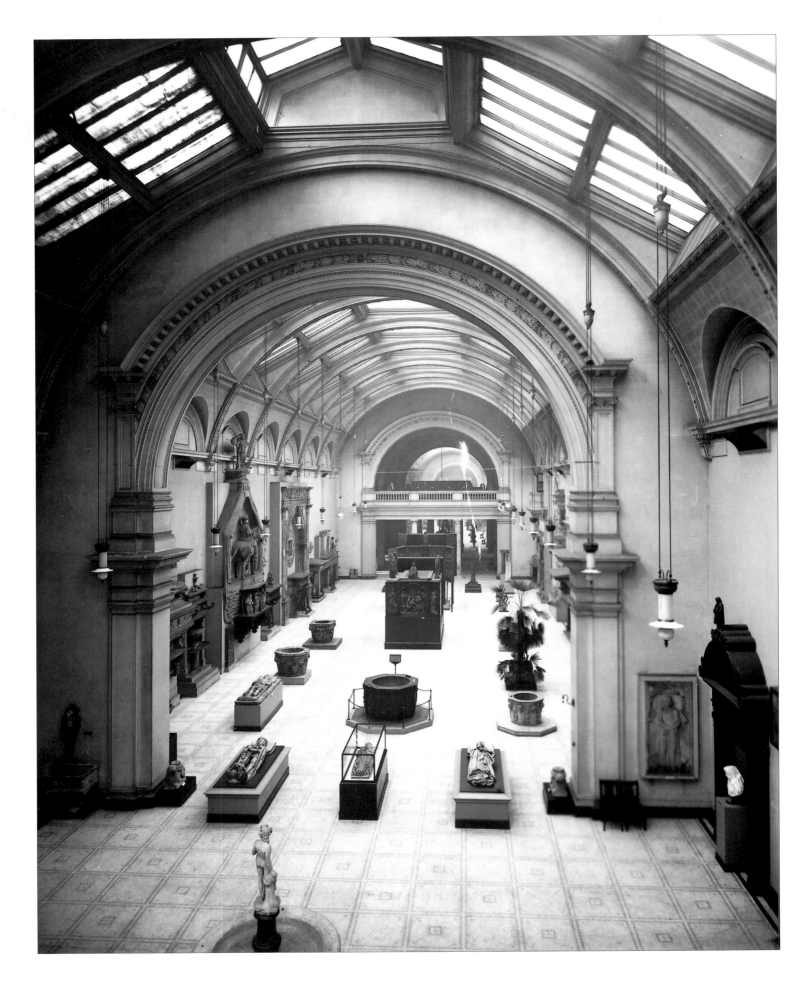

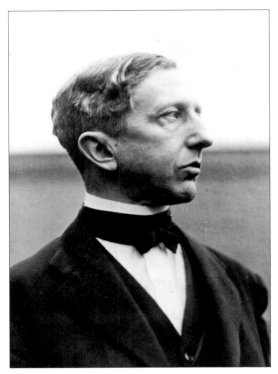

7. Sir Eric Maclagan (Keeper of Architecture and Sculpture 1921–24, Director 1924–44).

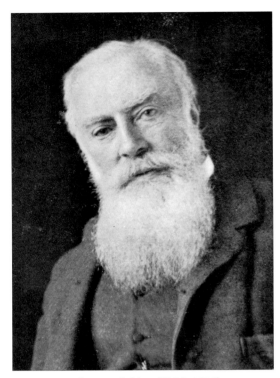

8. George Salting (1836–1909).

Keeper of the Department between 1921 and 1924 and finally Director in 1924-44 (figure 7).

As if setting the seal of approval on the new building and staff structure, in 1910 the Museum was hugely enriched with the Salting Bequest. George Salting (1836-1909) was born in Australia but, having inherited the fortune made by his father from sugar and sheep farming, moved to England in early middle age (figure 8). He quite soon became obsessed with European and Oriental works of art, and with his catholic tastes and considerable financial resources built an outstanding collection – bigger than many museums – remarkably quickly. Much of it was deposited on loan, in instalments, to the Museum from 1874 onwards, and this action might have led to the authorities' apparent lassitude in connection with acquisitions in the years 1875-1910: while there existed a distinct possibility that the Museum would be left the Salting treasures it was less likely that acquisitions would actively be sought in the same areas. This approach was vindicated

when Salting died in December 1909 and the works of art from his collection passed to the Museum early in the following year.

The quality of Salting's collection was remarkably high, and he spent his fortune with taste and discrimination. Although extremely wide-ranging, in the sphere of sculpture the collection was especially rich in Renaissance bronze statuettes, medals (page 120) and plaquettes and medieval ivories. Many of the most important pieces were acquired by Salting at the famous sale in Paris of the collection of Frédéric Spitzer in 1893, where his outlay exceeded £40,000. Outstanding amongst the more than 120 Italian bronzes are the *Shouting Horseman* by Riccio (page 91), two sphinxes (A.89&90-1910) related to the same artist's Santo candlestick in Padua, a Sienese relief of the Flagellation ascribed to either Vecchietta or Francesco di Giorgio (A.163-1910), and the *Neptune* variously attributed to Alessandro Vittoria or Vincenzo Danti (A.99-1910). Of the 40 ivories bequeathed by

Salting, pride of place must go to the celebrated English fourteenth-century diptych which now bears his name (page 57), but other important pieces of French and Italian origin also added immeasurably to an already unmatched collection.

Another generous benefactor, sometimes overlooked, was J.H. Fitzhenry, a contemporary and friend of George Salting and the great American collector J. Pierpont Morgan. Fitzhenry also helped to build up the Ceramic Collection, but in the first decade of the century he was instrumental in starting the acquisition of Romanesque sculpture at the Museum, and in 1906 and 1910 gave a total of ten pieces. However, perhaps the most imposing object given by Fitzhenry was the monumental early sixteenth-century dormer window from the château of Montal (page 114), which entered the Museum in 1905. His large collection was on loan until his death in 1913. The majority of it was then sold at Christie's, the Museum only being able to acquire a small number of pieces from the executors of the estate before the sale.

In the 30 years between its creation and the outbreak of the Second World War in 1939, the Department of Architecture and Sculpture went from strength to strength. The display of modern sculpture was given a boost on the eve of the First World War, when Auguste Rodin donated no less than 18 of his sculptures to the Museum, making it the primary holding in Britain of the sculptor's work (page 153). *The Times* of 13 November 1914 was in no doubt as to the importance of the gesture:

> The gift of sculpture which M. Rodin has made to the British nation is a piece of generosity without parallel. Others have given precious collections of works of art to England and other nations, but this gift is all the work of the man who bestows it, and it is the work of the greatest artist living in the world. Further, he gives it as a sign of the brotherhood between his people and ours, and as a token of his admiration for our soldiers. Coming as it does at this momentous crisis in the history of Europe, it will be remembered through future ages as a monument of that crisis, and of that brotherhood which M. Rodin wishes to commemorate. There are very few artists in the whole history of art who could make a gift worthy of such an occasion, but M. Rodin is one of them – one with Michel Angelo and Donatello, and with the earlier masters of Greece.

The lapidary collection of the Architectural Association was transferred in 1916, adding 100 architectural and sculptural fragments (mostly English medieval) and nearly 4,000 plaster casts to the Museum's collection, and from about 1920 onwards the remarkable and idiosyncratic Dr W.L. Hildburgh was making regular donations of objects of many kinds on an annual basis.

Walter Leo Hildburgh (1876-1955) was an American citizen of private means who had settled in London in 1912 (figure 9). His collecting provided the raw material for his scholarly work, and his published output covered an astonishing range. He established himself as the leading authority on English medieval alabasters with a stream of detailed and ground-breaking articles, and crowned his relationship with the Victoria and Albert Museum by the gift of his whole collection of over 260 alabasters in 1946, on his 70th birthday. More typical of Hildburgh than this *en bloc* donation, however, was the impulsive gift. A perfect illustration of his spontaneous generosity is provided by a short memorandum from Delves Molesworth to R.P. Bedford, the Deputy Keeper, in 1934. Molesworth, then a young Assistant Keeper (later Keeper of Architecture and Sculpture 1946–54) who already knew Hildburgh's kindness, had the foresight to leave a fine terracotta model (figure 10), on approval for purchase, on his desk when Hildburgh came to visit. He recounted that 'Dr Hildburgh saw this in the office and very generously offered to present it to us, as most of our other sketch models have come from him. He did not want to purchase it himself but gave me the money and asked me to pay for it on his behalf. I have not so far been able to identify the monument for which this sketch was made'. The terracotta cost just £4, and about 20 years after its acquisition was recognised as a model for one of the allegorical figures on the monument of Thomas Archer in Hale Church, Hampshire, by Henry Cheere. Many other sculptures – and metalwork

9. Dr Walter Leo Hildburgh (1876–1955), April 1920.

the Egyptologist Cecil Firth, with whom he dined in January 1926. Her diary entry for 17 January reads:

> In the evening Mr Maclaggan [sic] arrived; he is a tall man of 46 or so, slight and Spanish looking. If you have once seen him you can never forget him; he has two infallible marks: his rodent teeth, and his tie, which baffles all description. His hands are fine like a woman's and his eyes are blue under perfectly semicircular lids. He is fascinating. His conversation is like an entertaining encyclopedia; at one moment he is the fastidious gourmet, descanting on snails and cuttlefish stewed in its ink; the next he is the harassed curator battered by tasteless royalty and down at heels gentry seeking loans; soon after he is the collector penetrating the secrets of dealers' premises and opening up such vistas of romance as were never previously suspected. Wilder than any fiction are the stories of fakes and of antiquities. Then there were limericks, after dinner speech stories, discussions in art, in fact every branch of brilliant conversation – delivered in his soft delicious voice, with his suave manner and quiet humour, beautiful English and stock of foreign languages; truly he is more wonderful than any book.

The scholarly output in the two decades before the Second World War was impressive. In addition to numerous articles in the *Burlington Magazine*, many concerned with new acquisitions, Maclagan wrote a catalogue of the Italian plaquettes in 1924 and with Margaret Longhurst compiled the second comprehensive catalogue of Italian sculpture in 1932. Longhurst also published widely on medieval ivory carvings, writing a seminal book on English ivories in 1926 and producing the two-volume catalogue of ivory carvings in the Museum's collection in 1927-29. It could hardly be denied that by the end of the 1930s the Department had established an international reputation, with an intellectual network stretching throughout Europe and North America, and that the administrative changes made in 1910 had borne fruit.

After the end of the War in 1945 the opportunity radically to redisplay the contents of the Museum presented itself. The building had been largely stripped of works of art during hostilities so the new Director, Leigh Ashton – who had himself worked in

objects – were snapped up quickly and cheaply through Dr Hildburgh in a similar manner at a time when *kleinplastik* was comparatively underpriced.

Eric Maclagan's inspired guiding influence in the 1920s and 1930s affected both acquisitions and the direction of scholarship in the Department. He was fortunate to have in Margaret Longhurst an extremely able and productive Assistant Keeper who became, in 1938, the first woman Keeper of a Department in any national museum. Together they made numerous notable acquisitions, especially of medieval and renaissance sculptures, including Bernini's splendid bust of Thomas Baker (A.63-1921), Agostino di Duccio's Virgin and Child relief (page 80) and the Ottonian Basilewsky Situla (page 35), the last sold from the collections of the Hermitage in St Petersburg. Maclagan's political skill and intellectual vigour is apparent everywhere in the official papers of the Museum, and some idea of his bearing and the strength of his fertile mind may be gained from the impression he left on the daughter of

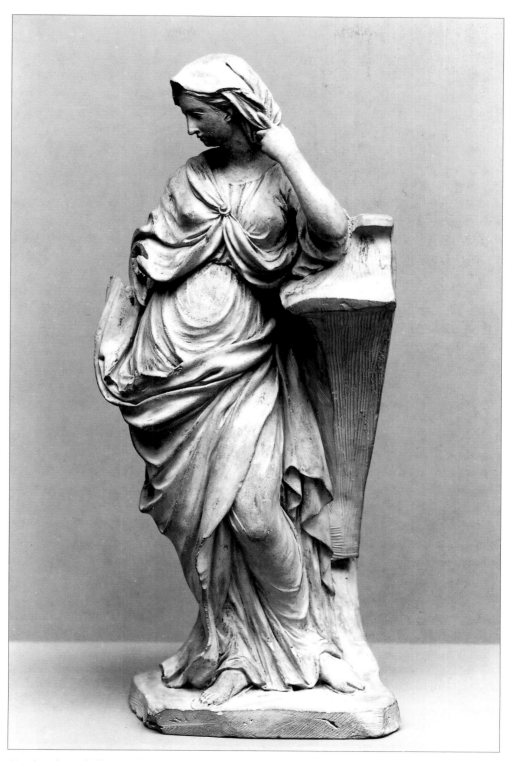

10. Terracotta sketch model for an allegorical figure on the monument of Thomas Archer in Hale Church, Hampshire; by Henry Cheere; c.1739 (inv.no.A.11-1934).

the Department of Architecture and Sculpture – was given a *tabula rasa* upon which to lay out the collections. Before the War the different collections had been displayed in separate galleries, but Ashton decided to re-arrange them completely, dividing the Museum into two types of galleries – the Primary and the Study galleries. The Primary galleries displayed together objects of different media to illustrate the historical development of the decorative and fine arts, so that medieval ivory carvings, for instance, were now shown alongside enamels, metalwork, textiles and other coeval material. Invariably the highest-quality works of art were chosen for the Primary galleries, and those visitors especially interested in a particular material category – such as bronzes – could be directed to the more densely packed Study galleries, which were sited on the upper floors, for more comprehensive displays of specific types of objects. This system is still effectively in place, although in 1989 the Primary galleries were renamed Art and Design galleries and the Study galleries became Materials and Techniques galleries.

Although the Sculpture Collection was now immensely strong in many areas, there was still room for improvement and some schools and categories of sculpture remained under-represented. Delves Molesworth was able to take advantage of the low prices for sculpture in the decade after the War, in many instances buying ahead of fashion with remarkable discrimination. It was Molesworth who was largely responsible for building up the collection of Baroque ivory carvings and wood sculpture before he transferred to the Keepership of Furniture and Woodwork in 1954, while his successor John (later Sir John) Pope-Hennessy made great additions to the Italian collection. Pope-Hennessy had joined the staff before the Second World War as an Assistant Keeper in the Paintings Department, but on returning to South Kensington after the War he effected a transfer to Architecture and Sculpture, a move which turned out to be of inestimable value to the latter Department and to the art-historical world as a whole. A man of formidable intellect and industry, Pope-Hennessy had already made acquisitions of the first importance before he was promoted to Keeper, most notably Bernini's *Neptune and Triton* in 1950 (page 132 and figure 11), and Giambologna's *Samson slaying a Philistine* in 1954 (page 123). The pursuit and capture of the Bernini exemplified Pope-Hennessy's tenacity and acquisitive instinct, as is recounted in his autobiography:

One evening in 1950 I was dining with an old friend, Paul Wallraf, who was then employed by Wildenstein [the art dealers]. To my surprise he asked me some questions about Lincoln and its cathedral, and when I got home I took a map and drew a circle with a thirty-mile radius round Lincoln. One major house fell within it, and that was Brocklesby [where the *Neptune and Triton* was then sited]. So we at once opened up negotiations with Lord Yarborough to forestall a bid from Wildenstein. Molesworth and I went down to see it, and found it standing desolately in an untidy garden. 'Since we can't keep up the rose garden,' said Lady Yarborough, 'the statue seems to have lost its point.' Shown out of doors for so long, it had lost not its point but its surface (the only part that was perfectly preserved was the inside of the thigh) and Molesworth was on that account reluctant to buy it. But I persuaded him that as a work of art the sculpture was unimpaired, and we succeeded in buying it for £15,000.

As Keeper and then Director (1967-73) Pope-Hennessy continued this outstanding record, adding such stellar pieces as Antico's gilt-bronze *Meleager* statuette in 1960 (page 89) and Giovanni Pisano's fragmentary bust of the Prophet Haggai from the façade of Siena Cathedral in 1963 (page 55). In addition, he contributed more than any other scholar in the last 50 years to the study of Italian sculpture with a ceaseless procession of fundamental publications on the subject, ranging from learned articles in specialist journals to wide-ranging surveys which educated many thousands of students.

John Pope-Hennessy's expertise was complemented in other areas by that of Terence Hodgkinson, John Beckwith and others. Terence Hodgkinson, an authority on English and French post-medieval sculpture, became Keeper in 1967 after many years in the Department: he greatly enlarged the holdings of eigh-

11. Sir John Pope-Hennessy (Keeper of Architecture and Sculpture 1954–66, Director 1967–73)
standing beside Bernini's *Neptune and Triton* (page 132)

teenth-century sculpture, adding Clodion's terracotta of Cupid and Psyche in 1958 (page 166), Houdon's bust of the Marquis de Miromesnil in 1963 (page 165) and Roubiliac's statue of Handel in 1965 (page 158). He was also responsible for the refurbishment of many of the Primary galleries and the redesign of Room 50 – the great sculpture court – in 1971, before taking up the Directorship of the Wallace Collection in 1974.

The medievalist John Beckwith (who had joined the Department in 1955) succeeded Hodgkinson as Keeper for five years until his retirement in 1979: during his tenure undoubtedly the most important acquisition was the Chellini roundel by Donatello (page 78). In common with Pope-Hennessy, Beckwith published extensively and like his predecessor had the distinction of being elected a Fellow of the British Academy, an extremely rare honour for a museum curator.

It has, of course, become increasingly difficult to make significant purchases of sculptures in recent years. The rise in prices since the early 1980s – in the case of some sculptures bringing them into line with paintings of the same date – and the freezing of the purchase grant has meant that the annual number of acquisitions has shrunk accordingly, so that the Museum is ever dependent on gifts and the financial support of outside funding bodies such as the National Heritage Memorial Fund and the National Art Collections Fund. Nevertheless it is still possible occasionally to augment the Collection with sculptures of great importance, and it is heartening that 11 of the just over 100 masterpieces included in this book have been acquired during the keeperships of Anthony Radcliffe (1979-89) and the present writer. These include the Gothic head from Thérouanne (page 50), Rysbrack's magnificent bust of the architect James Gibbs (page 155), Carlini's statue of Joshua Ward (page 160) and, most famously, Canova's Three Graces from Woburn Abbey, purchased jointly with the National Galleries of Scotland in 1994 (page 170). Additionally, in the last decade two important signed and dated marbles have been acquired from the dispersed collection of the 2nd Marquess of Rockingham at Wentworth Woodhouse in Yorkshire: the Nollekens *Diana* (page 163) and Vincenzo Foggini's monumental *Samson and the Philistines* of 1749 (A.1-1991), the latter an especially appropriate companion to Giambologna's sculpture of the same subject, which it is now shown alongside.

The display of sculpture has also been strengthened with a number of long-term loans. Many of these have been made by churches and local authorities concerned about the safety and condition of sculptures in their care, and a fruitful and mutually satisfactory relationship is maintained with the National Trust. The former category of loan would take in the important thirteenth-century sculptures from the parish church of All Saints, Sawley, in Derbyshire and the Eleanor Cross figures from the Waltham Cross, lent by the Hertfordshire County Council; and the National Trust has placed on long-term loan the four kings of about 1400 from the Bristol High Cross (now at Stourhead) and the bronze group of the Rape of Proserpina from Cliveden, attributed to the sixteenth-century Florentine sculptor Vincenzo de'Rossi.

One hundred and fifty years after its foundation, the Sculpture Collection at the Victoria and Albert Museum continues to grow, albeit at a considerably slower pace than in earlier years. A major problem is now one of space, and in the not too distant future additional room will undoubtedly be needed to show the Collection to its maximum advantage. Most sculpture – at least on a large scale – needs to be walked around, viewed from different angles, in changing lighting conditions, to be appreciated fully. So while this book will give an indication of the great wealth of the nation's holdings of European Sculpture, a cause for proud celebration, there can be no substitute for direct visual contact with the objects themselves. Only by standing in front of the actual sculptures illustrated here is it possible to experience something of the universal pleasure enjoyed by an early thirteenth-century visitor to Rome, who was transfixed before a classical figure of Venus

> made from Parian marble with such wonderful and intricate skill, that she seems more like a living creature than a statue; indeed she seems to blush in her nakedness, a reddish tinge colouring her face, and it appears to those who take a close look that blood flows in her snowy complexion. Because of this wonderful image, and perhaps some magic spell that I am unaware of, I was drawn back three times to look at it despite the fact that it was two stades distant from my inn.
>
> (J. Osborne (trans.), *Master Gregorius: The Marvels of Rome*, Toronto, 1987, p.26)

We hope the Sculpture Collection at South Kensington has the same magnetic effect on today's audience.

THE SCULPTURE

PART ONE

EARLY CHRISTIAN
TO GOTHIC
(*c*.400 – 1400)

Several decades before Christianity was officially recognised by the Roman Emperor Constantine the Great in 313, the adherents of the new religion were already formulating a small artistic repertory which inevitably owed much to the art of the time. It was convenient that these earliest images should be 'neutral', and thus the Good Shepherd or an orant figure might appear with equal propriety on pagan or Christian sarcophagi, the principal fields for sculpted imagery in the third and fourth centuries (figure 1). As the Christian faith became more public and widespread, artistic display could become more overt and complex. By the early fourth century images of undeniably Christian content had appeared – episodes from the Old and New Testaments becoming commonplace – but the style reflected the contemporary art of late antiquity. The rise of Christianity was not straightforward, and even after imperial edicts established it as the official state religion in 380 and prohibited pagan worship altogether in 391 there remained a strong resistance in favour of pagan ideals backed by powerful patrician families such as the Symmachi (page 30). Many years later Christian sculptors would periodically revert to earlier, even pagan, styles and programmes.

On a large scale, relief sculpture enjoyed more favour than the carving of free-standing figures in the years between the fall of the Roman Empire and the beginning of the Romanesque period. This was largely

1. An orant figure; detail from a late third-century sarcophagus, Museo Pio Cristiano, Vatican City, Rome.

2. Cloister, Santo Domingo de Silos, Northern Spain; early twelfth century

due to a fear of idolatry, a concern that led to continuous debate and controversy and the establishment of a period of iconoclasm in the East in 726–843. The technical excellence of the classical workshops was gradually lost and much relief sculpture degenerated into little more than roughly executed incised designs. It is a curious fact that the most accomplished stone sculpture from this long period is to be found in Britain, on the stone crosses of the eighth and ninth centuries (see page 31).

If the production of monumental sculpture in stone between about 500 and 1050 was patchy and largely unimpressive, the same could not be said of work on a small scale. Ivory carvings of the highest quality were made throughout the Early Middle Ages all over Europe, and a good number have survived. At the Carolingian Court in Aachen in the early ninth century, in Ottonian and Anglo-Saxon centres in the tenth and early eleventh centuries, and above all in

Constantinople in the ninth to eleventh century, ivory carvings of exquisite workmanship were made for both religious and secular patrons by craftsmen working in styles closely comparable to those of contemporary manuscript illuminators. The uniformity of style across different media in this period points to closely integrated workshops, and there is evidence in the North that many of the ivories were produced in monastic ateliers alongside the scriptoria.

The Church was of course the major patron of sculptors throughout the Middle Ages. The surge in ecclesiastical building which started after the turn of the first millennium served to reinvigorate the practice of large-scale sculpture. The eleventh-century Benedictine monk Raul Glaber memorably described this phenomenon: 'It was if the whole earth, having cast off the old by shaking itself, was clothing itself everywhere in the white robe of the church'. Within a century capitals topping the columns in the naves of

churches and around the cloisters of monasteries (figure 2) had been carved with scenes from the Life of Christ, the tympana of portals were decorated with imposing images of Christ and the Last Judgement, and the necessary pieces of church furniture, such as altars, choirscreens and pulpits, were embellished with narrative and iconic reliefs. The development of the Romanesque style from about 1050 took place quickly, the great early twelfth-century achievements of Moissac, Vézelay and Autun being executed surprisingly soon after such a long pause in sculptural production.

It was a short step stylistically to the first Gothic portals of Chartres and elsewhere, but a bigger transformation took place in Man's perception of his place in relation to God, which in turn permeated the iconographic programmes presented in stone. The Virgin was increasingly venerated in her own right, appearing at the centre of church portals (figure 3) and becoming the subject of countless statues in every material. By the early thirteenth century a more realistic approach was manifesting itself, prompted by a fresh study of both classical remains and the natural world, which produced not only the extraordinary heads of Reims Cathedral but also the closely observed foliate decoration at Southwell Minster. The making of sculpture was now firmly in the hands of small secular workshops, often regulated by guilds. Because of the changing market for their work – no longer solely the Church but also the merchant classes – these groups of 'imagers' began to enjoy a greater freedom of expression. Sometimes no more than a single sculptor and his apprentice, they foreshadow the individual masters of the following centuries.

3. West façade, Amiens Cathedral; 1225–40. The three portals are dedicated to the Last Judgement (centre), the Virgin (right) and a local saint, Firmin (left)

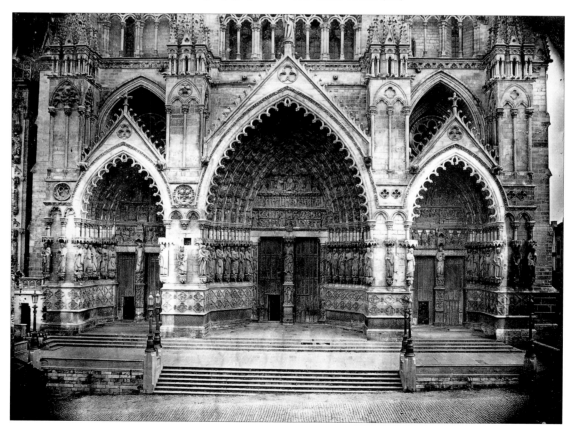

THE SYMMACHI PANEL

Rome; about AD 400

Ivory; h. 29.5 cm, w. 12 cm

212-1865

A priestess, standing beneath an oak tree and attended by a small girl, is preparing to sprinkle the contents of the bowl in her left hand on to the altar in front of her. At the top of the panel is the inscription 'SYMMACHORUM', linking it to a second panel in the Musée national du Moyen Age in Paris with the inscription 'NICOMACHORUM' and a similar priestess. Together they originally formed a diptych, made for the named Roman families probably to celebrate Dionysus. As such they provide vital material evidence for the dying gasp of paganism in aristocratic Late Antique Roman society. Ironically, both panels probably partly owe their survival to having been incorporated into an early thirteenth-century reliquary shrine at the abbey of Montier-en-Der in France, where they remained until the French Revolution; in turn the shrine was broken up, but the ivories escaped destruction and resurfaced just after the middle of the nineteenth century.

Because of its excellent condition – in contrast to the sadly damaged Nicomachi panel – the Symmachi leaf is one of the most important existing ivory carvings from the Late Antique period. Only a handful of ivory reliefs from around the end of the fourth and beginning of the fifth century survives, but from this small sample it is clear that the carvers worked for both pagan and Christian patrons simultaneously: from a stylistic point of view amongst the ivories closest to the Symmachi panel is a plaque showing the Maries at the Sepulchre, now in Milan.

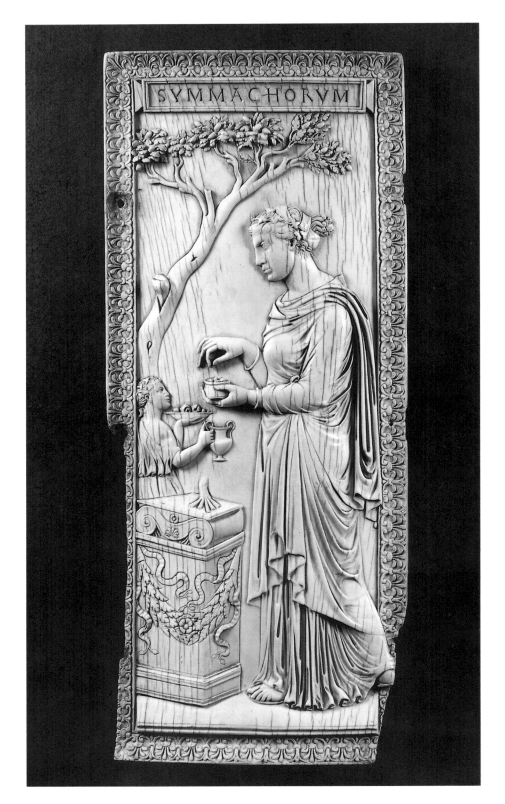

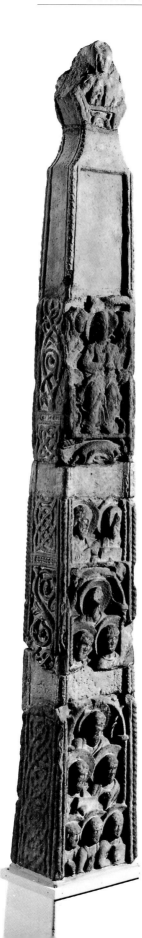

THE EASBY CROSS

Anglo-Saxon (Yorkshire);
about 800 – 820

Sandstone; h. (including modern support) 301 cm
A.88-1930, A.9 to A.11-1931 (presented by the
National Art Collections Fund)

Four large fragments of the cross – one
bought from a private collection in Easby
(near Richmond) in 1930, the other three
excavated from the walls of Easby parish
church later in the same year and
acquired in 1931 – have been
reconstructed in the Museum. The front
face shows Christ in Majesty with the
twelve apostles below, the back has birds
and animals amongst vine-scroll ornament
and the sides are carved with interlace.
The head-piece is carved on both sides
with a bust of Christ.

The Easby Cross is the finest remaining
example of Anglo-Saxon stone sculpture
in the group of pieces which follow the
great early crosses at Bewcastle and
Ruthwell. Executed in the early ninth
century, it shows the influence of Late
Antique sources transmitted probably
through Carolingian prototypes: this is at
its clearest in a comparison of the well
understood pecking bird on the back of
the central stone of the cross with the
same subject in a Carolingian ivory panel
now in the Vatican. But it also retains
elements of early Northumbrian style, as
in the interlace patterns of the short
sides, thus illustrating the continuity of
the English sculptural tradition between
the seventh and eleventh centuries.

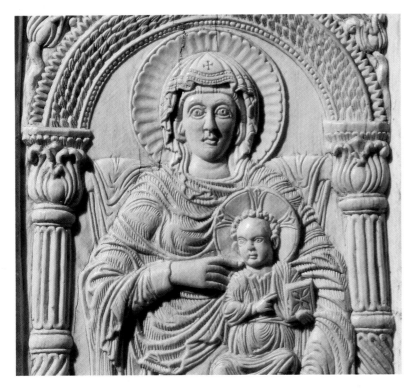

FRONT COVER OF THE LORSCH GOSPELS

Carolingian (Aachen); about 810

Ivory; h. 38.1 cm, w. 26.7 cm

138-1866

The Virgin and Child are shown at the centre with St John the Baptist to the left and the prophet Zacharias to the right. Above, two angels hold a medallion of Christ and below are the Nativity and the Annunciation to the Shepherds. This five-part ivory originally formed the front cover of an early ninth-century book of Gospels from the abbey of Lorsch, divided between the Vatican Library and Alba Iulia in Rumania, and the back cover is also now in the Vatican (Museo Sacro). The latter shows Christ treading on the beasts between the two archangels, with angels above holding a medallion with a cross and, below, the Magi before Herod and the Adoration of the Magi. Together, the Lorsch Gospels covers are amongst the largest and most splendid medieval book covers in ivory to have survived.

Ivory carving enjoyed a revival at the court of the Emperor Charlemagne in the late eighth and early ninth centuries. The classical heritage was drawn upon in the illumination of manuscripts executed in scriptoria associated with the Emperor; and ivory carvings, in addition to being modelled on Late Antique prototypes, were in certain instances actually physically dependent on them, as earlier plaques were sometimes planed down and recarved. This may partially be the case with the Lorsch Gospels covers, as it appears that the tops of the side panels have been carved to take into account the modified lower corners of the panel above; this perhaps indicates that the latter is of a considerably earlier date.

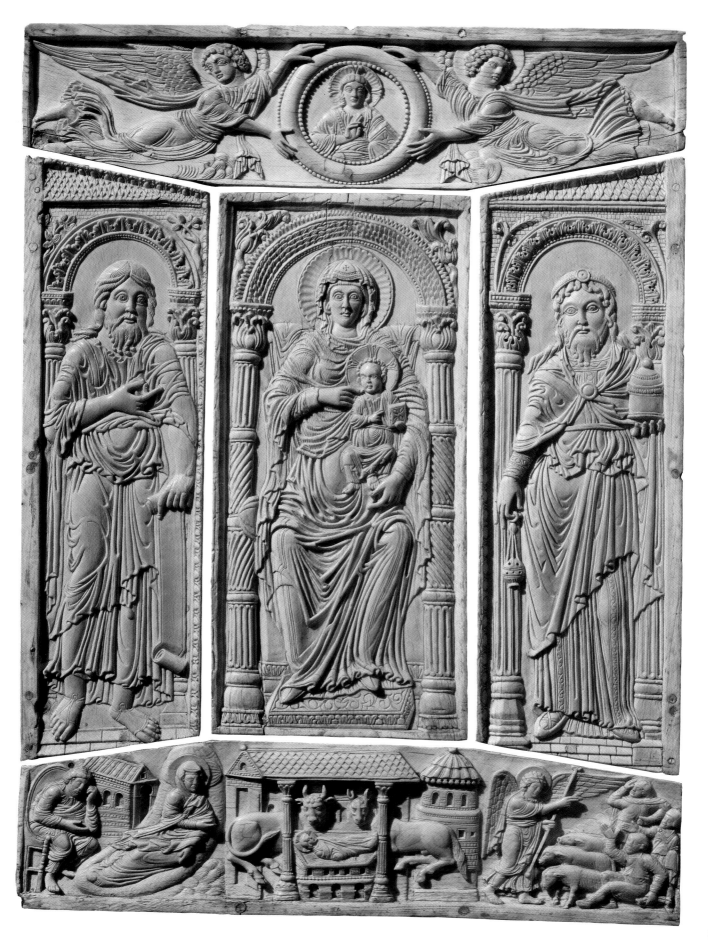

CHRIST IN MAJESTY

Anglo-Saxon (Winchester or
Canterbury); about 1020

Walrus ivory; h. 9.5 cm

A.32-1928

Christ is seated on a cushioned throne
and holds a book in his left hand and a
staff (now partly broken) in his right. On
acquisition in 1928 the relief was made
up with coloured plaster on the left side;
this was removed in 1984. At that time
the ivory was cleaned and closely
examined, revealing extensive – but
microscopic – traces of paint over a wide
range of the surface which allowed a
reconstruction of the colour scheme. The
background was originally blue, the
throne, footstool and cushion were gold,
as was the book in Christ's left hand and
much of his garments, his hair and crown.
His lips were red and his hands and feet
pink. The discovery of these remains
reinforced still further the close stylistic
correspondence between the ivory and
the illumination of *Christ in Majesty* in the
contemporary Trinity Gospels in
Cambridge, illustrating well the intimate
relationship between manuscript painters
and ivory carvers in Anglo-Saxon
England. The Christ in Majesty and
another walrus ivory relief of the Virgin
and Child in the Museum (A.5-1935)
share with the illuminations of the Trinity
Gospels and other English manuscripts of
the early eleventh century the
characteristic jagged draperies first seen
in the famous Benedictional of St
Aethelwold (now in the British Library),
executed at Winchester in about 980.

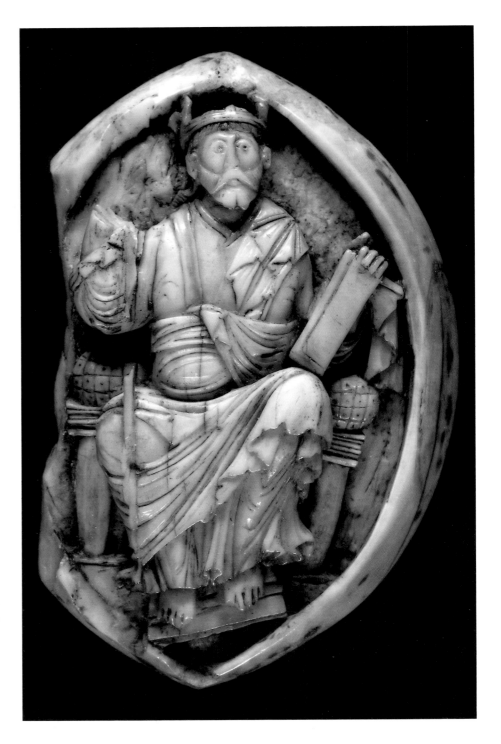

THE BASILEWSKY SITULA
Ottonian (Milan?); about 980

Ivory; h. 16 cm

A.18-1933; purchased with the Funds of the
Vallentin Bequest and with the aid of a
contribution from the National Art Collections
Fund

This situla (holy water bucket) is
decorated with 12 scenes from the
Passion of Christ, starting on the upper
tier with Christ washing the feet of the
disciples and ending on the lower register
with the scene of the Incredulity of St
Thomas. The two protruding heads at
each side were pierced to take a handle,
and a separately made - probably silver -
bucket would originally have been fitted
inside the ivory. The Basilewsky Situla
takes its name from the collection to
which it belonged before passing into the
Hermitage Museum in St Petersburg in
1884; it was sold by the Russian museum
in 1933.

The two upper lines of inscriptions
explain the scenes taking place beneath
them, while the bottom line is of
relevance to the Situla itself and its
imperial recipient: 'May the Father, who
added thrice five to the years of
Hezekiah, grant many lustres to the
august Otto. Reverently, Caesar, the
anointing-vessel wishes to be
remembered for its art'. This almost
certainly refers to the Emperor Otto II,
and it is likely that the Situla was
presented to him on the occasion of his
visit to Milan in 980. Ivory *situlae* are of
the greatest rarity, only three others
surviving in Aachen, Milan and New

York. That in Milan, given to the church
of Sant'Ambrogio by Archbishop
Gotfredus just before 980 in connection
with Otto's visit to the city, is not
surprisingly the closest in style to the
Basilewsky Situla.

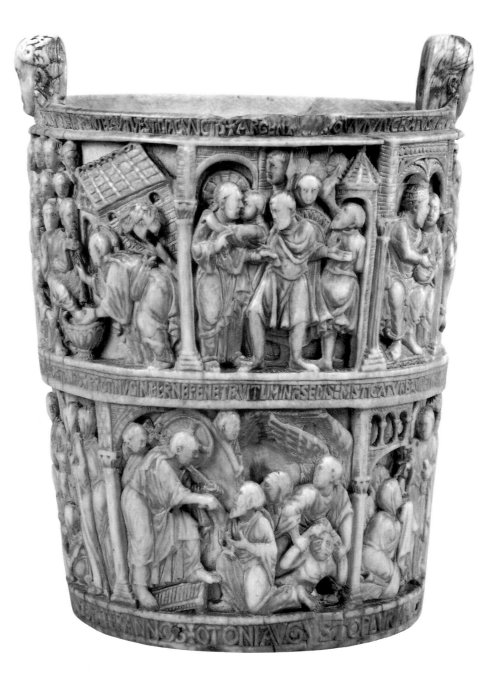

CASKET

Hispano-Arabic (probably Córdoba);
about 1000–1010

Ivory, with later silver mounts; h. 21.5 cm,
l. 27 cm, w. 16.5 cm
10-1866

This casket was modified in the seventeenth or eighteenth century, when the silver mounts were added and an inscription which would have run along the band at the bottom of the lid was removed. However, by comparison with a similar ivory casket in Pamplona which still retains an inscription relating that it was made for Abd al-Malik, son of al-Mansur, in 1004–05, it is likely that the present casket is of about the same date. Its original use is suggested by the inscription on another casket, now in the collection of the Hispanic Society in New York, which reads: 'I am a receptacle for musk, camphor and ambergris', although jewellery or other valuables might equally appropriately have been kept in it. The subject matter of the roundels on the front – pairs of seated figures playing musical instruments and holding drinking vessels – exemplifies the sophisticated *milieu* of the Umayyad house, for which the casket was undoubtedly made.

Many of the most important pieces of the great collection of medieval ivory carvings at South Kensington were purchased between 1865 and 1867: while the majority of these were Christian, the Islamic tradition was not neglected. John Charles Robinson bought this casket in León in 1866, and on the same trip to Spain he acquired in Madrid another, smaller ivory casket (301–1866), with an inscription showing that it was made for a daughter of the late caliph Abd al-Rahman III in around 962.

THE VEROLI CASKET

Byzantine (Constantinople);
about 1000

Ivory and bone plaques on a wood core; h. 11.5
cm, l. 40.5 cm, w. 15.5 cm

216-1865

Kept until 1861 in the Cathedral Treasury
at Veroli (south-east of Rome), the casket
shows scenes from classical mythology.
On the lid is the Rape of Europa with
centaurs and maenads playing and
dancing to the music of Herakles. On the
front are scenes from the stories of
Bellerophon and Iphigenia, and on the
back is part of a dionysiac procession,
with two figures identified as Mars and
Venus (or Ares and Aphrodite). The ends
bear scenes of Dionysus in a chariot
drawn by panthers, and a nymph riding a
seahorse.

The Veroli Casket belongs to a group of
Byzantine ivory and bone boxes made in
the late tenth and early eleventh
centuries and known as 'Rosette caskets'
because of their border decoration. There
is general agreement that this is the finest
of the group because of the detailed
treatment of the carving and the deep
undercutting of the scenes; and like the
preceding casket, made in all probability
for a member of the Umayyad house, it
must originally have belonged to a person
of high standing, possibly at the court of
the Emperor Constantine VIII
(976–1028).

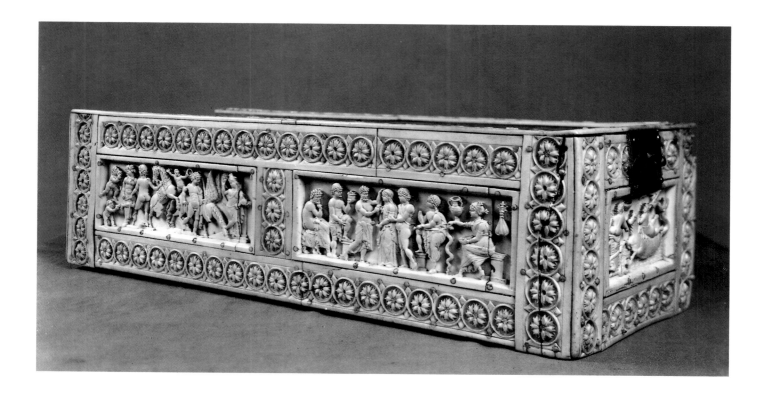

FOUR BYZANTINE CAMEOS

(a) Virgin *Blachernitissa*
Late twelfth century
Bloodstone; h. 4.5 cm
A.4-1982

(b) Christ Blessing
886–912
Jasper; h. 4.7 cm
A.21-1932

(c) Christ *Pantocrator*
Late tenth or early eleventh century
Bloodstone; h. (including rim) 3.7 cm, w. 2.7 cm
A.160-1978; purchased with the aid of the
funds of the W.L. Hildburgh Bequest

(d) The Crucifixion with the Virgin
and St John
About 900
Jasper; h. 6.5 cm, w. 6 cm
A.77-1937; purchased with funds from the
Francis Reubell Bryan Bequest

The Museum possesses a fine collection
of cameos and intaglios – known
collectively as glyptics – ranging in date
from the Early Christian period to the
nineteenth century. The small group of
Byzantine cameos is of special interest for
its high quality and because one of the
pieces, that of Christ Blessing (b), is
datable by an inscription on its back
which refers to the Emperor Leo VI
(886–912). Such pieces are very rare, and
are of great help in dating related
Byzantine small-scale sculpture.

Note: objects are shown enlarged

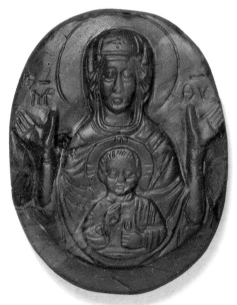

(a)

(b)

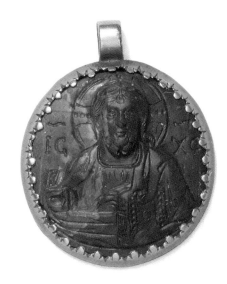

(c)

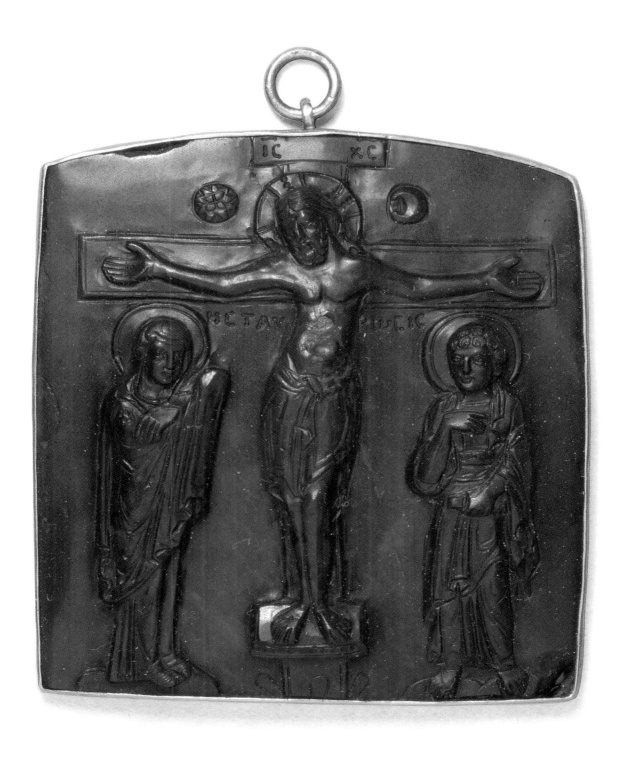

(d)

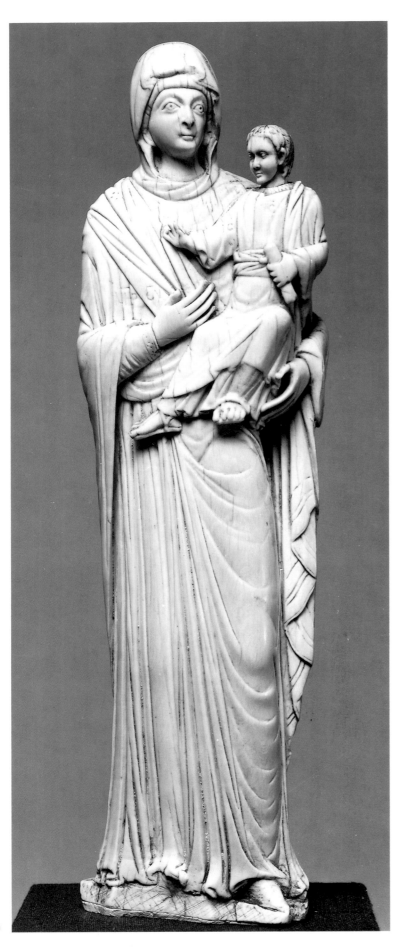

THE VIRGIN AND CHILD

Byzantine; eleventh century

Ivory; h. 32.5 cm

702-1884

The Virgin was an especially popular subject for Byzantine artists, who showed her in a variety of different ways in sculpture. These representations were invariably in relief, either on a large scale in marble or in smaller versions in ivory, metalwork or semi-precious stones (see the cameo on page 38). Although the present ivory Virgin follows the well-known Byzantine iconographic type of the *Theotokos Hodegetria*, where she gestures towards the Christ-Child, she is unique in the entire corpus of Byzantine ivories in being carved in the round. This feature, and the fact that the statuette was in the Castellani Collection in Rome before 1884, has led to speculation that it may have been carved in an Italian (Venetian) workshop under strong Byzantine influence. However, the closest stylistic parallels are undoubtedly with Constantinopolitan sculptures of the *Hodegetria*, most of which should be dated to the eleventh century. The head of the Christ Child is a restoration, probably added in Italy in the nineteenth century.

Ivory statuettes of the standing, rather than seated, Virgin are virtually unknown in the West before the thirteenth century; the *Hodegetria* appears to anticipate the similar treatment and scale of Gothic ivory Virgin and Child groups (see page 52) by at least 150 years.

THE ADORATION OF THE MAGI
Northern Spanish; about 1120–40

Whalebone; h. 36.5 cm, w. (at base) 16 cm

142-1866

This enigmatic relief has previously been
described as English, Irish, French or
Flemish, but scholarly opinion has now
settled on Northern Spain. The
iconographic type of the Virgin and Child
under an architectural canopy, with the
crowded group of diminutive pilgrim-like
magi approaching from the left, can be
paralleled in a twelfth-century tympanum
above the entrance to the church of Santa
Maria in Uncastillo (Saragossa), and
stylistically the most compelling
comparisons are with Northern Spanish
sculptures, on both a small and large
scale. Its original function is a mystery,
but it is perhaps most likely that it served
as a portable votive image. Carved from
the radius bone of a whale, it owes its
tapering shape to the raw material, which
would have made it difficult to set into a
separate framework, such as a bookcover.
Nothing is known of its history before it
entered the Soltykoff Collection in Paris,
from the sale of which it was purchased
by the dealer John Webb in 1861. It
passed to the Museum five years later.

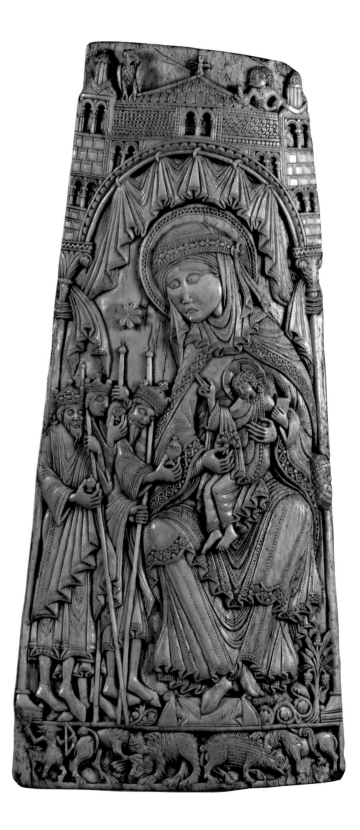

CAPITAL WITH DANIEL IN THE LIONS' DEN

Southern French (Saint-Pons-de-Thomières); about 1140

Marble; h. 40.5 cm

A.6-1956

The scene of Daniel in the lions' den was especially popular on capitals in the Romanesque period, the Old Testament figure being considered a prefiguration of the Judging Christ, and comparable examples to this capital are found throughout France, northern Spain and northern Italy. Here Daniel is shown sitting, his hands joined in prayer, in the lions' den, where he had been cast by the Babylonians. On the other sides of the capital the story continues as told in the apocryphal tale of Bel and the Dragon, with Habakkuk being brought by an angel to feed Daniel in the den.

The capital comes from the destroyed cloister of the Benedictine abbey of Saint-Pons-de-Thomières in the Hérault, inland from Narbonne. More than 30 other capitals from the cloister still survive, scattered throughout collections in France and the United States, and these show that the sculptural activity at the abbey continued over several decades.

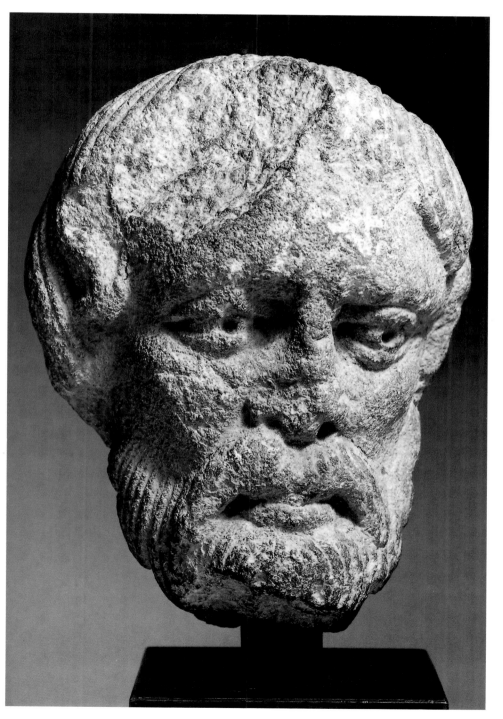

HEAD OF A MAN (AN APOSTLE?)
Southern French (Saint-Gilles-du-Gard); probably about 1150–60

Limestone; h. 18 cm

A.1-1988

This head comes from the great abbey church of Saint-Gilles-du-Gard, south of Arles. It was photographed *in situ* in the crypt before 1910, but its exact original location remains uncertain. It does not appear to have been removed from the celebrated sculptural programme on the west façade of the church, but it may have belonged to one of the side portals which no longer survive. Two large fragments of a tympanum, showing four of the apostles at the Last Judgement, still remain at Saint-Gilles (Musée de la maison romane) and probably also formed part of one of these doors. The heads of these apostles – which look to their right towards the now-lost figure of Christ – are the same size as the present head, and it may be that the latter, looking in the opposite direction, belonged to one of the apostles (St Peter?) on the other side of the tympanum. This must remain as conjecture, but the style of the head is certainly closer to the heads of these apostles than to the figures of the west façade, and like them it reveals the strong influence of the Antique so characteristic of Provençal Romanesque sculpture. The brooding intensity of the face, as if in deep thought, shows the increasing ability of the most gifted sculptors to indicate the physiognomic expression of meditation, and looks forward to the achievements of the Early Gothic.

ST PHILIP, ST JUDE AND ST BARTHOLOMEW

Spanish (Vic); about 1150–60

Limestone; h. 81.4 cm. w. 63.4 cm

A.49-1932; purchased with the assistance of the National Art Collections Fund

This relief, with another carved with the apostles Paul, Andrew and James (now in the Nelson-Atkins Museum of Art, Kansas City) and a third with three prophets (Musée des Beaux-Arts, Lyons) probably formed part of the decoration of the now-demolished west front of the cathedral of Sant Pere at Vic, north of Barcelona. There still remain in the Episcopal Museum in Vic many pieces of fragmentary and much abraded sculpture which also belonged to the decorative ensemble. It is likely that this resembled in general form the façade of Santa Maria at Ripoll, also in Catalonia, and showed apostles and prophets flanking the central figure of Christ in Majesty, and additionally small narrative panels.

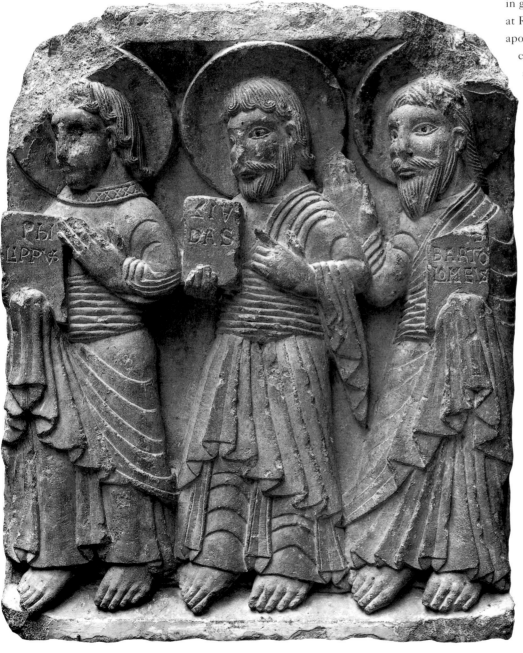

THE NATIVITY AND ANNUNCIATION TO THE SHEPHERDS

German (Cologne); about 1150–60

Walrus ivory, with traces of staining;
h. 21, w. 19 cm
144-1866

The Nativity takes place inside the walls of Bethlehem, the star shining above the manger and an adoring angel approaching from the left. Outside, a choir of angels announces the Birth to three shepherds. Because of the physical limitations of the walrus tusk, the relief has been made up of three panels fixed together and held in place by a frame which in turn consists of four separate strips of walrus ivory. The Museum

also possesses two other walrus ivory reliefs of the same size and facture, showing the Adoration of the Magi (145-1866) and the Ascension (378-1871), which presumably came from the same ensemble, probably an altar frontal or some other piece of church furniture. Two further panels in the Metropolitan Museum of Art in New York, with the Maries at the Sepulchre and the Incredulity of St Thomas, also appear to have formed part of the complex.

The individual style of the workshop responsible for this group of ivories is distinguished by the rows of punched dots, or pricks, along the lines of the draperies. The distinctive style of these ivories and this particular technique is seen again in a smaller but extremely similar group of walrus ivory reliefs, one of which (the Ascension, 258-1867) is also to be found in the Museum's Collection. All were made in Cologne in the years around the middle of the twelfth century.

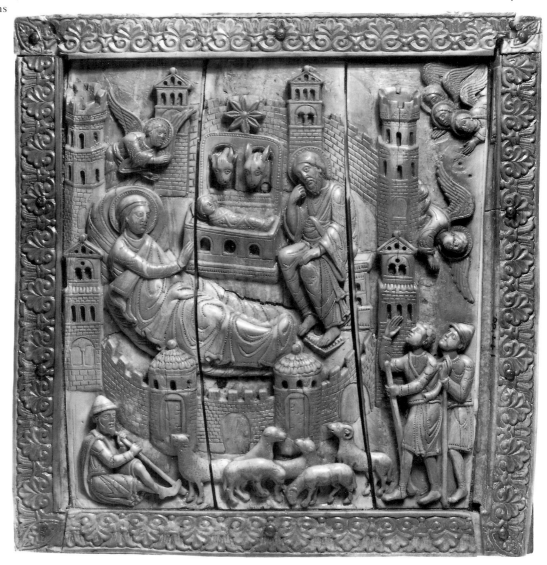

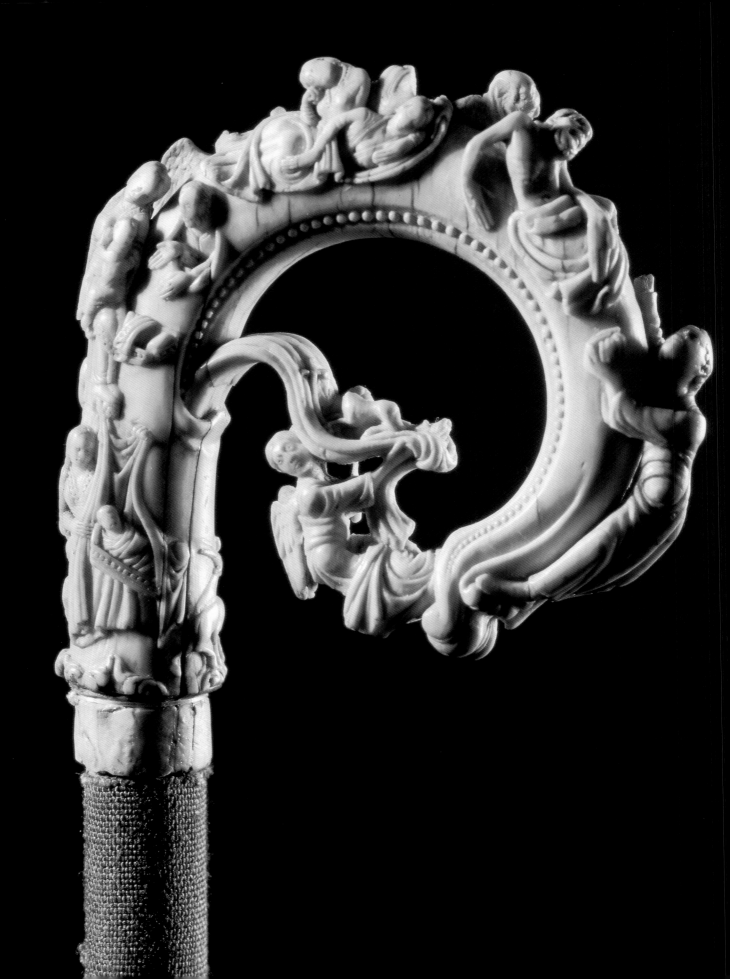

THE ST NICHOLAS CROZIER
Probably English (Winchester?);
about 1160–70
Ivory; h. 12 cm, w. 11 cm
218-1865

The crozier shows scenes relating to Christ and St Nicholas. At the end of the volute an angel supports the Lamb of God (now lacking its head), while on the other side is the Nativity. The Annunciation to the Shepherds takes place on one side of the shaft, but the rest of the crozier proper is dedicated to three scenes from the Life of St Nicholas. These comprise his birth, the infant saint's abstinence from his mother's milk – according to the *Golden Legend* 'he took the breast only once on Wednesdays and Fridays' – and his gift of gold to the impoverished and emaciated nobleman of Myra, to prevent the latter's three daughters being put out on to the streets. Because of its very particular iconography it is assumed that the crozier was made for a high-ranking ecclesiastic either named after the saint or in charge of a foundation dedicated to him.

This crozier is justifiably considered one of the most sublime achievements of the medieval ivory carver's art. The awkward shape of the volute has here been brilliantly transformed into a fantastic landscape for the two separate but interlinked narratives, while the creative fertility of the sculptor's imagination is evident throughout. Most striking perhaps is the extraordinary depiction of Nicholas's father, half-way up the crozier, who emerges from inside the surface of the ivory in a tour de force of technical and creative genius.

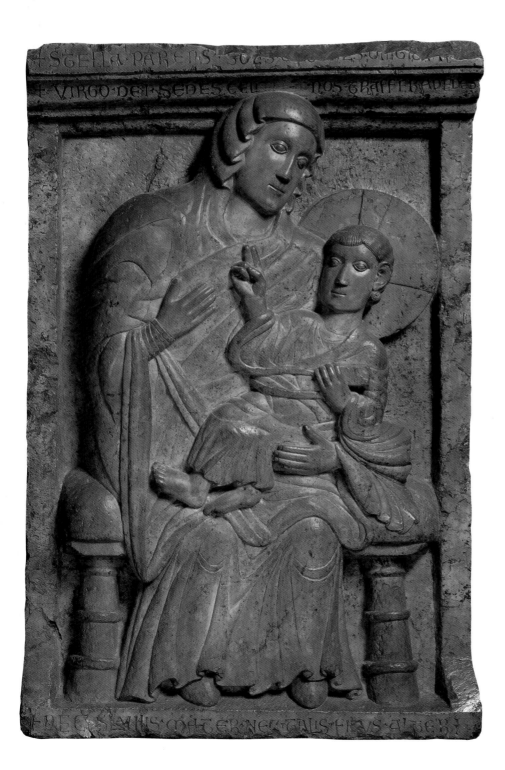

VIRGIN AND CHILD

North Italian (Cremona); about 1170

Orange-red ('Verona') Marble; h. 94 cm, w. 60 cm

A.6-1913

On acquisition the relief was said to have come from Auer (Ora), a small town in the Adige Valley in North Italy, between Bolzano and Trento. It was subsequently discovered that this provenance was false (or at best only concerned its most recent resting place before London), and that prior to about 1880 it had been set on to a staircase between the cathedral and episcopal palace at Cremona. A Lombard origin is confirmed by its close similarity to a number of other sculptures still *in situ*, such as a relief of the Virgin and Child in Piacenza Cathedral and tympana at Castellarquato, Cadeo and Lodi. The relief originally may have functioned as a three-dimensional icon, or alternatively may have been set into a larger ensemble, such as a choirscreen or pulpit. The full rhyming inscription on the upper and lower borders, extolling the virtues of the Virgin and suggesting a devotional context, favours the former.

THE LARNACA TYMPANUM
Cypriote (Larnaca); probably about
1210–30
Marble; h. 61.5 cm, w. (including wings) 104 cm
A.2-1982

The tympanum shows the Ascension of Christ in a mandorla supported by four angels with, below, the twelve apostles, two archangels and the Virgin *orans*; in the small compartments to each side are scenes of the Carrying of the Cross, the Crucifixion, the Baptism of Christ, the Annunciation and the Maries at the Sepulchre.

Discovered in the foundations of a house in Larnaca between 1873 and 1879, this tympanum is an extremely rare and important example of medieval Cypriote sculpture and the only piece in a museum collection outside Cyprus. Executed probably by a Tuscan workshop, possibly working for Lusignan (French) patrons, it combines Italian Romanesque style with elements of Byzantine iconography in a manner similar to contemporary 'Crusader' works in the Holy Land.

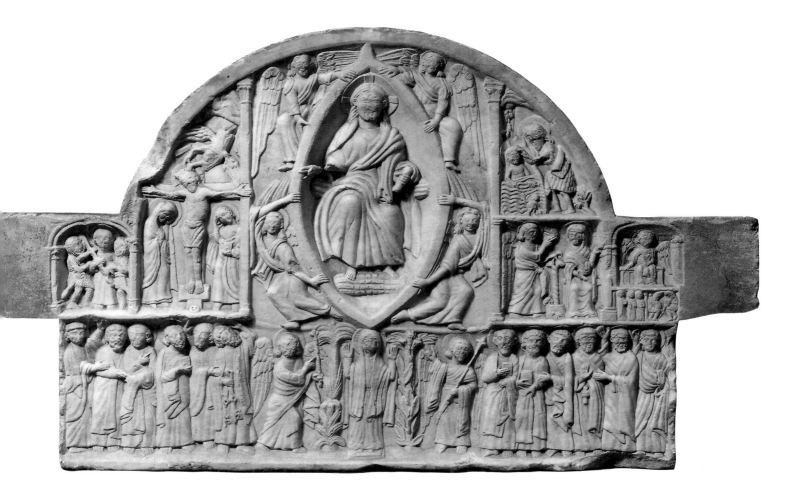

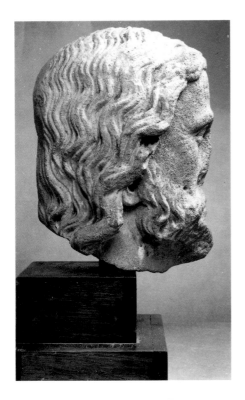

HEAD OF CHRIST OR AN APOSTLE
Northern French (Thérouanne);
about 1230

Limestone; h. 36.1 cm

A.25-1979; bought with the assistance of funds
from the W.L. Hildburgh Bequest and the
Associates of the V&A

The portals of the Gothic cathedrals of
Northern Europe were often embellished
with life-sized statues on the jambs to the
sides of the door and standing figures of
Christ or the Virgin on the trumeau (the
column supporting the lintel). This head
comes from the main portal of the
cathedral of Thérouanne, which was
destroyed in 1553 by the forces of the
Emperor Charles V. After the demolition
several pieces of sculpture were taken to
neighbouring Saint-Omer, including the
figures of the seated Christ in Judgement
and the kneeling Virgin and St John the
Evangelist which still remain in the north
transept of the cathedral there. The
Museum's head and four others in the
same style were found in the wall of a
house in the same town in 1923: the latter
have now entered American collections
(two are in the Cleveland Museum of Art,
one is in the Museum of Fine Arts in
Houston, and the other is in a private
collection in New York).

By comparison with other early
thirteenth-century figures it is likely that
the present head is that of Christ. On
doorways with the Last Judgement in the
tympanum it was usual to have Christ on
the trumeau and the twelve apostles on the
jambs, and the four other surviving heads
from Thérouanne have parallels with the
apostle heads on the Chartres south
transept central portal and elsewhere.
Stylistically, the Thérouanne sculptures
represent the classic phase of High Gothic
sculpture, deriving, like the Chartres
transept sculptures, from works produced
at the very beginning of the thirteenth
century, such as at Sens and Laon.

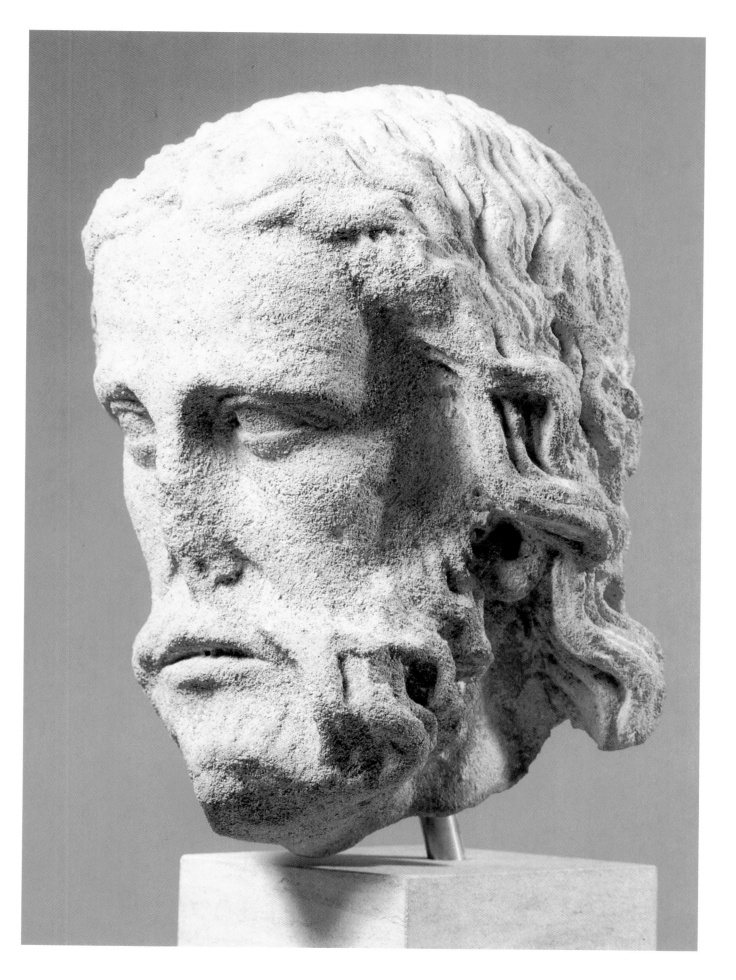

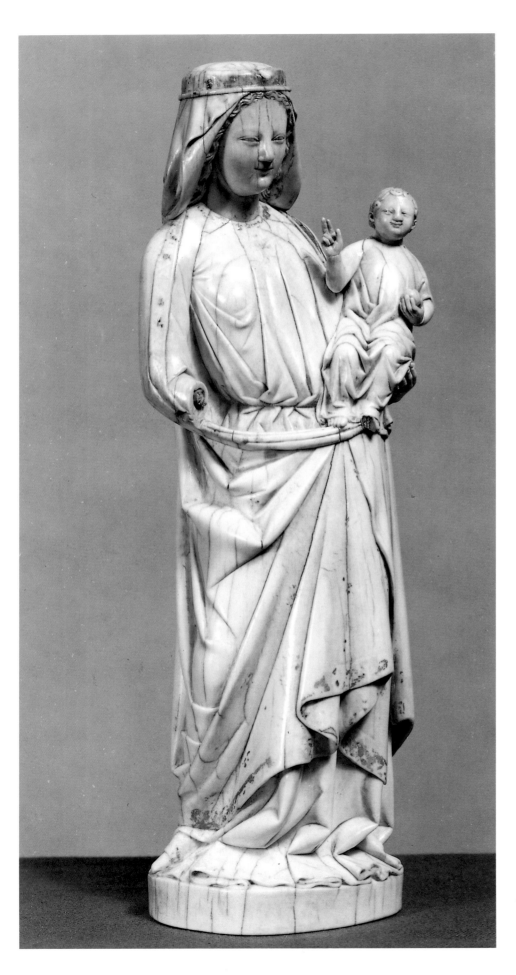

THE VIRGIN AND CHILD

French (Paris); about 1250–60

Ivory; h. 26 cm

209-1867

The earliest Gothic ivory carvings appeared in the second quarter of the thirteenth century, when the raw material once again became available in reasonable quantities; during the Romanesque period of the eleventh and twelfth centuries the tusk of the walrus was almost invariably used instead. The first Gothic ivory Virgins share the same stylistic traits as their monumental counterparts on the doorways of cathedrals, and this Virgin has a similar arrangement of drapery to the famous stone Madonna on the south doorway of the west front of Amiens Cathedral, of about 1230–35.

It has been suggested that Nicola and Giovanni Pisano were influenced by such ivory carvings when executing the figures on the Siena Cathedral pulpit in 1265–68, and it is likely that similar pieces were also used as models in Spain.

THE ARCHANGEL MICHAEL

Workshop of Nicola Pisano (active
1258–78)

Italian (Pisa); about 1260–70

Marble; h. 96.5 cm

5798-1859

By the thirteenth century the cult of the
Archangel Michael had spread across
Europe, and several mount sanctuaries,
such as that at Monte Sant'Angelo on the
Gargano Peninsula in South Italy, had
been established. The representation of
the Angel trampling the devil in the form
of a dragon underfoot, with a spear in his
raised right hand, became very popular
and many sculptures of this type survive.

This *St Michael*, with its companion
Archangel Gabriel (5800-1859) and other
sculptures now in Florence, Boston and
Paris, has been proposed as one of the
supports of the *Arca* (shrine) of St
Dominic in San Domenico Maggiore in
Bologna. This was made under the
supervision of Nicola Pisano in 1264–67,
with much of the work being executed by
the young Arnolfo di Cambio and Fra
Guglielmo. The physical and
documentary evidence is inconclusive
about the original form of the shrine,
however, and it is possible that the St
Michael and St Gabriel formerly
belonged to a different ensemble,
possibly a pulpit. At the time of their
acquisition, John Charles Robinson stated
that they came 'from a church in the
neighbourhood of Pisa'.

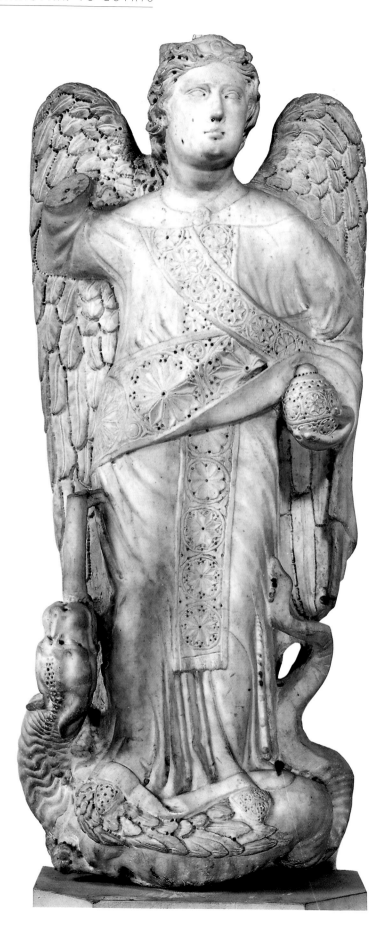

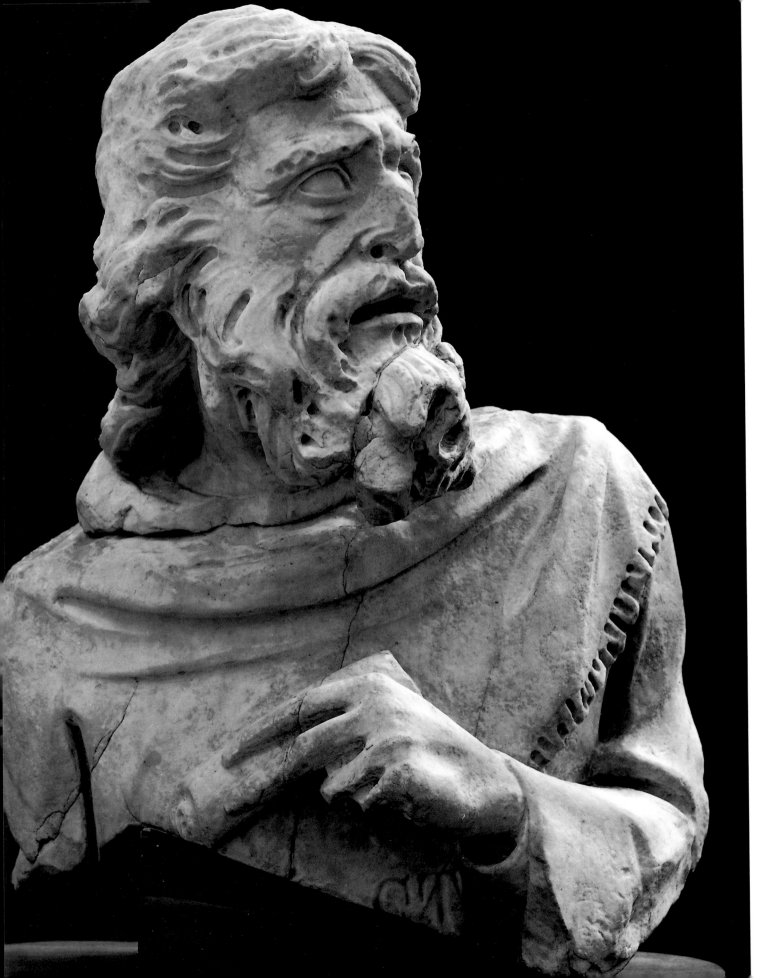

THE PROPHET HAGGAI

By Giovanni Pisano (about
1250 – after 1314)
Italian (Siena); 1285 – 97

Marble; h. 63.8 cm

A.13-1963; bought with the assistance of the
National Art Collections Fund

This bust formed part of one of the 14
statues of prophets and wise men and
women which originally decorated the
west façade of Siena Cathedral. These are
now replaced by copies, most of the
originals being displayed in the Museo
dell'Opera del Duomo. The fragment of
Haggai, identifiable by the remains of the
inscription on the scroll in the prophet's
left hand, stood in a shallow niche on the
north face of the façade as a counterpart
to Isaiah, and is the only part of Siena
Cathedral's external sculptural decoration
to have left Italy.

Because of its intended position, high
up on the façade, the head of Haggai was
carved more vigorously than if it had
been placed nearer the eye. Giovanni
Pisano, the *caput magistrorum* (head of
works) at the cathedral, made repeated
use of the drill in the hair and beard of
the prophet to catch the light and create
shadows, so that the head would register
more clearly from below. As elsewhere in
Giovanni's *oeuvre* the debt to antique
sculpture is apparent, but the classical
impulses have been transformed by an
awareness of contemporary Northern
Gothic sculpture and a recognition of the
importance of the individual figure's
place in a larger scheme.

THE CRUCIFIED CHRIST

By Giovanni Pisano (about
1250–after 1314)
Italian (Pisa); about 1300

Ivory; h. 15.5 cm

212-1867

It is known that Giovanni Pisano carved
the great ivory Virgin and Child in the
Museo dell'Opera del Duomo in Pisa in
1298 and that scenes from the Passion of
Christ also belonged to the ensemble of
which it formed a part. Although it is
unlikely that the present crucifix figure
came from that Pisan commission, its
style – closely comparable to figures on
Giovanni Pisano's pulpit of 1302–10 in
Pisa Cathedral – and superb quality allow
a confident attribution to the same
sculptor to be made.

Originally partially painted (the
loincloth) and gilded (the hair and beard),
this figure is similar to the polychrome
wood crucifix figures made by Giovanni
Pisano which still survive in Siena,
Pistoia, Prato, Pisa and Berlin. Small
crucifixes such as this were made for side
altars and chapels, and medieval
inventories also list ivory crucifixes
amongst the possessions of the rich and
powerful.

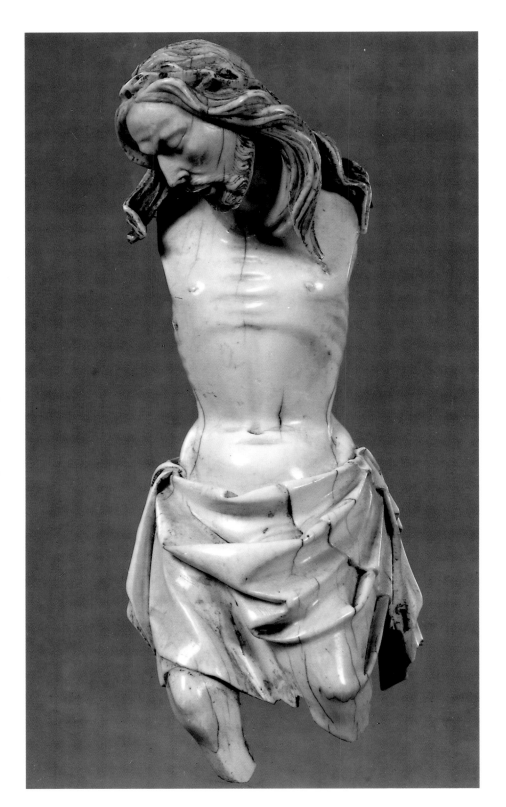

THE SALTING DIPTYCH

English (London); about 1310–20

Ivory, painted and gilded; h. 21.6 cm, w. 16.2 cm

A.545-1910; Salting Bequest

This diptych, so-named after its donor to the Museum (see page 18), is one of the comparatively rare Gothic ivories to be unequivocally accepted as English. Thicker than any existing French ivory relief – each leaf measures 2.6 cm in depth – the style of the figures of Christ and the Virgin and Child has traditionally been associated with late thirteenth- and early fourteenth-century work at Westminster and on the Eleanor Crosses of the early 1290s; parallels have also been drawn with slightly later sculptures, such as the Percy tomb at Beverley (c.1330–40). The use of the ogee arch and the unusual, monumental, form of the individual figures – as opposed to the smaller and more crowded scenes from the Gospels found on French ivories – further isolate the diptych as an English product, probably produced in a court workshop. In effect, the figures have the appearance of small free-standing statues enclosed within niches, or of three-dimensional Northern versions of the full-length figures to be found in Italian fourteenth-century painted predella panels.

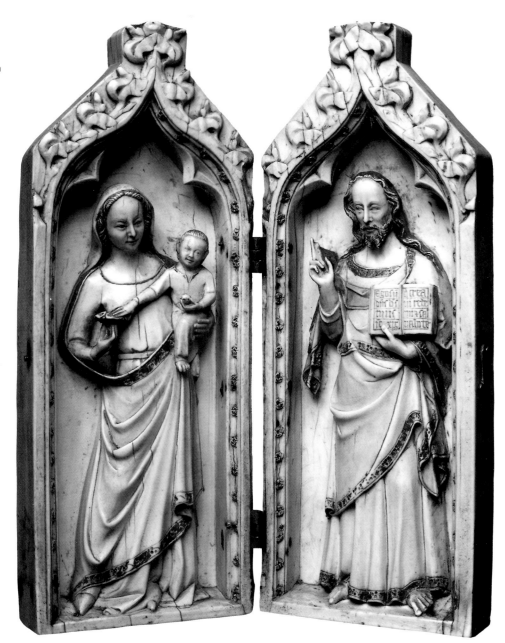

THE SOISSONS DIPTYCH

French (Paris); about 1280–1300

Ivory, painted and gilded; h. 32.5 cm, w. 11.5
cm (each leaf)

211-1865

The scenes from the Passion of Christ
should be read across the two leaves of
the diptych, from the bottom left and
back again.

On the bottom tier, they show Judas
receiving the 30 pieces of silver, the
Betrayal of Christ, the Death of Judas,
the Buffeting of Christ, Pilate washing his
hands, and the Flagellation; Christ

carrying the Cross, the Crucifixion, the
Deposition from the Cross, the
Entombment, the Resurrection, and the
Harrowing of Hell in the second row; and
the Maries at the Sepulchre, Christ's
appearance to Mary Magdalen, Christ's
appearance to the Maries, the Doubting
of Thomas, the Ascension, and the
Descent of the Holy Spirit on the top
register.

The diptych is traditionally supposed to
have come from the abbey of Saint-Jean-
des-Vignes at Soissons, although there is
no firm documentary evidence to support
this. It nevertheless gives its name to a
number of related Gothic ivories of the
late thirteenth century – the 'Soissons
group' – which share the same densely
populated, stacked bands of narrative
scenes and elaborate High Gothic
architectural forms. These diptychs,
mostly showing scenes from the Passion
of Christ, took over this form of narrative
sequence from the tympana over the
doors of the great French cathedrals – as
at Reims, Amiens, Notre-Dame in Paris
and Rouen – and because the ivories were
portable they in turn probably acted as
conduits for carrying Gothic style and
iconography from the Ile-de-France to
other areas of Europe.

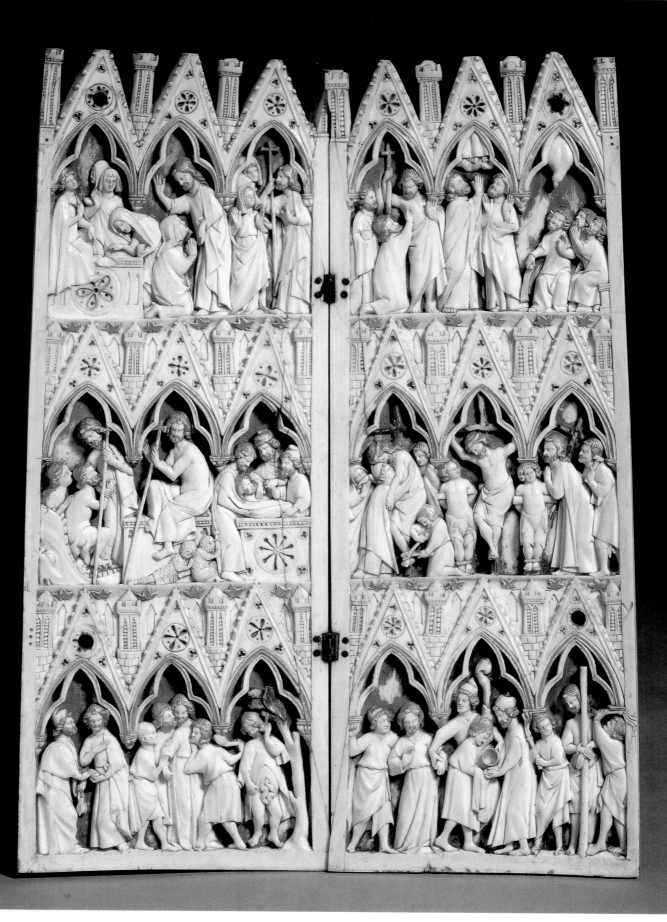

VIRGIN FROM A CORONATION GROUP

Mosan (probably Liège); about
1330–50

Oak, painted and gilded with raised gesso
patterns, inset with cabochon stones; h. 57 cm
A.4-1929; given by Mrs F. Leverton Harris

The seated Virgin turns and looks
towards a figure of Christ who once sat
beside her; the latter is now in the
Rijksmuseum, Amsterdam, the pair
having been separated at some time after
1905. The scene is frozen at the moment
just after Christ has placed the small
crown on the Virgin's head, and would
have been set at the centre of an
altarpiece, with apostles and possibly
other saints flanking it. The scene of the
Coronation of the Virgin first appeared in
the middle of the twelfth century and
became increasingly ubiquitous as the
popularity of the Virgin grew. The
devotion to the Virgin was connected
with her perceived intercessionary powers
on behalf of sinners and her widespread
appeal to women and mothers especially.
Numerous churches and cathedrals were
dedicated to the Virgin in the twelfth to
fourteenth centuries and the scene of the
Coronation of the Virgin, celebrating her
status as the Queen of Heaven, is often to
be found sculpted above their entrances.

Some idea of the original opulence of
much medieval sculpture can be gained
from this figure. Although the painted
decoration has been abraded and lost in
places, enough remains to show the
refined painting technique – especially
on the face of the Virgin – and the love of
surface encrustation, as manifested in the
raised gesso and inlaid false-gem
decoration of her draperies. The oval
hollow in the Virgin's chest almost
certainly once contained a relic covered
by rock crystal.

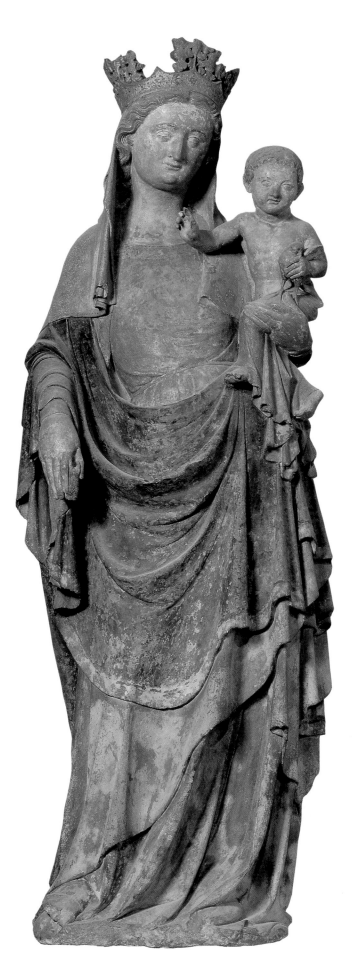

THE VIRGIN AND CHILD

French (Ile-de-France); about
1340–50

Limestone, painted and gilded; h. 173 cm
A.98-1911; given by J. Pierpont Morgan

Life-sized statues of the Virgin and Child
abounded in the thirteenth, fourteenth
and fifteenth centuries. Some of the most
influential types were those on the portals
of cathedrals, such as at Notre-Dame in
Paris, Amiens and Reims; these
prototypes were copied and their images
disseminated throughout Europe from
about 1250 to 1350, on both a large and
small scale (see page 52 for the latter).
The bond between the Virgin and the
Christ Child is usually visually reinforced
by interlinked poses which bring the two
figures together, the Child often reaching
out to touch a flower held in the Virgin's
hand. An allusion to Christ's future
suffering at the Passion is sometimes
provided, as here, by the goldfinch which
turns to peck the Child's hand: this
particular bird was specifically associated
with the Passion of Christ by medieval
writers, the thistles it eats being linked
with the Crown of Thorns.

MIRROR CASE
French (Paris); about 1360

Ivory; diam. 13.5 cm

1617-1855

Ivory mirror cases were made in large numbers from the second half of the thirteenth century for a growing *bourgeois* market which also commissioned ivory caskets, combs, knife handles and other secular items. The images chosen to decorate the outside faces of the mirror cases most often consisted of pairs of lovers engaged in courting, usually playing chess or riding together, but a good number show more ambitious scenes drawn from romantic or chivalric legend. The Storming of the Castle of Love was one of the most popular of these. Here, the knights clamber over the battlements to be received ardently by the waiting ladies while above the winged God of Love smites two young damsels with the arrows of desire.

Gothic ivory carvings were amongst the first acquisitions of sculpture by the Museum, this mirror back being one of the earliest purchases, in 1855. Many additions have been made since then, so that the collection is now one of the most comprehensive in the world, with over 200 pieces. These were acquired mostly by purchase, although an important group of 16 religious ivories was bequeathed in 1940 by Mrs Gilbertson in memory of her husband, Canon Gilbertson.

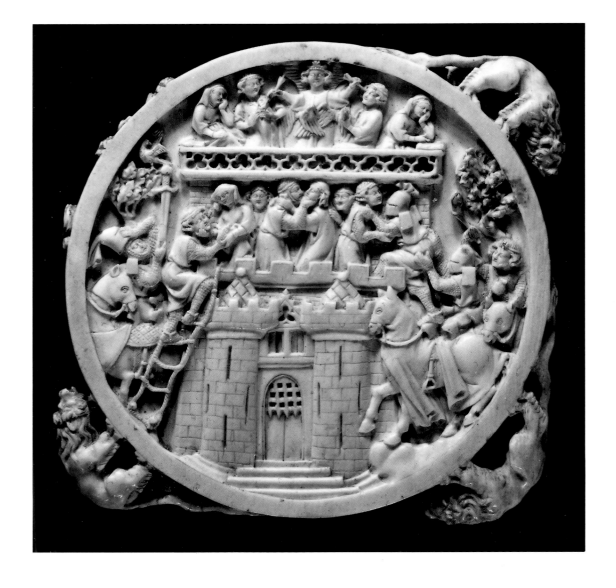

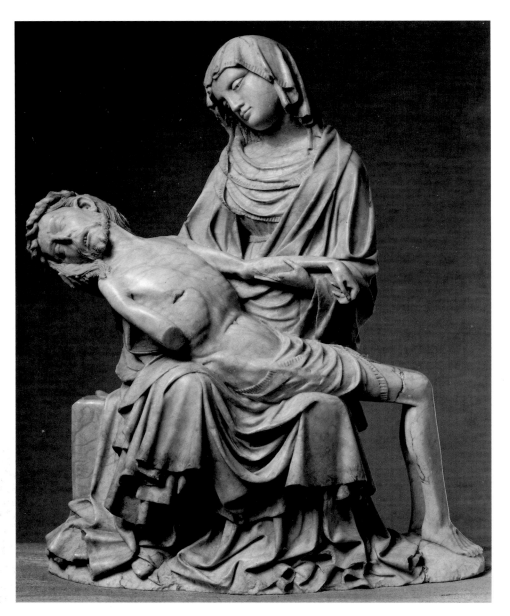

THE VIRGIN WITH THE DEAD CHRIST

Southern Netherlandish;
about 1430

Alabaster; h. 38.4 cm

A.28-1960; given by Sir Thomas Barlow

Small sculptures of the Virgin and Dead Christ, known as the Pietà (in German *Vesperbild*), became increasingly popular objects of private devotion – as aids to prayer – from about 1300 onwards. The image arose out of the writings of German medieval mystics such as Heinrich Suso (c.1295–1366), who described the maternal anguish of the Virgin at the death of her Son and their reaction to her sorrow.

In the fifteenth century especially, sculptures of the Pietà were made in large numbers, in a wide variety of materials, throughout Northern Europe. This extremely fine example may be attributed to the so-called 'Rimini Master', an outstandingly gifted sculptor who also made a multi-figured alabaster altarpiece for the church of Santa Maria delle Grazie in Rimini-Covignano (now in the Liebieghaus in Frankfurt am Main). Because of stylistic analogies with South Netherlandish works, especially the paintings of Rogier van der Weyden and the Master of Flémalle, it is likely that the sculptor came from the same region.

THE SWANSEA ALTARPIECE

English; second half of the fifteenth century

Alabaster panels in a painted framework of oak;
max h. 83.2 cm, w. 215 cm

A.89-1919

The Swansea Altarpiece, so-called because it formerly belonged to Lord Swansea's collection at Singleton Abbey, Swansea, is a rare complete example of a genre once widely represented in Britain. The carving of alabaster, mostly quarried in Tutbury and Chellaston near Nottingham, took on industrial proportions in England between the middle of the fourteenth and the early sixteenth centuries, but most of the figures and reliefs in this material contained in British churches were comprehensively destroyed during the Reformation of the sixteenth century and the Civil War in the seventeenth. Consequently the majority of the examples now in museum collections were acquired elsewhere in Europe, where they had been exported in large numbers during the Middle Ages. The Victoria and Albert Museum's collection of over 260 English medieval alabasters – by far the largest in the world – is overwhelmingly the result of Dr W.L. Hildburgh's great beneficence in this area: he gave his entire collection to the Museum in 1946 (see pages 19–20).

The subject matter of the altarpiece is primarily concerned with the Joys of the Virgin, comprising (from the left) the Annunciation, the Adoration of the Magi, the Ascension and the Assumption/ Coronation of the Virgin; at the centre is a taller relief of the Trinity and at the ends single figures of St John the Baptist and St John the Evangelist.

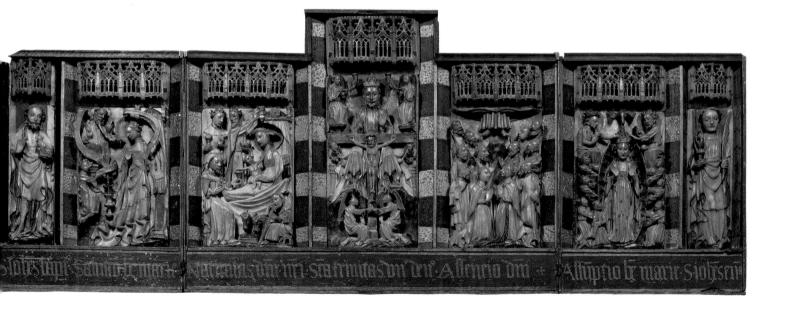

ST CHRISTOPHER

English; middle of the fifteenth century

Alabaster, with traces of painting and gilding; h. 94.7 cm

A.18-1921; given in memory of Cecil Duncan Jones by his friends

Christopher, the patron saint of travellers, was one of the most popular saints of the Late Middle Ages. As related in the thirteenth-century *Golden Legend* of Jacobus de Voragine, he was 'a man of prodigious size, twelve cubits in height [a cubit is an ancient measurement, roughly the length of a forearm], and fearful of aspect'. He was converted to Christianity after carrying a small child across a river, who mysteriously became heavier and heavier. On setting the child down on the other side, Christopher exclaimed

'Child, thou hast put me in dire peril, and hast weighed so heavy upon me that if I had borne the whole world upon my shoulders, it could not have burdened me more heavily!' And the child answered: 'Wonder not, Christopher, for not only hast thou borne the whole world upon thy shoulders, but Him who created the world. For I am Christ thy King, whom thou servest in this work! And as a sign that I say the truth, when thou shalt have returned to the other side of the river, plant thy staff in the earth near thy hut, and in the morning thou shalt see it laden with flowers and fruits!' And straightaway He disappeared.

Representations of the saint were widespread, ranging from images on small objects such as medallions to monumental paintings on the piers of churches. The Museum has no less than four English alabaster figures of this particular saint, the present example being the finest in quality. The original context of the sculpture is not clear. Such figures often stood at the ends of altarpieces (see the Swansea Altarpiece on page 65 for comparable figures of St John the Baptist and St John the Evangelist); the large size of this example, however, and the presence of a diminutive kneeling donor figure at the bottom right, suggest that it stood singly within a tabernacle as an object of private devotion.

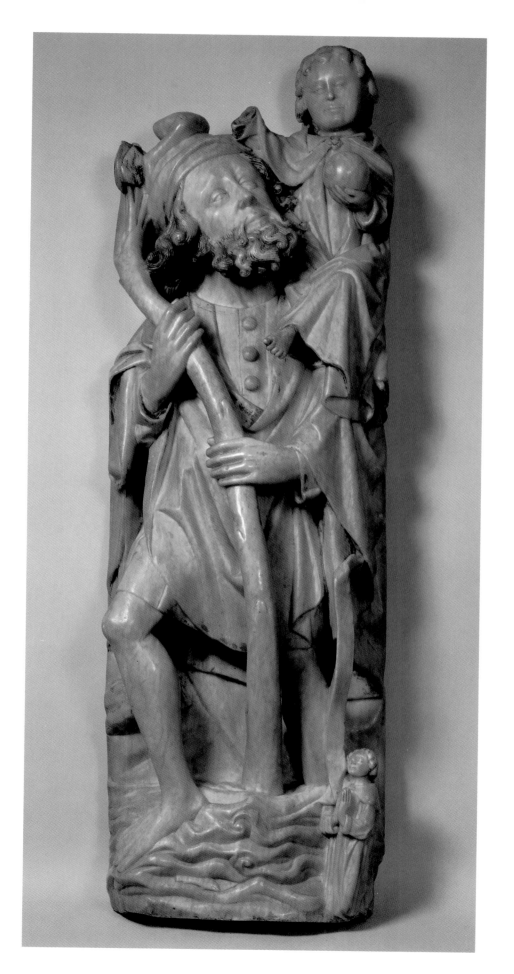

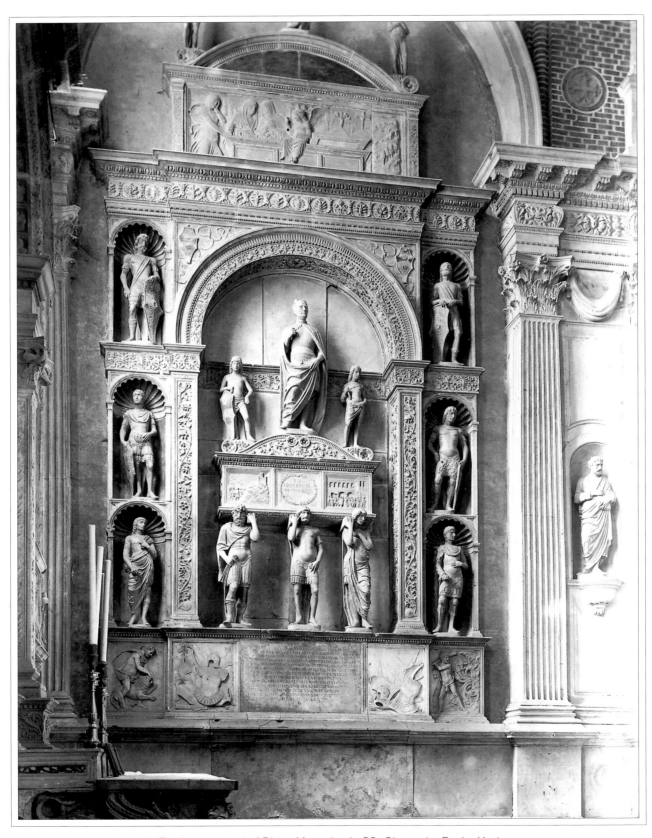

1. Tomb monument of Pietro Mocenigo in SS. Giovanni e Paolo, Venice;
by Pietro Lombardo; 1476–81

LATE GOTHIC AND RENAISSANCE

The Italian Renaissance is with reason considered one of the high points of European civilisation, and the sculptors from this period, no less than the painters, have long been celebrated as some of the most creative artists to have ever lived. No history of art would be complete without mention of Donatello, perhaps the most influential artist of the Quattrocento, and the prodigious Michelangelo, who was held in awe by his contemporaries. Alongside these two central figures there was a legion of sculptural talent, including such famous names as Antonio Rossellino, Andrea del Verrocchio, Luca della Robbia and Jacopo Sansovino, who made their own very individual contributions to the development of sculpture in Italy. The pre-requisites to this flowering of sculpture were a prosperous economy which produced a plethora of patrons, both secular and ecclesiastical, a rivalry between the Italian city-states for the best works, and a ready supply of the fine raw materials – Carrara marble especially – which were so essential for high-quality monuments and figures. These factors in themselves would not have produced great sculptors, but in fifteenth-century Florence and elsewhere there was a new spirit of enquiry which manifested itself not just in the world of art but also in the advances made in science, medicine and engineering, and which provided the platform to elevate the gifted to new heights. Leonardo da Vinci is, of course, the quintessential *uomo*

universale, but his intellectual curiosity and brilliant technical skills were also found in others, if not in combination.

It would be a mistake, however, to judge the artistic achievements of the fifteenth and sixteenth centuries solely by reference to Italy. The new wealth generated in this period was of course just as conspicuous north of the Alps, and the range of commissions even more varied. The influence of Donatello in Italy can be paralleled by the pre-eminent sculptor of the Burgundian court, Claus Sluter (active c.1380–1405), whose astonishing realism in the depiction of facial types and emotional gesture spawned numerous followers; and in the period 1400–1530 there are several sculptors who stand comparison with the great sculptors of any age. Nikolaus Gerhaerts, Hans Multscher, Tilman Riemenschneider and Veit Stoss are perhaps the most celebrated of these, but it is as well not to dwell too much on the individual and to overlook the the rôle of the workshop in the production of sculpture. Guild regulations clearly defined what was permitted of sculptors and their workshops in different cities, including the materials to be used and the number of apprentices to be trained at any one time, and penalties were imposed for deviation from these rules. Artistic originality and even genius could certainly prosper in such an environment, but a good deal of the work was collaborative and the contributions of specific masters are not always clear.

The range of commissions in both North and South is suggested by the different types of sculptures illustrated in this book. Large wall monuments, as exemplified by that made for the Marchese Spinetta Malaspina in Verona (page 72), abounded in Italy and elsewhere and provided sculptors – in conjunction with the client – with considerable scope for artistic invention, often incorporating multi-figured groups into a complex ensemble loaded with propagandist meaning (figure 1). The earliest sketch models in terracotta date from this period (page 84) and provide evidence of the evolving process of design. The application of decorative sculpture to architecture, such a notable feature of the Romanesque and Gothic periods, continued unabated into the Renaissance, and was especially effective when enlivening the flat surfaces of otherwise purely functional structures (pages 87 and 115).

The Church continued to provide employment for the majority of sculptors in the fifteenth century, and the development of the altarpiece evinces a growing sophistication shared by sculptors and those responsible for commissioning the works. Relatively simple structures, often containing no more than one figure set within a tabernacle, were replaced in the North by much larger altarpieces which provided a framework for sometimes complicated narrative relief programmes (see figure 2 and page 108); but alongside these increasingly grandiose schemes there was still a need for the single devotional image – the Virgin and Child and individual saints – which filled every church. In parts of Germany and the Netherlands and in England the demand for religious imagery was to be drastically curtailed with the advent of the Protestant Reformation. In addition to the widespread destruction of such sculptures between 1520–40, there was a concomitant hostility to the commissioning of religious works, and many of the sculptors who made their livelihood from the Church fell on hard times. Those who could turned to commemorative secular works and the burgeoning new market – the private collector of small sculpture.

In Italy, classical bronze statuettes were collected by a small intellectual élite interested in Roman antiquity. As the fifteenth century progressed such pieces attracted the attention of sculptors and goldsmiths, who imitated them and created new compositions of their own design, making the genre more widely available. Antico and Riccio are the best known practitioners of the art of the small bronze, but because of the easy portability of such pieces the fashion spread quickly throughout Europe. If the effect of the Reformation was not enough to change the course of the history of sculpture the arrival of the Italianate manner delivered the final blow to the Late Gothic sculptors' lodges of Northern Europe.

2. Carved altarpiece of the Life of the Virgin in the Herrgottskirche, Creglingen, South Germany; by Tilman Riemenschneider; about 1505–10

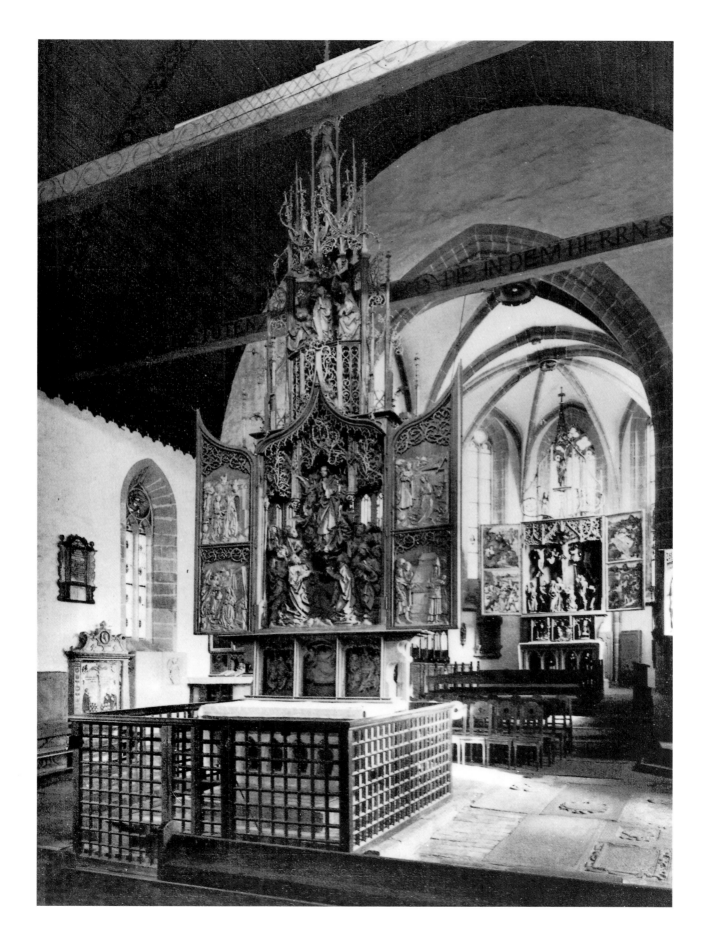

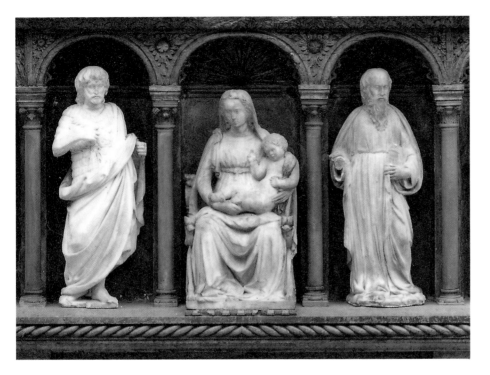

**MONUMENT TO MARCHESE
SPINETTA MALASPINA** (d. 1352)
Attributed to Antonio da Firenze
(active 1435) and (the five figures
below) Pietro di Niccolo Lamberti
(about 1393–1435) and Giovanni di
Martino da Fiesole
Italian (Verona); about 1435

Cement, marble and Istrian stone; h. 899.2 cm,
w. 487.7 cm

191-1887

The upper part of the monument,
showing a tent topped by a standing
angel, is modelled in cement over a brick
core. The curtains of the tent are held
open by two armed men, revealing the
mounted figure of the distinguished
soldier Spinetta Malaspina; below is a
Verona marble sarcophagus, supported by
lions bearing shields with the Malaspina
coat of arms. The monument was
purchased from the deconsecrated church
of San Giovanni in Sacco at Verona, which
had been founded by Spinetta Malaspina
and was finally destroyed in 1888. The
church had before this been burnt by the

troops of the Emperor Maximilian in 1516
and transferred to a new site in 1519. The
short inscription on the lowest slab refers
to the re-erection of the monument in the
new church in 1536.

This commemorative monument
(Malaspina was buried elsewhere) is
closely similar in form to the tomb of
Cortesia Serego in Sant' Anastasia in
Verona of 1424–29. The latter is
attributed to Antonio da Firenze, a pupil
of the Florentine sculptor Pietro di
Niccolo Lamberti who was active mainly
in the Veneto and was employed by the
Serego family in 1435. The five Istrian
stone figures in the niches on the
sarcophagus, representing (left to right)
St Jerome, St John the Baptist, the Virgin
and Child, St Paul and St Mary
Magdalen, had been removed from the
monument after 1845, but were
recognised from engravings and reunited
with the ensemble when it was purchased
for the Museum. They are also attributed
to Pietro di Niccolo Lamberti, together
with his assistant, Giovanni di Martino da
Fiesole, by comparison with figures of
saints on the monument they executed to
Tommaso Mocenigo in the church of
Santi Giovanni e Paolo in Venice (1423).

The long inscription below the
sarcophagus refers to Leonardo Malaspina,
Governor of Bologna (active after 1375;
d.1403) and his son, Galeotto (active after
1406; d. before 1466), who probably had
the monument erected. (*PE*)

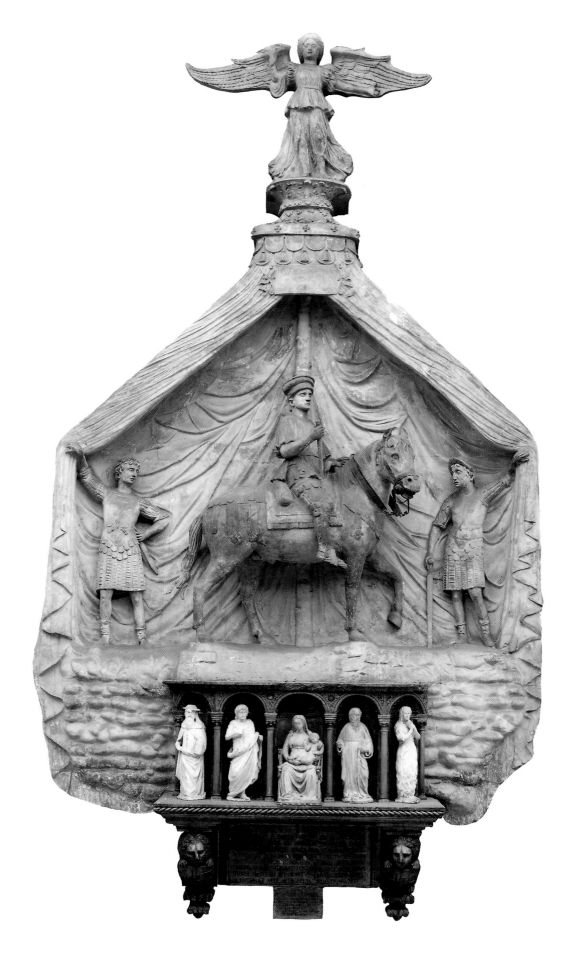

THE MADONNA DELLA MISERICORDIA (VIRGIN OF MERCY)

By Bartolommeo Buon
(about 1374 – 1467?)
Italian (Venice); probably about
1445 – 50

Istrian stone; h. 251.5 cm, w. 208.3 cm

25-1882

The standing Virgin, assisted by two angels, holds open her mantle beneath which kneel praying members of the Scuola Grande of Santa Maria della Misericordia, one of the largest of the Venetian charitable confraternities. Behind her, amongst the branches of a fig tree, are six busts of kings and prophets holding scrolls. In a mandorla before the Virgin the naked Christ Child is shown blessing, a motif of Byzantine origin which occurs on other works produced in Venice around this date and which was adopted by the Scuola as its emblem. The relief was originally painted and slight traces of blue pigment remain in the background.

The relief, carved from six blocks of stone, was made for the tympanum over the principal doorway of the Scuola Vecchia della Misericordia. It was amongst the sculptures transferred to the new building of the Misericordia in 1612, but by 1828 the building had fallen into disrepair and the church was finally closed in 1864. The tympanum, which had been dismantled and lay in pieces on the ground, was bought for the Museum by John Charles Robinson in 1882. Although the purchase guaranteed the object's safety, Robinson regretted its removal, describing it as 'a page torn from the record of Venetian art'.

The Buon family were the most important Venetian sculptors of the first half of the fifteenth century. The workshop was established by Giovanni Buon and taken over on his death by his son, Bartolommeo, in 1443. The attribution of the tympanum to their workshop is not disputed, but the date of the work is less certain, sometimes being placed as early as 1420–25. However, it is usually associated with the reconstruction of the façade of the Scuola Vecchia, which was agreed at a meeting of the Guild on 6 August 1441. (*PE*)

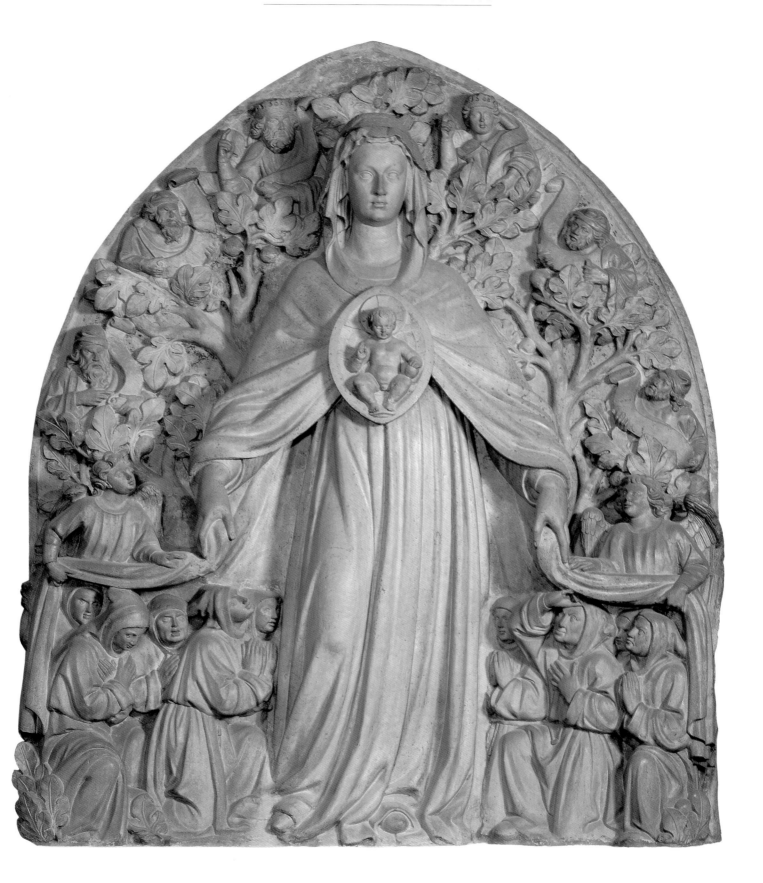

THE ASCENSION WITH CHRIST GIVING THE KEYS TO ST PETER

By Donatello (about 1386–1466)
Italian (Florence); about 1428–30

Marble; h. 40.6 cm, w. 114.3 cm

7629-1861

The relief, which combines two separate scenes from the New Testament, shows the seated Christ ascending to Heaven in clouds supported by winged putti, and handing down the Keys of the Church to St Peter. The kneeling figure of the Virgin, the apostles and two angels witness the scene. The relief is recorded in 1492 in the palace of the Medici, the leading Florentine banking and political family, in an inventory made after the death of Lorenzo the Magnificent, and in 1591 was in the possession of the Salviati family, who had connections with the Medici through marriage.

This is one of the finest surviving examples of extremely low-relief carving known as *rilievo schiacciato* (literally 'squashed relief'). The technique was developed by Donatello, the most important and influential Italian sculptor of the fifteenth century. Donatello's combination of traditional and classical influences reflected the prevailing humanist culture and taste of his patrons, notably Cosimo de' Medici (1389–1464), Lorenzo's grandfather. A range of emotions and relationships was explored in his sculpture, evident here in the attitudes of the figures and their dramatic gestures.

The circumstances of the commission are not known, and several theories have been proposed, one being that the relief was carved for the altar of the Brancacci Chapel in the church of the Carmine in Florence, where the painted decoration showing the Life of St Peter omits this significant scene. A similar relief by Donatello showing the *Ascension of the Virgin* was made for the tomb of Cardinal Rainaldo Brancacci in Sant'Angelo a Nilo, Naples, in about 1427–28.

(*PE*)

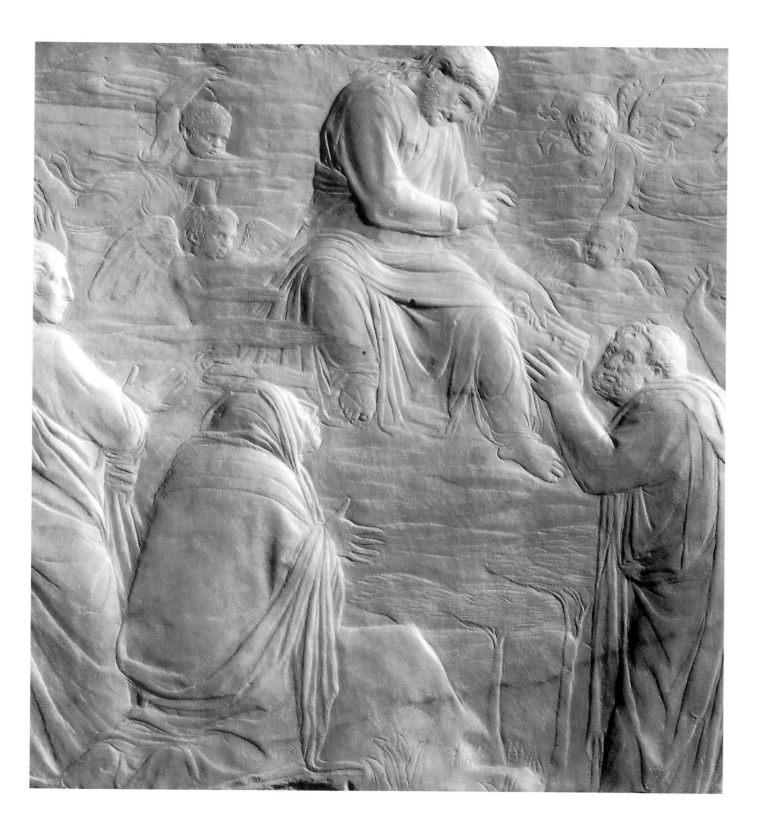

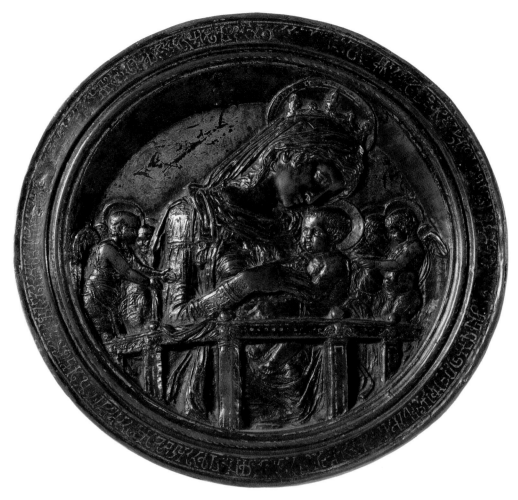

THE VIRGIN AND CHILD WITH FOUR ANGELS (THE CHELLINI MADONNA)

By Donatello (about 1386–1466)
Italian (Florence); mid-fifteenth
century (before 1456)

Bronze with gilt decoration; diam. 28.2 cm
A.1-1976; purchased with the aid of public
subscription, with donations from the National
Art Collections Fund and the Pilgrim Trust, in
memory of David, Earl of Crawford and
Balcarres

By extraordinary good fortune we know
that this bronze relief was given by
Donatello to his doctor, Giovanni
Chellini, in 1456. The physician's account
book, which still exists, records that on 27
August of that year,

> while I was treating Donato called
> Donatello, the singular and principal
> master in making figures of bronze of
> wood and terracotta ... he of his kindness
> and in consideration of the medical
> treatment which I had given and was
> giving for his illness gave me a roundel
> the size of a trencher in which was
> sculpted the Virgin Mary with the Child
> at her neck and two angels on each side,
> all of bronze, and on the outer side
> hollowed out so that melted glass could
> be cast on to it and it would make the
> same figures as those on the other side.

The Museum is also highly fortunate to
possess a marble bust of Giovanni
Chellini (7671–1861), signed by Antonio
Rossellino and dated by inscription to the
same year – 1456 – as Donatello's gift.

Donatello was a supremely innovative
sculptor whose style varied considerably
throughout his career. The
documentation connected with this
roundel provides an important guide for
the dating of his other stylistically related
Virgin and Child reliefs. It was not
necessarily made specifically for Chellini,
however, and may date from an earlier
period, possibly when Donatello was
working in Padua between 1443 and
1453. According to Chellini's testimony
cited above, the hollow reverse was used
to cast replicas from molten glass. This is
a unique feature, but the veracity of
Chellini's statement has been confirmed
by the making of a mould of the back of
the roundel from which glass versions
have successfully been cast; one of these
is displayed in the Museum alongside the
roundel.
(*PE*)

AUGUST, ONE OF THE LABOURS OF THE MONTHS

By Luca della Robbia (1399–1482)
Italian (Florence); about 1450–56
Blue, white and yellow tin-glazed terracotta;
diam. 59.7 cm.
7639-1861

The roundel is one of a series of 12 showing the Labours of the Months. Each scene is set within a circular border coloured light and dark blue to indicate the period of light and darkness relevant to the month and with an inscription giving the number of daylight hours. At the top of each roundel is the sun in the appropriate House of the Zodiac and opposite it the crescent moon. *August* shows the sun in the sign of Virgo and the labour of the month is represented by a man guiding a plough drawn by two oxen.

The roundels seem to have been commissioned from the Florentine sculptor Luca della Robbia (see page 85) between 1450–56 to decorate the ceiling of Piero de' Medici's study in the Palazzo Medici in Florence, destroyed during reconstruction of the palace in 1659.

Piero, who was the father of the famous Lorenzo the Magnificent, owned an impressive library and amongst his classical texts was Columella's *De Re Rustica* ('On Agriculture') which may have inspired the choice of decoration. From the curvature of the twelve roundels it appears that Piero's study was a small barrel-vaulted room about 3 metres wide and 5 metres long and that the roundels were set in three rows of four, with *August* in the centre row along the apex of the vault.

(*WF*)

VIRGIN AND CHILD WITH FIVE ANGELS

By Agostino di Duccio (1418–81)
Italian (Rimini); about 1450–60

Marble; h. 55.9 cm, w. 47.9 cm

A.14-1926; bought with the aid of contributions
from Lord Duveen of Millbank and the National
Art Collections Fund

The style of the relief is closely related to sculptures in the Tempio Malatestiano at Rimini, where Agostino di Duccio was responsible for much of the sculptural decoration from 1449 until 1457. The Tempio was the Gothic church of San Francesco, transformed into a Renaissance temple by the soldier, scholar and Lord of Rimini, Sigismondo Pandolfo Malatesta. The attendant angels of the relief are particularly close in style to the *Playing Children* in the Chapel of the Infant Games in the Tempio, attributed to Agostino.

The stylised rose on the foreheads of the angels is a Malatesta emblem which also appears at Rimini. Similarly, the pendant around the Christ Child's neck, with a figure in a chariot which derives from a Greek coin from Syracuse, is related to the relief on the keystone of the arch of the Tempio's Chapel of the Planets. The figure on the coin is crowned by Victory and the pendant may therefore allude to the victory of Christ, as may the laurel wreath held by the angel to the right, another motif frequently found in the Tempio. It therefore seems likely that the relief was a Malatesta commission, carved in Rimini in the 1450s.

Agostino left his native Florence in 1433 and did not return for about 30 years, working also at Modena and Perugia, where he eventually settled. He probably received his training in Emilia, and his distinctive, linear style is quite different from that of his Florentine contemporaries.

(*PE*)

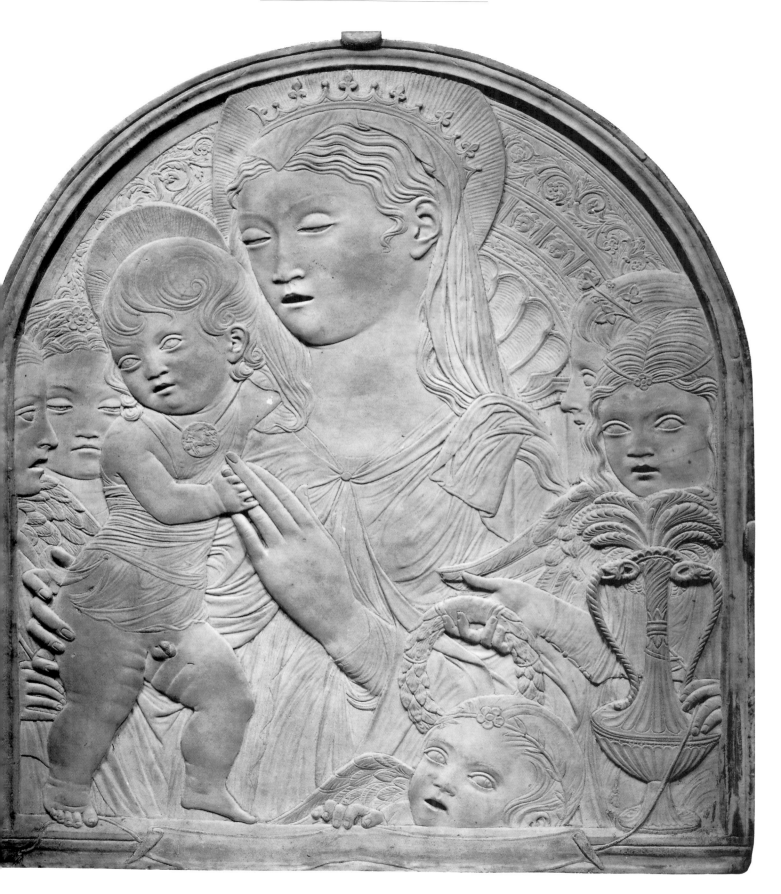

THE VIRGIN WITH THE LAUGHING CHILD

By Antonio Rossellino (1427–79)
Italian (Florence); about 1465

Terracotta; h. 48.3 cm
4495-1858

This sculpture, one of the most celebrated pieces in the Victoria and Albert Museum, has been attributed to a variety of fifteenth-century Florentine sculptors, including Verrocchio, Leonardo da Vinci and Desiderio da Settignano. The Christ Child is certainly reminiscent of Desiderio's work, but the naturalistic intimacy of the figures is typical of the treatment of the subject at the time, emphasising the human relationship between mother and child. The present terracotta is stylistically similar to other work by Antonio Rossellino, notably the Virgin and Child on the monument to the Cardinal of Portugal in San Miniato al Monte in Florence of about 1461–66. The statuette was probably a sketch-model for a life-size marble group similar to the *Madonna del Latte* on the Nori Monument in Santa Croce, Florence (1478), a late work by the artist. The works of Antonio Rossellino, the most important member of a family of sculptors, can mainly be found in his native Florence, but some survive in other centres, such as Prato and Naples. His first signed work, the bust of Giovanni Chellini (dated 1456), can also be seen in the Museum (see page 78). (*PE*)

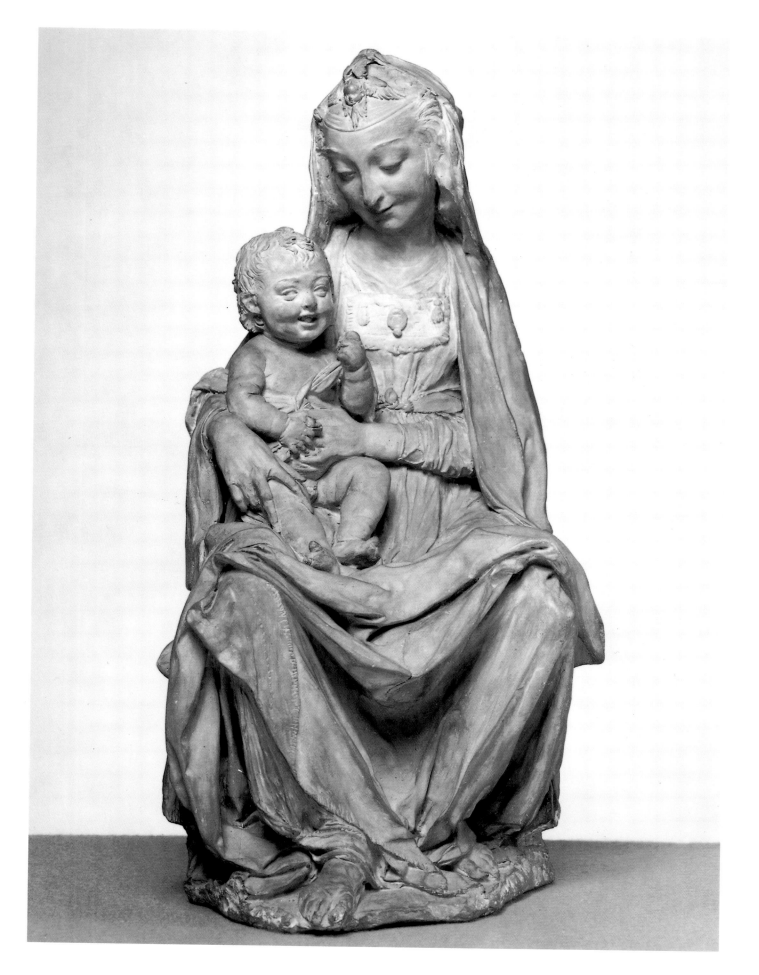

SKETCH-MODEL FOR THE MONUMENT OF CARDINAL NICCOLO FORTEGUERRI

By Andrea del Verrocchio (1435–88)
Italian (Florence); about 1476

Terracotta; h. 39.4 cm, w. 26.7 cm

7599-1861

The monument to Cardinal Niccolo Forteguerri (1419–73) in Pistoia Cathedral was commissioned from Verrocchio by the commune of Pistoia in 1476, and this terracotta is probably the documented model which formed the basis of the commission. It shows the figure of Christ in a mandorla supported by four flying angels, beneath which is the figure of Charity. Below, the figure of Faith, holding a chalice, moves towards the Cardinal, shown kneeling on a sarcophagus, with the figure of Hope to the right. The lower part has areas of repair in pigmented stucco (such as the heads of Hope and the Cardinal) and red wax (including the Cardinal's hands).

The upper part of the existing monument in Pistoia Cathedral, executed in marble by Verrocchio and his assistants before his departure for Venice in 1483, varies in detail from the model. The monument was not completed and erected until 1514, long after Verrocchio's death, and the kneeling Cardinal (now in the Museo Civico, Pistoia) was replaced by a bust when the monument was moved and modified in 1753. Terracotta models – or *bozzetti* – of this early date are extremely rare. (*PE*)

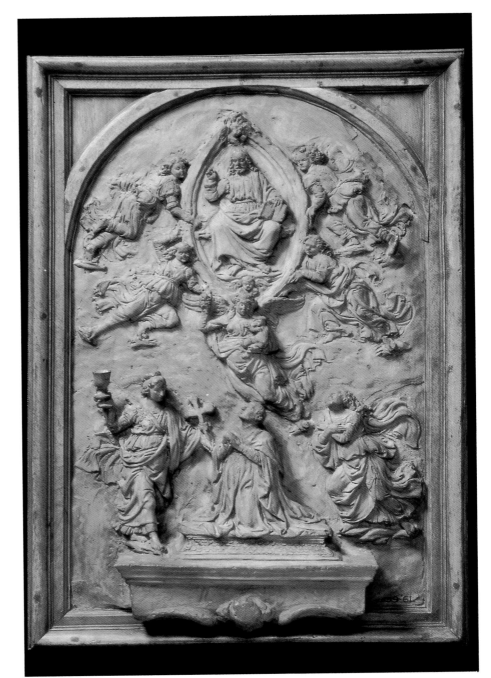

THE ADORATION OF THE MAGI

By Andrea della Robbia
(1435–1525)
Italian (Florence); about 1500–10

Polychrome tin-glazed terracotta; h. 222.3 cm,
w. 175.3 cm

4412-1857

The scene is set in a hilly landscape, with
the Holy Family, the Magi and attendants
in the foreground, and a group of riders
and the stable behind. Two angels bearing
the star hover above the Christ Child. The
frame and predella were fired separately in
sections, and areas of damage have been
repaired with painted plaster.

The composition is related to a number
of paintings depicting the Adoration of
the Magi produced in Umbria, the most
important of which is an altarpiece of
about 1475 by Perugino (active
1472–1523) in the Pinacoteca Nazionale
at Perugia. The arms shown to the right
and left of the predella are those of the
Albizzi, a prominent Florentine family,
who probably commissioned the
altarpiece either for the church of San
Michele or for Sant'Andrea at nearby
Rovezzano. Both churches were
patronised by the Albizzi and both were
also severely modernised in the first half
of the nineteenth century.

Andrea della Robbia was the nephew
and successor of Luca della Robbia (see
page 79), who developed the technique of
tin-glazing terracotta; this produced
sculptures which were colourful, durable
and relatively cheap. The technique is
similar, but not identical, to that used for
the decorated tableware and pottery

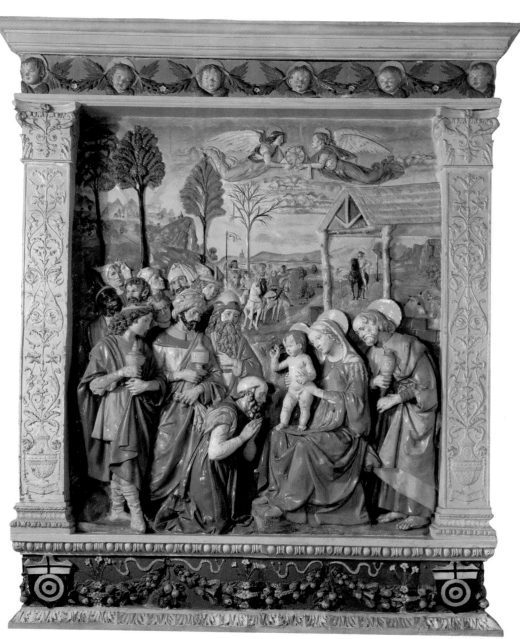

produced by the maiolica workshops.
Sculptures made under the supervision of
Luca and Andrea were of higher quality
than those of the later generations, when
modelling was increasingly replaced by
the use of moulds. (*PE*)

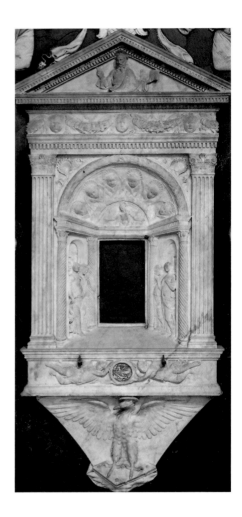

CHANCEL CHAPEL (CAPPELLA MAGGIORE) FROM SANTA CHIARA, FLORENCE

By Giuliano da Sangallo (1445–1516)
Italian (Florence); about 1493–1500

Sandstone (pietra serena); h. about 1110 cm;
w. about 540 cm

7720/A-1861

This was the main chapel in the conventual church of Santa Chiara in Florence, rebuilt in 1493 by Giuliano da Sangallo at the expense of Jacopo di Ottavio di Bongianni di Mino (d.1492). Bongianni was buried in front of the high altar and according to a surviving document gave instructions that no other chapels should be constructed in the church and that no other armorial bearings should be erected. The chapel is decorated with a polychrome frieze of cherub heads in tin-glazed terracotta, the Lamb of God (*Agnus Dei*) and the monogram, 'YHS', of the Holy Name. A similar frieze with garlands and candelabra was commissioned from Andrea della Robbia in 1491 for a comparable setting in Santa Maria delle Carceri at Prato – also designed by Giuliano da Sangallo – at about the same time, and it therefore seems likely that the present frieze is a product of the same workshop.

The altarpiece in white, red and black marble was probably made between 1493 and 1500, shortly after the chapel was commissioned, by Leonardo del Tasso (1466–1500?), a member of a large family of craftsmen specialising mainly in wood carving and intarsia work. His style is closely related to that of Benedetto da Maiano (1442–97), and he may at one time have been an assistant in the da Maiano workshop. In the centre of the altarpiece is a tabernacle attributed to the workshop of Antonio Rossellino and dated to the 1460s–70s on stylistic grounds. Close examination of the structure indicates that the altarpiece was designed from the beginning to incorporate the tabernacle, the arrangement of which is unusual. The church was deconsecrated in 1842, and the chapel purchased in Florence from an unrecorded vendor in 1861.

(PE)

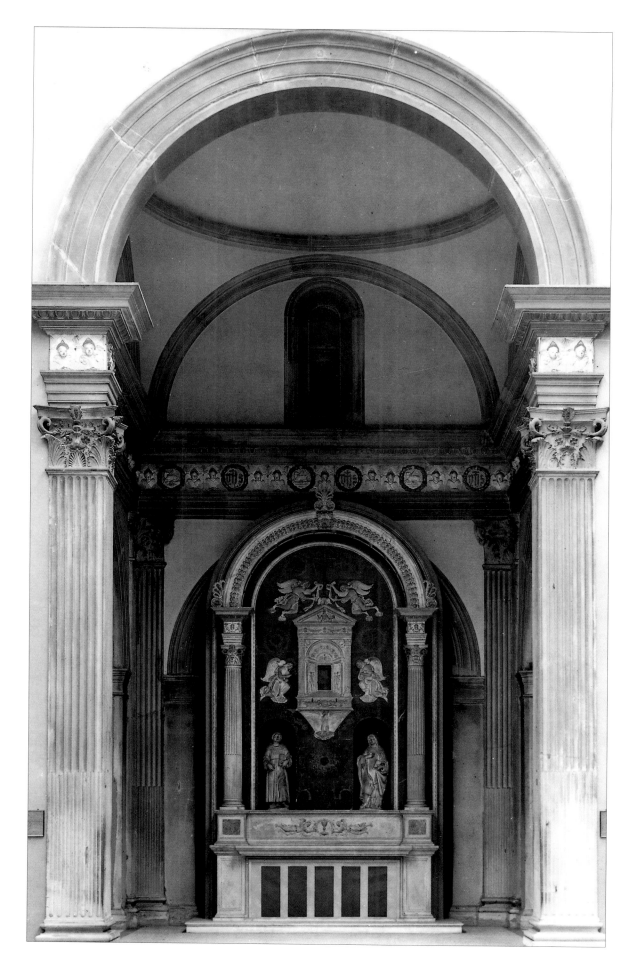

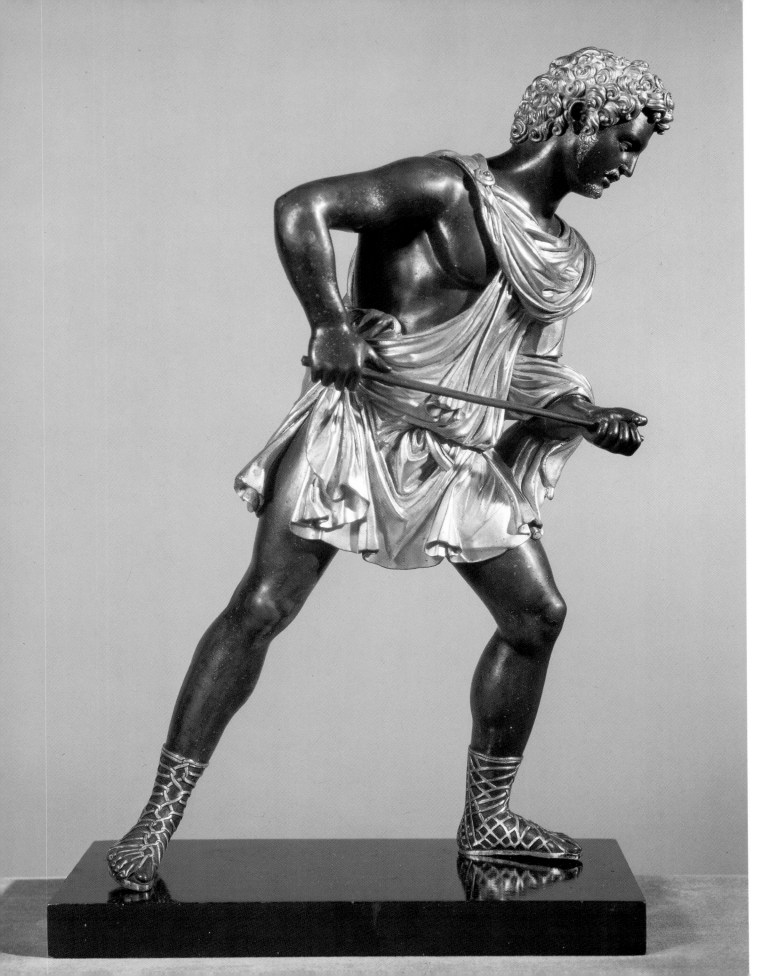

MELEAGER

By Pier Jacopo Alari-Bonacolsi,
called Antico (about 1460–1528)
Italian (Mantua); about 1484–90

Bronze, parcel-gilt with silver inlay; h. 32.1 cm
A.27-1960; purchased with funds from the Horn
and Bryan Bequests and with the assistance of
the National Art Collections Fund

The statuette represents Meleager, the
heir to the throne of Calydon, shown
poised to kill the great boar sent by the
goddess Artemis to attack his homeland.
It is based on the classical marble statue
formerly in the Uffizi, Florence, which
was popularly known as the *Contadino* or
Villano (peasant). The marble was
previously at the Belvedere in Rome and
is recorded in 1638 in the Uffizi, later
being destroyed in the fire of 1762. This
bronze statuette is probably the 'figure of
metal called the little peasant' listed in the
inventory made in 1496 after the death of
Gianfrancesco Gonzaga of Bozzolo, the
third son of Marchese Ludovico Gonzaga
of Mantua, and is one of a number of
bronze figures based on classical models
which appear in the same list.

Antico was one of the finest masters of
bronze sculpture of the late fifteenth and
early sixteenth centuries. He trained as a
goldsmith and was court artist to three
generations of the Gonzaga dynasty,
primarily in Mantua, but also working at
Gianfrancesco's castle at Bozzolo in the
late 1480s. The Gonzaga court cultivated
humanist ideals and attracted renowned
artists to Mantua, notably the painter
Andrea Mantegna, who maintained a
particularly high status. Mantegna's style
and interest in the antique were widely
influential and he provided designs for
other artists to follow, Antico doubtless
amongst them.

It was in this atmosphere that Antico
developed a sophisticated technique of
reproducing small-scale bronzes which
involved taking moulds from his original
model, from which the statuettes were
cast. The moulds could be reused, and
Antico was therefore able to provide
copies of several of his bronzes for the
great patroness of the arts, Isabella
d'Este, about 20 years after the originals
were made. This is, however, the only
known version of the *Meleager*. The
figure's hair, moustache, beard, teeth,
tunic and sandals are fire-gilded and the
eyes are inlaid with silver. This rich
decorative treatment is characteristic of
Antico's work and reflects the taste of his
Gonzaga patrons, contrasting with the
rougher but more vibrant handling of
contemporary bronzes produced in the
humanist circle at Padua (see page 91).
(*FL*)

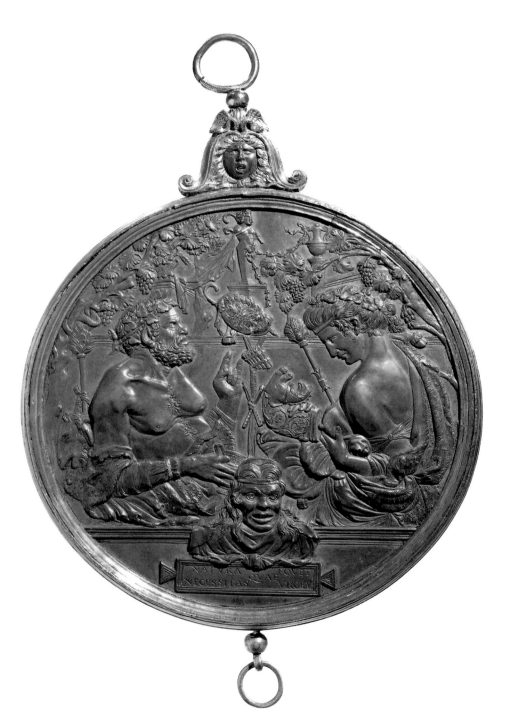

THE MARTELLI MIRROR
Possibly by Caradosso Foppa,
called Caradosso del Mundo
(1452–1527)
Italian (Milanese); about 1495–1500
Bronze with gold and silver; diam. 17.3 cm
8717-1863

Profile figures of a satyr and bacchante
face each other beneath a term
representing the ancient fertility god,
Priapus. These figures, together with the
inscription, 'NATVRA FOVET QUAE
NECESSITAS VRGET' ('Nature
encourages what necessity demands'),
suggest that the relief is an allegory of
reproduction.

Traditionally attributed to the great
Florentine sculptor Donatello, the mirror
was purchased in 1863 from the Martelli
family, with whom he was associated.
However, the style of the piece is quite
distinct from Donatello's other bronze
reliefs and the exquisite detailing
suggests the work of an accomplished
goldsmith. A circular cutting from a
document, written largely in cipher, was
discovered inside the mirror in the late
1950s. The contents of the text, together
with a watermark, indicate that it came
from the secret diplomatic archive in
Milan. This suggests a place of
manufacture in that city in the late
fifteenth century and supports an
attribution to Caradosso, a goldsmith and
maker of plaquettes, who was active there
between 1475 and 1505.
(*PE*)

WARRIOR ON HORSEBACK ('THE SHOUTING HORSEMAN')

By Andrea Briosco, called Il Riccio
(about 1470–1532)
Italian (Padua); about 1510–15

Bronze; h. 33.5 cm

A.88-1910; Salting Bequest

The warrior is shown wearing classical armour and riding bare-back, apparently crying out in the midst of battle. In his right hand, he holds the hilt of a sword (the blade missing) and his left may originally have held a spear or shield. The bronze was repaired and repatinated while in the collection of Frédéric Spitzer in Paris before 1893. Spitzer was probably responsible for making copies of the rider, as all other known versions are late casts, displayed on a variety of horses. This horse and rider, however, are unique, having been cast separately using the direct lost-wax technique whereby the original model is lost.

Riccio (meaning 'Curly-Head') worked primarily in bronze and is acknowledged as the master of the bronze statuette during the late fifteenth and early sixteenth centuries. He was active in the humanist circle of Padua University and the tense, nervous energy of the horse relates it to a passage describing the same subject in the treatise on sculpture by his friend, Pomponius Gauricus, published in 1504. Gauricus also describes this type of

light cavalry, and Riccio appears to have combined such literary sources with his own observations of the stradiot cavalry of the Venetian army. Similar riders are seen in Riccio's relief of the *Victory of Constantine* (Galleria

Giorgio Franchetti alla Ca' d'Oro, Venice) of about 1500, but the decorative detail relates it to the Paschal Candelabrum which Riccio made for the church of the Santo in Padua, between 1507 and 1515. (*PE*)

VENUS ANADYOMENE

By Antonio Lombardo
(about 1458–1516)
Italian (Venice); about 1508–16

Marble; h. 40.6 cm, w. 25.1 cm

A.19-1964; purchased with the assistance of
the National Art Collections Fund

According to Hesiod, one of the earliest Greek poets, Venus was born at sea and floated ashore on a scallop shell. The relief of *Venus Anadyomene*, or Venus rising from the sea, depicts this scene: the composition is apparently based on descriptions of a lost work by the Greek painter Apelles, which also inspired Botticelli's *Birth of Venus* in the Uffizi in Florence. On the base is an inscription taken from Ovid's *Art of Love* (*Ars Amatoria*): 'NVDA VENVS MADIDAS EXPRIMIT IMBRE COMAS' ('Naked Venus wrings spray from her hair').

Antonio Lombardo was the youngest of a family of Lombard sculptors. His major works include bronze sculptures for the Zen Chapel in St Mark's, Venice, and a marble relief for the Chapel of St Anthony in the Santo in Padua. In 1506 he moved to Ferrara, where he executed a number of mythological reliefs for Duke Alfonso I d'Este's so-called Camerino d'Alabastro, several of which survive in the Hermitage in St Petersburg. This relief, together with one of *Philoctetes on the Island of Lemnos* (A.9-1928), may have been made for the same ensemble. The influence of the Antique is clearly evident in the style as well as the subject matter, and was a feature of Antonio's work. (*PE*)

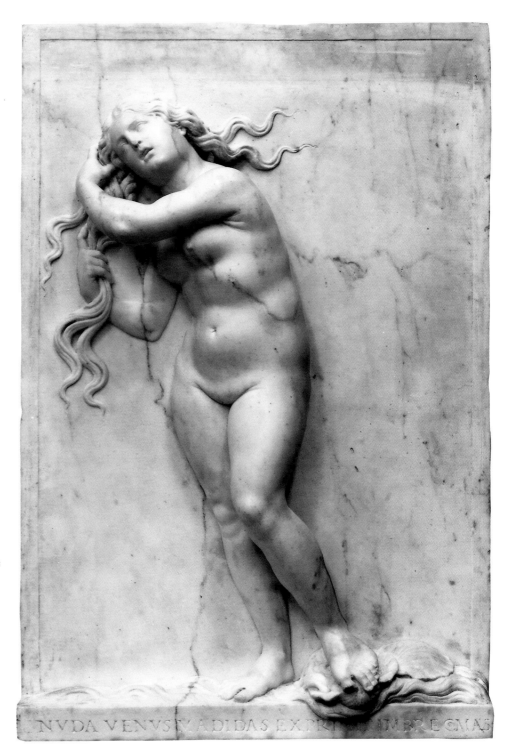

CHARITY

By Agostino Busti, called Bambaia
(1483–1548)
Italian (Milan); about 1518–22

Marble; h. 66 cm

7100-1860

The statuette represents Charity, shown
as a female figure in classical dress,
supporting a naked child on her left arm
and holding a coin in her right hand. It is
one of three related representations of
Virtues in the Museum almost certainly
carved for the funerary monument to
Gaston de Foix, which was intended for
the church of Santa Marta in Milan but
never completed. Other fragments
survive in Milan, including the
impressive effigy and another Virtue, now
headless. The Museum also possesses a
drawing for the monument, and plaster
casts of the effigy and reliefs.

Gaston de Foix, the nephew of King
Louis XII of France and Governor of
Milan, died in 1512 at the battle of
Ravenna. Although the French were
victorious, the death of the young
commander led to the withdrawal of their
troops so that Gaston's tomb was not
commissioned until later, when Louis'
successor, Francis I, entered Milan. Work
began in 1518, but was abandoned after
four years when the French again left the
city. Bambaia was trained at the Certosa
of Pavia, and later established a
substantial workshop in and around Milan
Cathedral; this was responsible for a
number of important commissions, but
unfortunately much of its work has been
destroyed or dispersed. (*PE*)

THE DESCENT FROM THE CROSS

By Jacopo Tatti, called Sansovino
(1486–1570)
Italian (Rome); about 1508
Gilt wax and wood, with cloth drapery;
h. (including frame) 97.8 cm
7595-1861

Christ is shown at the centre being lowered from the Cross; the two thieves have already been taken down. To the right, two men stagger under the weight of one thief, while the other – the penitent thief – is caught on the ladder leaning against his cross. The swooning figure of the Virgin is attended by two of the Maries and St John. The Instruments of the Passion (a hammer, pincers and the Crown of Thorns) lie on the ground.

The scene is identical to that described by the famous painter and biographer Giorgio Vasari, who stated that Jacopo Sansovino made a wax model of the *Descent from the Cross* while he was in Rome (in 1506–11) for the use of the painter Perugino. This is likely to be correct as copies of a lost painting by Perugino, clearly based on the present model, still survive. An early work of the painter Andrea del Sarto in the Pinacoteca del Seminario, Venice, also appears to have been derived from this model. Jacopo Sansovino was born and trained in Florence, but worked in Rome before settling in Venice in 1527, where he became the leading sculptor and architect, establishing a major school of followers who worked primarily in marble and bronze.

The wooden tabernacle in which the model is housed dates from the early sixteenth century. In the mid-sixteenth century the model was in the collection of Giovanni Gaddi in Florence, and was bought from the Casa Gaddi in 1766 by the painter and art critic Ignazio Hugford, who may have been responsible for repainting the now-faded landscape on the backboard. It entered the collection of Ottavio Gigli in 1855, and was amongst the works acquired for the Museum from the Gigli-Campana Collection (see page 12). (*PE*)

BUST OF KING HENRY VII

(reigned 1485–1509)
By Pietro Torrigiano (1472–1528)
Anglo-Italian (Westminster);
1509–11

Painted terracotta; h. 60.6 cm

A.49-1935

Technical examination has revealed that the facial features of both this bust and that of Henry VII's plaster funeral effigy in Westminster Abbey were probably based on a deathmask of the King. The measurements and features of the two are virtually identical, but the Museum's bust has been 'fleshed out' to make it more life-like. The portrait, along with those of King Henry VIII and John Fisher, Bishop of Rochester – both now in the Metropolitan Museum of Art in New York – may have been commissioned by Fisher himself. The attribution to the Florentine sculptor Pietro Torrigiano is based on the close relationship between this bust and the gilt-bronze effigy of Henry VII by the same artist in Westminster Abbey.

The use of casts to produce portrait busts was common practice in Renaissance Florence, where the desire to produce a close likeness was paramount. The maleability of clay made it an ideal material for this purpose, and it could then be fired to form a more permanent terracotta. This was then naturalistically painted, heightening the realism of the portrait, although in many instances the paint was removed by later collectors. This bust provides a rare example of original polychromy, fully revealed during recent conservation. Sculptor's tools were found inside the bust; these probably belonged to the English sculptor John Flaxman (see page 164), who is recording as having repaired the piece as a young man. (*PE*)

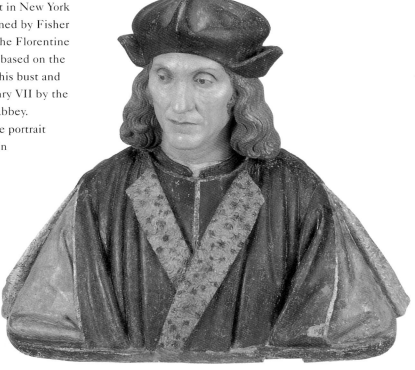

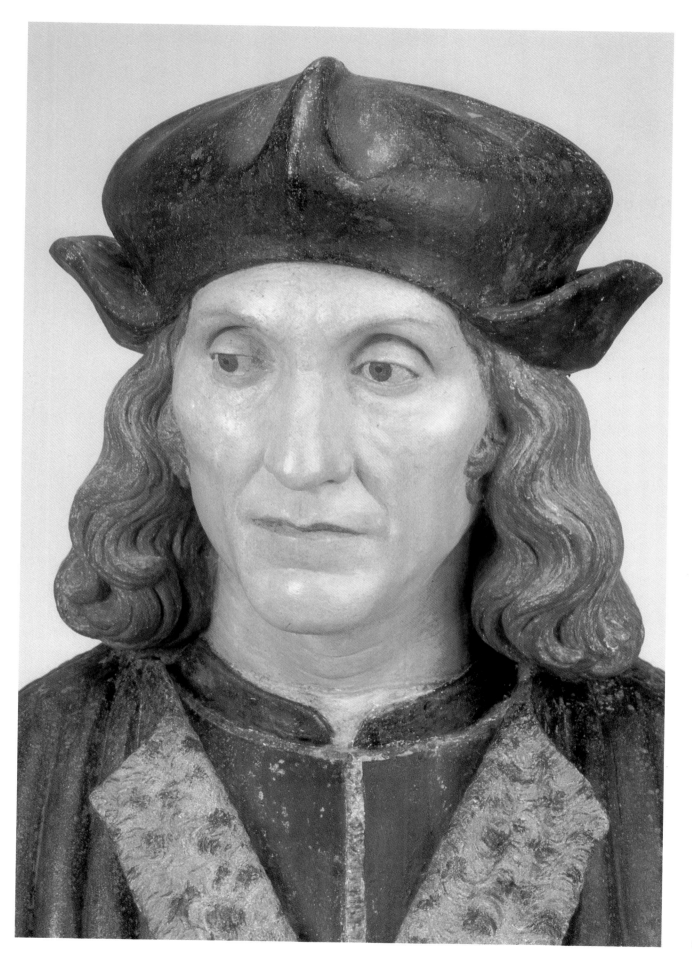

A SLAVE

By Michelangelo Buonarroti
(1475–1564)
Italian (Florence); about 1516–19
Wax; h. 16.5 cm
4117-1854

The small wax figure is a sketch model for the unfinished marble of the *Young Slave* in the Accademia in Florence, designed for the 1516 scheme for the tomb of Pope Julius II (d.1513). This scheme was the third of six produced for the problematic project which, when it was commissioned in 1505, was planned as a large free-standing structure with over 40 statues of life-size or above, intended for St Peter's in Rome. The existing, much reduced tomb was finally erected in San Pietro in Vincoli, Rome, in 1545.

Michelangelo made a large number of drawings and models in wax, clay and terracotta in connection with both his painting and sculpture. This model differs from the unfinished marble in several details, suggesting that he refined the design at a later stage. Michelangelo destroyed many of his preparatory works, but the growing interest in the creative process and the artist's extraordinary celebrity led several of his contemporaries to collect his drawings and models. One such collector was the painter and biographer Giorgio Vasari, a great admirer and friend of the artist. In his *Life* of Michelangelo, he described what he claimed to be the sculptor's working method: a small model of wax or other firm material was immersed in water and gradually raised to reveal more of the figure as the carving of the marble progressed. (*PE*)

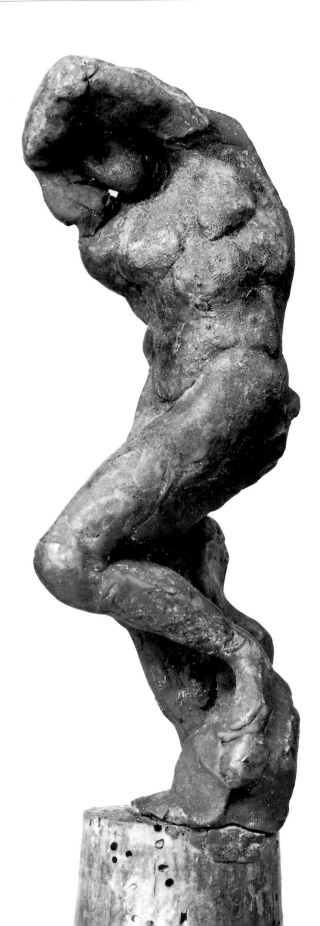

AN ANGEL, THE SYMBOL OF ST MATTHEW

Attributed to Jan van Schayck
(active c.1496–1517)
North Netherlandish (Utrecht);
around 1497

Sandstone, painted and gilded; diam. 32.8 cm
A.14-1945; given by Mr Sebastian Pugin

This is one of nine roof bosses which almost certainly originally decorated the vault of the library on the north side of Utrecht Cathedral. Three more bosses from this series, showing the other symbols of the evangelists, were also given to the Museum by Sebastian Pugin in 1945 (A.15 to 17-1945), and the decorative scheme was completed by bosses of the Virgin and Child or God the Father (now lost) and the four Fathers of the Church. Three of these – St Augustine, St Jerome and St Gregory the Great – remain in Utrecht at the Centraal Museum.

Jan van Schayck was one of the principal sculptors working in Utrecht in the years around 1500, and is recorded as having carried out a number of commissions in the cathedral. One of these was to carve 'the bosses and capitals with half-figures in the library', for which he was paid in 1497, and the documentary evidence coupled with the material remains leave little room for doubt that the bosses now in London and Utrecht are his work. It is also recorded that the painting of the sculptures was executed, as was customary, by other specialists, Ernst van Schayck and Dirck Scay.

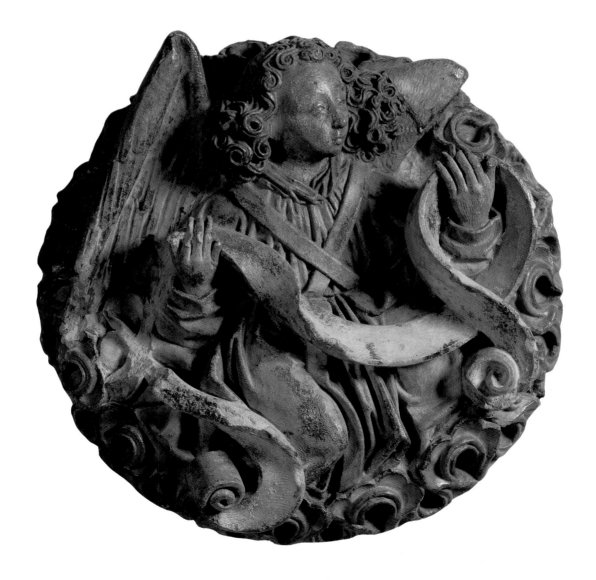

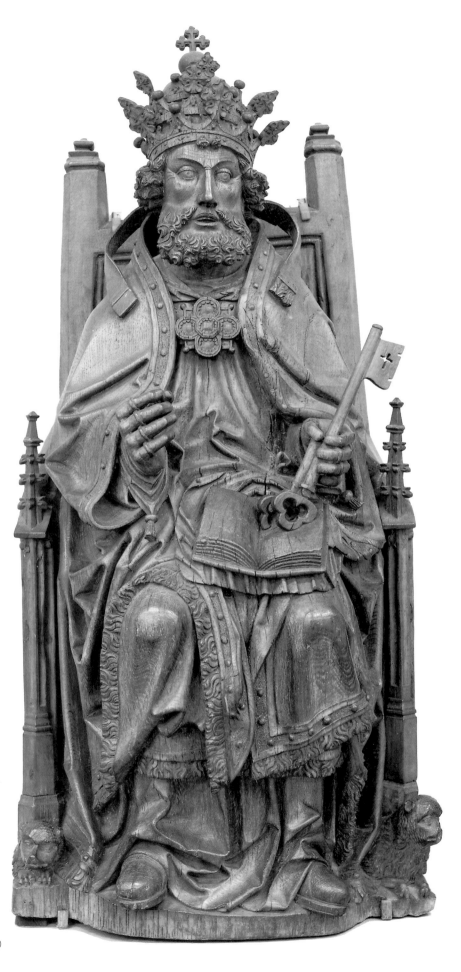

ST PETER
South Netherlandish (Antwerp);
about 1500
Oak; h. 119.5 cm
107-1888

St Peter is shown dressed in full papal regalia, as the first Bishop of Rome, and holds the keys to the Kingdom of Heaven in his left hand. The sculpture was originally probably displayed on a console set on to one of the pillars of the nave of a church. Such figures were especially popular in the early sixteenth century in France and the Netherlands, both in wood and stone, and a comparable *St Peter* in limestone, probably from the parish church of Saint-Pierre in Pommard, Burgundy (now in the Wadsworth Atheneum, Hartford, Connecticut), illustrates how widespread this particular image of the saint became. The present figure's South Netherlandish provenance – as indicated by its style – is confirmed by its close similarity to an oak figure of Solomon in the Vleeshuis in Antwerp.

ALTARPIECE OF THE PASSION OF CHRIST AND ANNUNCIATION

French (Troyes); about 1525

Limestone, painted and gilded; h. (in centre) 187 cm, w. 269.5 cm

4413-1857

The altarpiece is divided into six principal scenes, with numerous smaller episodes from the Passion of Christ taking place in the backgrounds to the lower register. The Annunciation to the Virgin is shown in the upper half of the central section, while below the Passion of Christ unfolds from left to right with the scenes of the Flagellation, the Carrying of the Cross, the Crucifixion, the Entombment and the Resurrection. Behind these scenes are the more diminutive Betrayal, the Mocking of Christ, the Crowning with Thorns, Christ presented to the people (*Ecce Homo*), the Preparation for the Crucifixion, the Deposition, the Descent into Limbo, the Three Maries at the Sepulchre, Christ appearing to St Mary Magdalene (*Noli me tangere*) and Christ appearing to the Three Maries. The architectural surround is also densely crowded with small figures and complementary scenes.

The altarpiece was originally made for the collegiate church at Lirey, near Troyes. The donor, who kneels in the robes of a canon at the foot of the Cross in the central panel, was Jean Huyard l'Aîné (d. 1541); his coat-of-arms appears in the spandrel between the two arches on the left panel, while a variant, quartered with other arms, is shown on the right-hand side. The church at Lirey was consecrated in 1526 and it is likely that this retable, which probably decorated the high altar, was ready by then. An attribution to the workshop of the Flemish sculptor Nicolas Halins, who worked in Troyes in the first half of the sixteenth century, has been suggested; there is no documentation to support this, however, and there are differences between the style of the altarpiece and sculptures certainly by him.

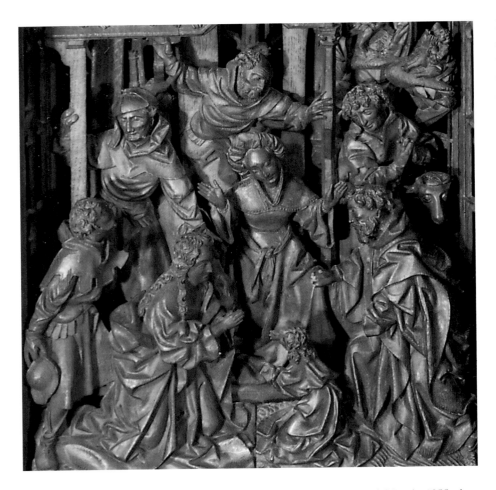

ALTARPIECE WITH SCENES FROM THE LIFE OF THE VIRGIN

South Netherlandish (Brussels or Ghent); about 1520

Oak; h. (of framework) 189 cm, w. 210 cm

1049-1855

At the time of its acquisition in 1855, the altarpiece was said to have come from the cathedral of St Bavo in Ghent. Although this has not been confirmed by documentary evidence, the style of the carving and the type of altarpiece does indeed point to a place of production in the Southern Netherlands, probably in Brussels or even Ghent itself. The altarpiece is dedicated to scenes from the Life of the Virgin: on the left is the Adoration of the Shepherds, on the right the Adoration of the Magi, and in the centre is the Death of the Virgin with her Assumption above; a single crouching figure of Synagogue, blindfolded and holding the tablets of the old law, is carved into a square panel below the central scene. The three figures of apostles standing on the pinnacles at the sides and in the centre are the result of a nineteenth-century restoration probably carried out just prior to acquisition, and the other nine apostles – also restorations – were placed around the base. These have been removed, but are clearly visible in the watercolour of the altarpiece at Marlborough House in 1856 (page 10). The altarpiece would originally have had wings – probably painted rather than carved – but these are now missing.

Carved wooden altarpieces were produced in large numbers in the Netherlands in the late fifteenth and early sixteenth centuries. Most were made up, as here, of several scenes with small figures set in elaborate architectural frameworks, and were invariably painted. The two main centres of production of altarpieces in the Southern Netherlands were Brussels and Antwerp, while individual figures of the Virgin and Child and saints were made in Malines (Mechelen); many of the sculptures carved in these cities were marked with distinctive stamps, guaranteeing their quality and place of manufacture.

CHRIST RIDING ON AN ASS (PALMESEL)

German (Swabia); about 1510–20

Limewood, painted; h. 142.7 cm

A.1030-1910; Captain H.B. Murray Bequest

The *Palmesel* – a German term for a sculpture of the Blessing Christ riding on an ass – was an integral part of the Palm Sunday procession, when it was drawn through the streets. This ritual was based on the episode of the Entry into Jerusalem in the New Testament, as recounted in the Gospel of Matthew (XXI, 5-10):

Behold, thy king is coming to thee, humbly, riding on an ass, on a colt whose mother has borne the yoke ... Most of the multitude spread their garments along the way, while others strewed the way with branches cut down from the trees. And the multitudes that went before him and that followed after him cried aloud,

Hosanna for the son of David, blessed is he who comes in the name of the Lord, Hosanna in heaven above.

Like certain other medieval sculpted images, such as the figure of the Resurrected Christ which was pulled up into the vault of the church at Easter, the *Palmesel* was a physical manifestation of Christ's presence in the liturgy.

There is evidence for the existence of a *Palmesel* as early as the tenth century in Augsburg, but many of the surviving examples date from the fifteenth and early sixteenth centuries, when the subject became increasingly popular. The style and type of the present figure is in a tradition deriving from a *Palmesel* carved in 1456 by the Ulm sculptor Hans Multscher for the church of Sts Ulrich and Afra in Augsburg (now housed in the Dominican nunnery at Wettenhausen), which served as a model for several other sculptures in South Germany. (*NJ*)

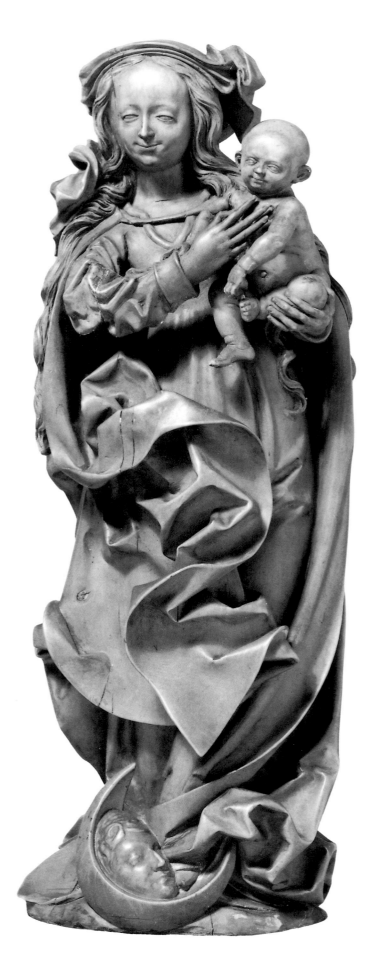

THE VIRGIN AND CHILD

By Veit Stoss (about 1447–1533)
German (Nuremberg); 1500–10

Boxwood; h. 20.3 cm

646-1893

The Virgin, still retaining traces of
gilding, is shown holding the naked
Christ Child and with the crescent moon
at her feet, identifying her as the Woman
of the Apocalypse: 'in heaven, a great
portent appeared; a woman that wore the
sun for her mantle, with the moon under
her feet, and a crown of twelve stars
about her head' (Apocalypse, XII, 1-2).
Veit Stoss excelled in this type of small
sculpture. Such figures, although still
executed in the late Gothic style, were
not intended for religious purposes but
were made for the newly emerging
connoisseur-collector's market.

 Despite the great accomplishment of
his carving on a small scale, Veit Stoss's
name is normally associated with
commissions for larger religious sculpture
in both wood and stone, such as
altarpieces and single statues. Between
1477 and 1496 he executed the
monumental high altarpiece for St Mary's
in Cracow, Poland, and from a later period
numerous figures are to be found in
Nuremberg, among them the superb
Annunciation of the Rosary of 1517–18 in
the Lorenzkirche. His limewood figure of
St Roch in Santissima Annunziata in
Florence was highly praised by Vasari in
1568, in terms which might equally apply
to the small Virgin and Child: 'he
executed its drapery with most subtle
carving, so soft and hollowed, and as it
were paper-like, and with such a fine
movement in the arrangement of the
folds, that nothing more wonderful is to
be seen'. (*NJ*)

MARY SALOME AND ZEBEDEE

By Tilman Riemenschneider
(about 1460–1531)
German (Würzburg); about 1505–10
Limewood, glazed; h. 119.4 cm
110-1878

Tilman Riemenschneider, born in
Osterrode in the Harz region, qualified as
a master sculptor in Würzburg in 1485.
Here he established a large workshop,
productive for over 30 years, which
executed altarpieces and single figures in
stone and limewood for many churches
throughout Franconia. This group of St
Anne's daughter Mary Salome and her
husband Zebedee originally formed the
right wing of an altarpiece of the Holy
Kindred. The central panel showed St
Anne seated with her three husbands,
Joachim, Cleophas and Salomas (now in a
German private collection), together with
her primary daughter the Virgin Mary, the
Christ Child and St Joseph. On the left
wing was St Anne's third daughter, Mary
Cleophas, and her husband, Alphaeus,
which in 1994 was acquired by the
Württembergisches Landesmuseum in
Stuttgart. The cult of St Anne was
popular throughout Europe in the Late
Middle Ages; charitable brotherhoods
often took her as a patron saint and the
demand for images became considerable.

Unusually, the reliefs of this altarpiece
were never painted but were instead
covered with a translucent monochrome
glaze, a technique characteristic of
Riemenschneider's workshop. (*NJ*)

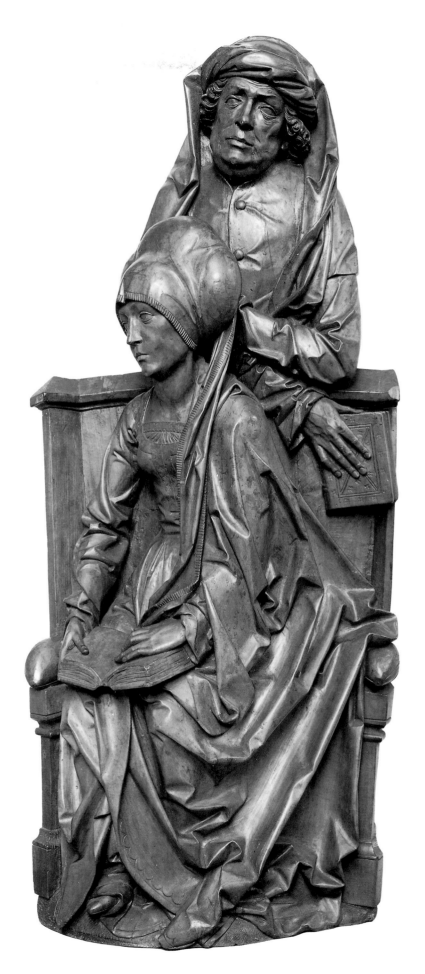

WINGED ALTARPIECE

Tyrolese (Brixen); 1500–10

Wood, painted and gilded; h. 443.2 cm

192-1866

Amongst the many German reliefs and figures in the Museum's Collection, most of which originally formed part of a retable, three more or less intact altarpieces of the early sixteenth century from different parts of the German-speaking lands stand out. The first, with

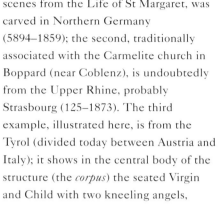

scenes from the Life of St Margaret, was carved in Northern Germany (5894–1859); the second, traditionally associated with the Carmelite church in Boppard (near Coblenz), is undoubtedly from the Upper Rhine, probably Strasbourg (125–1873). The third example, illustrated here, is from the Tyrol (divided today between Austria and Italy); it shows in the central body of the structure (the *corpus*) the seated Virgin and Child with two kneeling angels,

flanked by St Florian (left) and St John the Baptist (right). The two reliefs on the left wing depict the Annunciation (above) and the Presentation in the Temple (below), those on the right wing the Nativity (above) and the Adoration of the Magi (below). In Lent and on certain other days, when the *corpus* was closed from view, the paintings on the backs of the wings were visible, showing on the left St Corbinian, St Adalbert (?) and St George and the Dragon, on the right a Virgin Martyr, St Beatrice (?) and St Martin and the Beggar. On the outside of the doors of the predella below are paintings of St Barbara, St Dorothy, St Catherine and St Margaret. The crowning superstructure originally above the *corpus* is now missing, as are the sculptures from the predella.

In the late fifteenth and early sixteenth centuries the making of altarpieces was a flourishing industry in the Tyrol, and it has been estimated that there were over 2,000 examples in the churches and chapels of the region. They were produced in large workshops in Bruneck (today Brunico in Italy), Sterzing (Vipiteno), Bozen (Bolzano) and Brixen (Bressanone), and their construction was often sub-contracted to local sculptors, painters and joiners in the Alpine valleys; in addition, many retables were imported from Swabia and Bavaria. The present altarpiece is stylistically related to the workshop of Hans Klocker, active in Brixen at the end of the fifteenth century. (*NJ*)

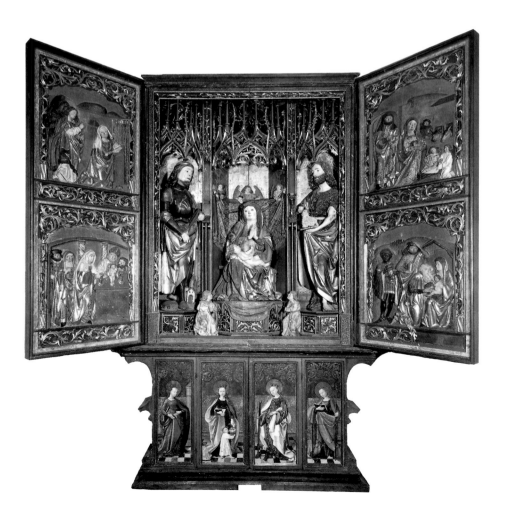

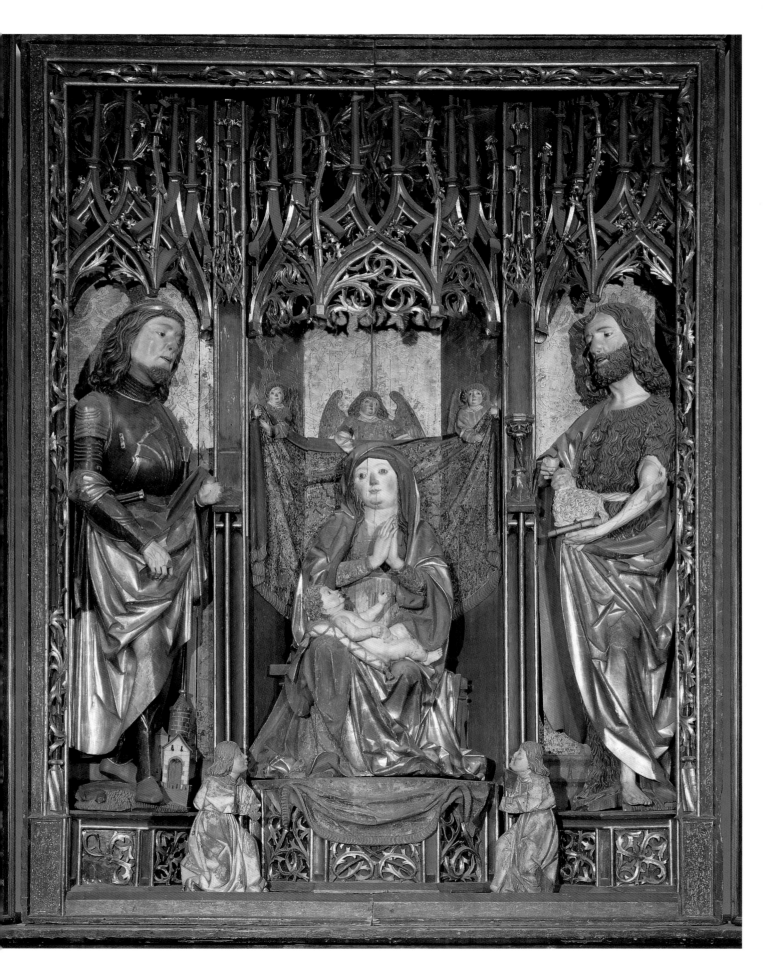

THE VIRGIN AND CHILD WITH ANGELS
Austrian (Styria); 1500–1520

Limewood, painted and gilded;
h. 83.2 cm, w. 92.1 cm
A.13-1960; given by Sir Thomas Barlow

This idiosyncratic and charming group shows the figures as if caught in a gale – note the flying veil of the Virgin and the swooping angels, clinging on to the Virgin's cloak to avoid being blown away. The Christ Child, as if oblivious to the wind, offers a pomegranate to the adjacent angel. The sculpture is said to have come from the area of Mariazell in Styria – today Steiermark in Austria – and the closest parallels that have so far come to light tend to confirm an origin in that region, although none has the quirky exuberance of the Museum's group.

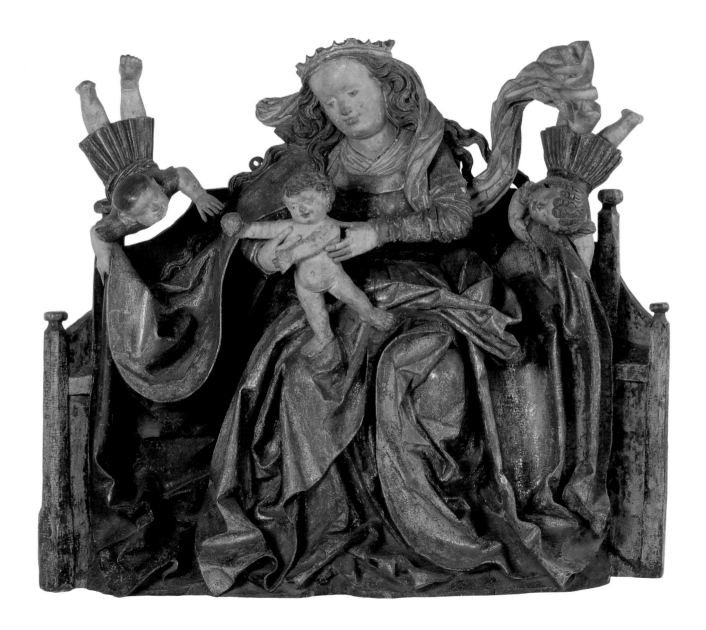

ST JOHN THE EVANGELIST

By Hans Daucher (about
1485–1538)
German (Augsburg); about 1523

Limestone, partly gilded; h. 81.3 cm
49-1864

The history of this figure might be said to
encapsulate the epoch-making struggles
which took place in Reformation
Germany over the rôle of religious
images. In a letter of 21 August 1524,
Ritter Hans Lamparter von Greiffenstein
wrote from Augsburg that the epitaph he
was having made to commemorate his
father, Gregorius, for erection in
Nuremberg was ready to be sent from
Augsburg. It consisted of a Crucifixion
with the Virgin and St John, accompanied
by figures of St Gregory and the kneeling
Gregorius Lamparter. Before dispatching
it, however, he wished to be reassured
about its long-term safety, as he had
heard that the city fathers of Nuremberg
were intent on doing away with images.
The answer he received presumably did
nothing to encourage him, as the epitaph
was subsequently not erected at
Nuremberg but in the church of St
Michael at Krumbach near Augsburg.
That this figure of St John – which was
obviously originally intended for a
Crucifixion group – belonged to the
documented ensemble is confirmed by
the arms at his feet, which are those of
Lamparter von Greiffenstein.

The close stylistic relationship with the
work of Hans Daucher, the leading
Augsburg sculptor of the time, allows a
confident attribution to be made. (*NJ*)

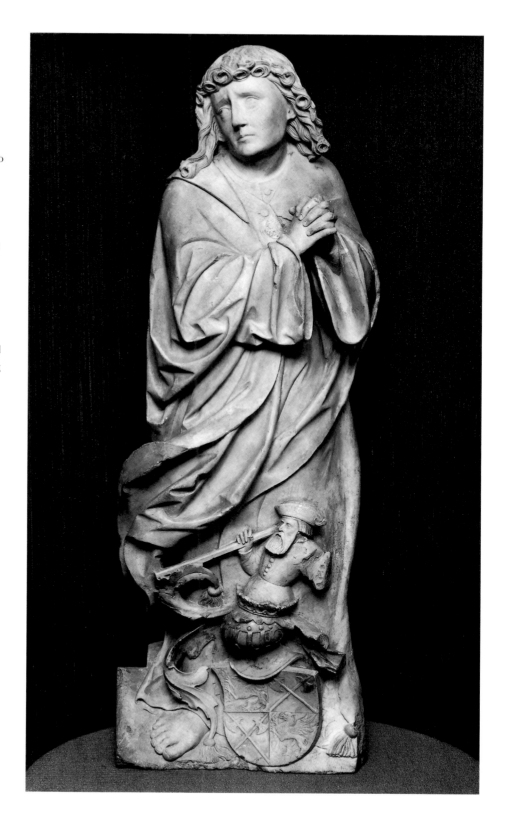

FIVE OF THE CARDINAL VIRTUES

By Peter Flötner (about 1490–1546)
German (Nuremberg); about
1540–46

Solnhofen stone

(a) *Prudence* (183-1867): diam. 7.3 cm;

(b) *Justice* (186-1867): 7.2 cm

(c) *Charity* (185-1867): 7.2 cm;

(d) *Temperance* (184-1867): 6.8 cm;

(e) *Fortitude* (187-1867): 7.2 cm

These five medaillons formed part of a
series of the eight Cardinal Virtues.
Those of *Faith* and *Hope* are now in the
Kestner-Museum in Hannover; no version
of *Patience* is known to survive in
Solnhofen stone, however, although
versions in other materials exist. All the
reliefs show the Virtues as seated female
figures with a distant landscape and
architecture in the background. *Prudence*
(a) is seated on a throne and looks into a
mirror held by a winged putto; *Justice* (b)
is shown with her symbols, a sword and a
pair of scales; *Charity* (c) plays with two
small children; *Temperance* (d) pours water
into a dish of wine; and *Fortitude* (e) is
shown with subjugated lion and broken
column.

Peter Flötner was born in the Thurgau
region in Switzerland, but had settled in
Nuremberg by 1522. He was a prolific
designer, draftsman, medallist and
sculptor and cooperated with other
Nuremberg artists in providing models
and designs. Johann Neudörfer, the
biographer of Nuremberg artists and
craftmen, recorded in 1547 that Flötner's
'pleasure in his daily work was to carve in
white stone, but these were nothing else

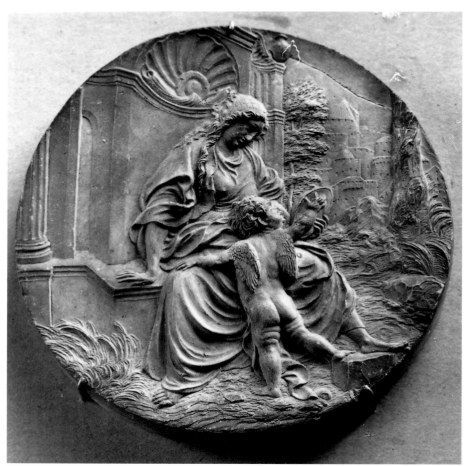

(a)

but histories which serve goldsmiths for
repoussé and casting so that they, with
this, embellish their work'. The function
of the present reliefs was indeed to serve
as models for goldsmiths, but the designs
were often multiplied in brass or lead and
were widely disseminated. Silver-gilt
roundels based on the *Faith*, *Hope* and
Fortitude of this series decorate the so-
called Elizabeth I Salt-Cellar in the
Tower of London, which was made in
London in 1572–73.

(*NJ*)

(b)

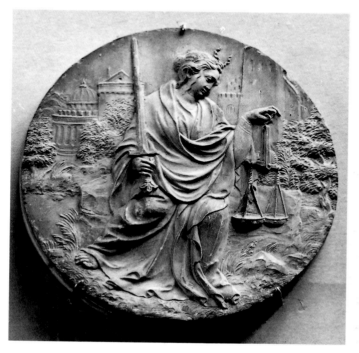

(c)

d)

(e)

DORMER WINDOW

French; about 1523–35

Stone; h. 747.5 cm, w. 340.5 cm

531-1905; given by Mr J.H. Fitzhenry

This dormer window originally faced into the courtyard of the château of Montal (Lot), about 50 km to the north-east of Cahors, built by Jeanne de Balzac in the years after 1523. The Balzac arms are shown combined with those of Jeanne's late husband, Amaury de Montal (d. before 1520), in the lozenge-shaped shield at the centre; to each side are classicising medallion busts and above a now-headless figure in antique armour, holding a skull (presumably a symbol of the transience of life on earth). Under the pierced finial on the summit is the motto '*PLVS:DESPOIR*' ('More than Hope'). Much of the decorative sculpture from the château (including this window) was taken down and sold at auction in 1903, but several of the major pieces were subsequently retrieved and reinserted in a thorough restoration of the building in the decade after the sale. The present window, and another now in the Philadelphia Museum of Art with the date 1534, were replaced by copies.

The acquisition of large-scale architectural sculptures was from an early date an important part of the collecting policy of the Museum. In many instances plaster casts had to serve as illustrations of the application of ornamental sculpture to architecture (see pages 182–84), but original monumental specimens such as this window and the Santa Chiara Chapel (page 87) were acquired when the opportunity presented itself.

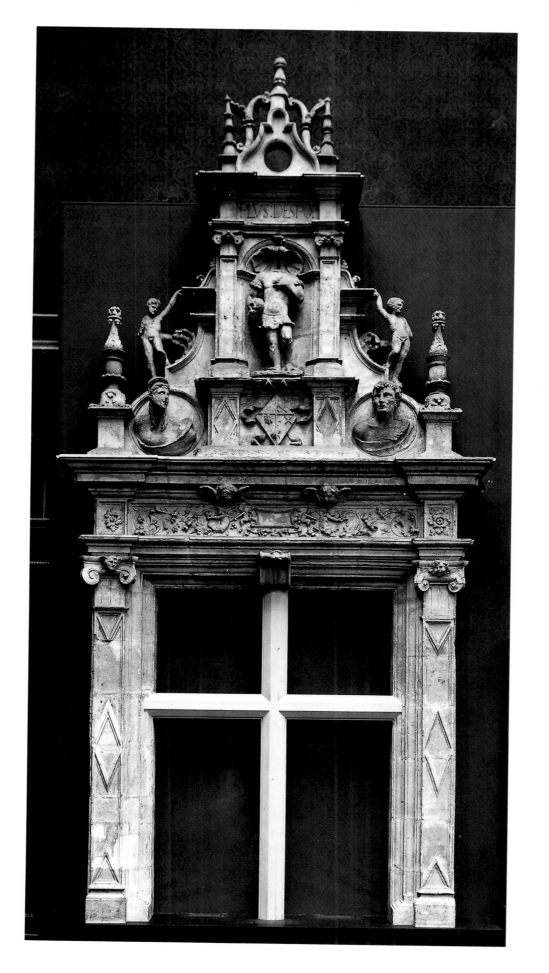

MANNERISM AND BAROQUE

According to Giorgio Vasari in his Lives of the Artists, published in 1550, the 'modern' artists had achieved perfection, with 'the inspired Michelangelo Buonarroti' reigning supreme. Vasari's emphasis on grace and the ability to surpass nature and the ancients identifies elements which became characteristic of the Mannerist style, with its sophisticated, elegant and exaggerated forms. The most sought-after and influential sculptor of the late sixteenth century (and well into the seventeenth) was Giovanni Bologna, or Giambologna, who spent virtually all his working life in the service of the Medici in Florence. His highly efficient workshop produced bronze statuettes of supreme quality, as well as large-scale sculpture, including fountain figures for gardens and city squares (page 122 and figure 1) and equestrian bronzes. His works were disseminated throughout all the main courts of Europe, including those of France, Spain and England, sent either in response to commissions (largely executed by his followers) or as diplomatic gifts. In addition, numerous sculptors from the North visited or trained in his workshop and later produced their own interpretations of his style further afield, amongst them Hubert Gerhard and Adriaen de Vries (pages 125–27).

Adriaen de Vries, an artist of exceptional talent, worked at Prague for the court of the Hapsburg Emperor Rudolph II, one of the greatest patrons and collectors of the arts in Europe. As well as establishing his

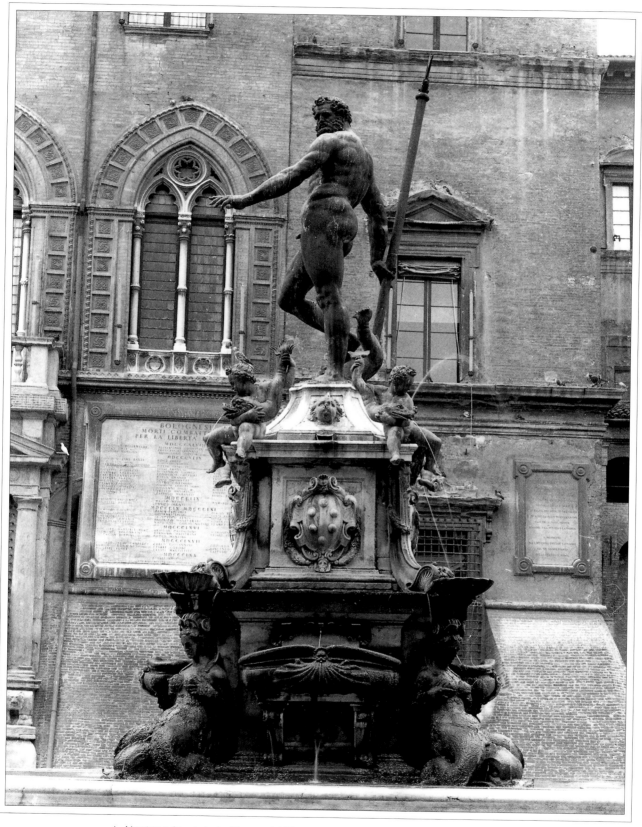

1. Neptune fountain in Piazza del Nettuno, Bologna; by Giambologna; 1563–67

own extensive collection, Rudolph had inherited the famous *Kunst und Wunderkammer* (Art Collection and Cabinet of Curiosities) of the Archduke Ferdinand II at Ambras Castle, near Innsbruck. The origins of museums stem from the growth of such collections, in which virtuoso works of art, including small sculpture such as wax reliefs and ivory tankards (page 137), were often shown in conjunction with scientific instruments and specimens from the natural world.

The establishment of artistic academies in the main centres of Europe during the sixteenth and seventeenth centuries ensured that many artists received a systematic and thorough training. Local variations in artistic production are therefore largely accounted for by the different demands of patrons, whether religious or secular. The religious wars and persecution which continued until the end of the sixteenth century in the North and through the early seventeenth century in Central Europe obviously had their effect on the art market. The Protestants did not adorn their churches with elaborate decoration, and actively destroyed a vast amount of 'Papist' sculpture during the Reformation and after.

England, which had suffered severely from such iconoclasm, produced few native sculptors of note at this time, but sculptors from abroad were attracted to the court. Following the failure of King Charles I to persuade Giambologna's successor, Pietro Tacca, to come to London, the King's brother-in-law Louis XIII of France released his Court Sculptor Hubert Le Sueur (page 130), who arrived in 1625, later to be followed by the Italian Francesco Fanelli. The lack of church patronage in large parts of the Netherlands meant that Dutch artists of the seventeenth century had to operate in the open market, catering for the middle classes who had little interest in monumental sculpture – other than tombs – and preferred small genre paintings to decorate their homes.

In contrast, the Counter-Reformation had a profound effect on the patronage of the Catholic Church throughout this period, particularly in Italy and Spain. Artists had to adhere to specific rules which set out the suitable portrayal of religious subjects established by the General Council of the Catholic Church held in Trent between 1545 and 1563. The influence of the new doctrine led one sculptor, the Florentine Bartolommeo Ammanati (1511–92), to renounce formally the nudity of his statues.

Italy remained the focus of sculptural development throughout the seventeenth century, most particularly in Rome, where the Baroque style found expression in the elaborately decorated churches and palaces built under the patronage of the wealthy Papal court. The undoubted master of the period was the great architect and sculptor Gianlorenzo Bernini. The dramatic expression of emotions, typical of the Baroque style, is exemplified in the Cornaro Chapel in Santa Maria della Vittoria, which Bernini specifically designed to house his group of The Ecstacy of St Teresa (figure 2). Like Giambologna before him, Bernini's infuence spread throughout Europe (page 135), although the French court of Louis XIV rejected the flamboyance of the Italian Baroque in the production of its own more classicising style.

Bernini was nevertheless called to France in 1665, where he carved a bust of Louis XIV and was commissioned to produce an equestrian monument to the King. His model was rejected, but equestrian statues of Louis XIV – the 'Sun King' – were later erected throughout France as symbols of royal authority. Although these were destroyed during the French Revolution, they are known from engravings and small bronze copies such as those by François Girardon, who was also responsible for much of the garden sculpture at the King's palace of Versailles (page 138). Under Louis XIV the visual arts flourished and by the early eighteenth century Paris had usurped Rome as the main artistic centre of Europe.

(PE)

2. The Ecstacy of St Teresa in the Cornaro Chapel, Santa Maria della Vittoria, Rome; by Gianlorenzo Bernini; 1645–52

(a) IPPOLITA GONZAGA (1535–63)

By Leone Leoni (1509–90)
Italian (Milan); about 1551

Bronze, cast; diam. 6.8 cm
A.249-1910; Salting Bequest

(b) ANTOINE COEFFIER (1581–1632)

By Jean Warin (1606/7–72)
French (Paris); dated 1629

Bronze, cast and chased; diam. 7 cm
A.362-1910; Salting Bequest

The format of the Renaissance and later portrait medal had its origins in Imperial Roman coins, which bore the image of the Emperor on the obverse (primary face) and a device or symbol on the reverse. The development of the commemorative medal as a type followed the spread and assimilation of Renaissance ideals and the revival of an interest in the Antique throughout European culture. Its history begins in Italy with Pisanello, who trained as a painter and signed himself as such in Latin on the reverse of his medals, and many specialist sculptors were attracted to the art form in the following centuries.

It was recognised that there was a ready market for medals amongst the growing class of collectors, usually members of the intelligensia or the gentry, who were attracted to small-scale works of art; in addition medals, especially official ones, were often made in large numbers for presentation. The Gonzaga of Mantua, great patrons of the arts, commissioned Leone Leoni – master of the imperial mint in Milan – to make a medal of Ippolita Gonzaga in the middle of the sixteenth century for just such an occasion (a). Ippolita was already famed for her beauty and accomplishment by her 16th year, when Leoni cast this medal. She appears on the reverse as Diana, the huntress and moon goddess, and – as indicated by the presence of Pluto, Proserpina and Cerberus – as Hecate, goddess of the underworld. The medal format proved ideal for this type of personal and intimate object.

The commemorative portrait medal was especially highly regarded in France during the first half of the seventeenth century. Guillaume Dupré (1579–1644), court medallist to Henry IV, undertook medallic portrait commissions in Italy

from 1612. Dupré's grasp of the Italian tradition, together with his considerable technical skills, enabled him to cast medals in a style which proved influential on succeeding generations of French medallists. The medal of Antoine Coeffier, called Ruzé, by Jean Warin (b), is close in style and technical accomplishment to that of Dupré and was for many years attributed to him. The Museum's version is a particularly fine specimen, and the reverse – which shows Hercules receiving the burden of the world from Atlas – is conceived in such high relief that Hercules' left arm stands out free of the field.

Medallic art has always been collected at South Kensington within the context of the history of sculpture. The Collection is consequently rich in examples of the work of known sculptors in this medium, and emphasis has been placed on the acquisition of particularly fine examples. Both the medals illustrated here were bequeathed by George Salting, whose great collection contained many other important and beautiful pieces (see pages 18–19).

(*WF*)

(a)

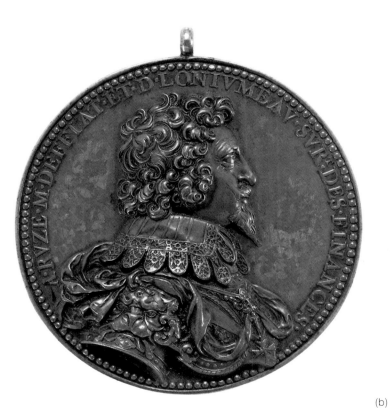
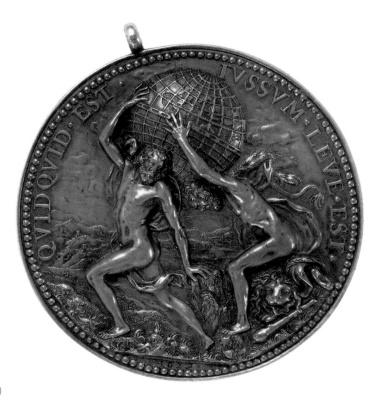

(b)

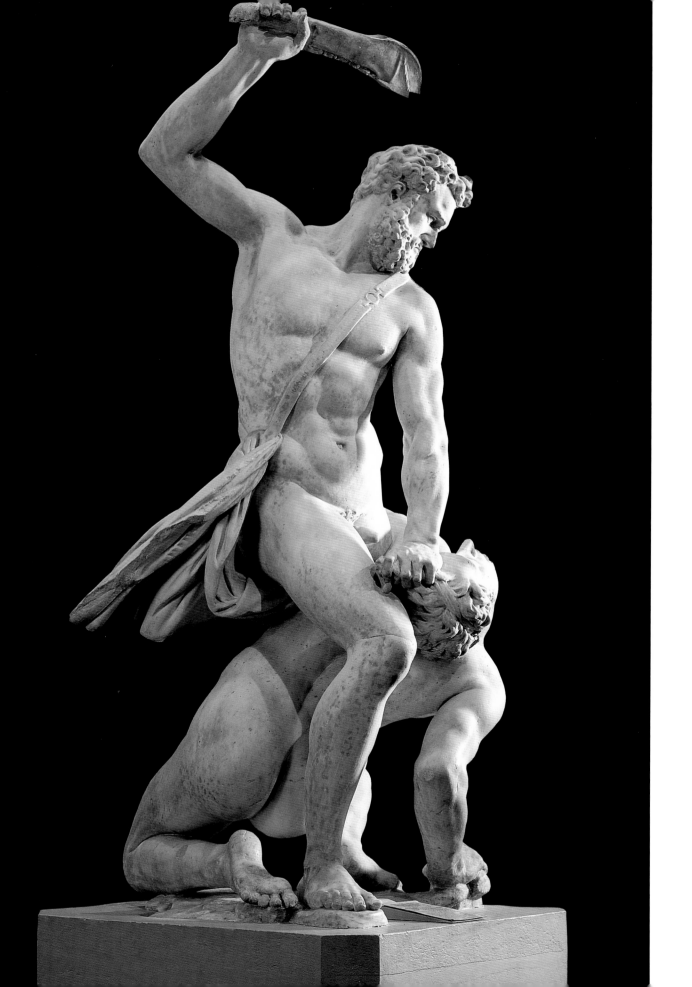

SAMSON SLAYING A PHILISTINE

By Giovanni Bologna, called
Giambologna (1529–1608)
Italian (Florence); about 1562

Marble; h. 209.9 cm

A.7-1954; purchased with the assistance of the
National Art Collections Fund

The *Samson slaying a Philistine* is the
earliest of the great marble groups by
Giambologna, and the only substantial
work by the artist to have left Italy. It was
commissioned by Francesco de' Medici
(1541–87) and after completion in about
1562 was set up on a fountain in the
Cortile de' Semplici in Florence. In 1601
the fountain was sent to Spain by the
Grand-Duke Ferdinando I as a gift to the
Duke of Lerma, chief minister of Philip
III of Spain, where it was placed in the
royal gardens of Valladolid. The basin is
preserved at the Jardin de la Isla at
Aranjuez, Spain, but the central group
was presented to King Charles I on his
visit to Spain as Prince of Wales in 1623.
It became the most famous Italian
sculpture in England, being widely
copied and changing hands three times
before being purchased by the Museum
in 1954.

Giambologna was born in Douai in
Flanders (now Belgium), but went to
Rome to study antique sculpture from
about 1550 to 1553. On his way
homewards he visited Florence, and was
persuaded to stay. As Sculptor to the
Medici Grand-Dukes, Giambologna
became the most famous and influential
sculptor of the late sixteenth and early
seventeenth centuries, attracting artists
from Northern Europe to his studio and
disseminating his style principally
through the production of small bronzes.
However, he was also the natural
successor to Michelangelo, producing
several large marble groups which explore
daring solutions to two- and three-figure
relationships. The *Samson slaying a
Philistine* is based on a composition by the
older master, known through small bronze
copies.

The group is signed on the strap across
Samson's chest, '*IO ... BELGAE*', indicating
that it is a work of the master himself.
Giambologna established a large and
efficient workshop, and many of his later
marbles were carved by assistants, such as
Pietro Francavilla (1548–1615), following
his designs. The dramatic composition of
the group demonstrates Giambologna's
technical expertise, as the marble block
has been deeply excavated, leaving the
figures supported on only five points and
with Samson's arm raised above his head.
Elements of the composition were taken
up by Vincenzo Foggini (active 1725–53)
in his *Samson and the Philistines* (1749),
also in the Museum (A.1-1991), which
was probably carved from the block
originally reserved by Giambologna for a
replacement for this group when it was
sent to Spain. (*PE*)

VENUS REMOVING A THORN FROM HER FOOT

By Ponce Jacqueau
(after 1536–70)
French (School of Fontainebleau);
about 1560–70
Bronze; h. 24.9 cm
A.13-1964

According to legend the rose was originally a white flower, but in Venus' haste to help the dying Adonis, a thorn pierced her foot and her blood stained the petals red. This bronze shows the kneeling figure of the naked Venus removing the thorn from her foot. The pose is similar to that of the same subject engraved by Marco Dente after a fresco executed by Raphael's workshop in 1516 for the bathroom of Cardinal Bibbiena in Rome. The terracotta model for the present figure, which was formerly painted to imitate bronze, is now in the Musée du Louvre in Paris. The former was once in the collection of the artist François Girardon, being mentioned in the inventory made after his death in 1710 and shown in an engraving of the *Galerie de Girardon* of the same date.

Ponce Jacqueau, who also worked in Rome, was amongst the leading Parisian sculptors of his day.

The *Venus* is closely related in style and handling to the bronze figures of Prudence and Temperance which he made for the funerary monument of Henry II of France in the abbey church of Saint–Denis in Paris, in about 1565–70. It is a unique cast, although smaller versions exist in other collections. A *Mother and Child* in the Wallace Collection in London is also attributed to the artist. (*PE*)

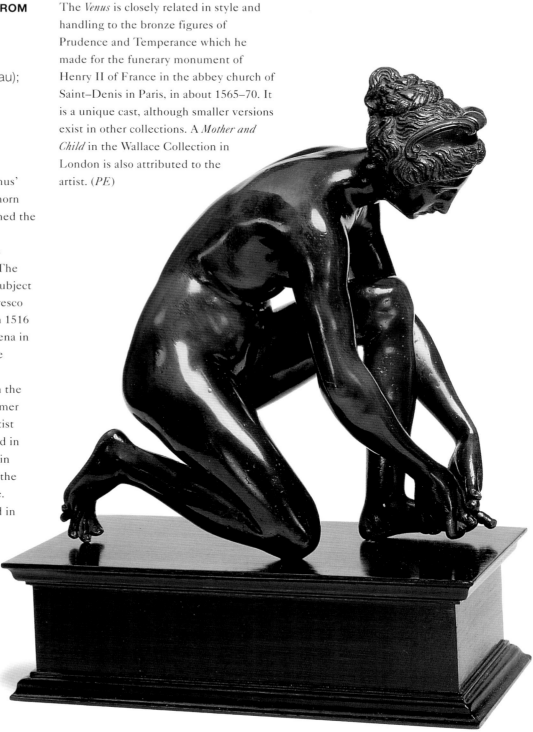

THE EMPEROR RUDOLPH II

By Adriaen de Vries
(about 1545–1626)
Prague; 1609

Bronze; h. 71.1 cm, w. 52.7 cm
6920-1860

This bronze portrait of Rudolph II is the last in a series of three which Adriaen de Vries produced at the Emperor's court workshop in Prague. Two signed busts of 1603 and 1607, now in the Kunsthistorisches Museum in Vienna, preceded it. The relief is signed under the left edge 'ADRIANVS FRIES · FEC:', the sitter being identified by another inscription, 'RVD: II· ROM· IMP: CAES: AVG AET: SVAE: LVII· ANNO· 1609' ('Rudolph II, Roman Emperor, Caesar Augustus, aged 57, in the year 1609'). The lion mask on the pauldron, the supporting imperial eagle, and the allegorical reliefs on the cuirass depicting Hercules holding up the world and Minerva with a trophy of arms and a statue of Victory allude to the Emperor's military and political power.

Adriaen de Vries was born in The Hague probably in about 1545, and like many of his fellow countrymen went to Italy for experience and training. Here he worked in Florence in the workshop of Giambologna and as Court Sculptor for Duke Carl Emmanuel I of Savoy in Turin. By the 1590s he was back north of the Alps, in Augsburg, where he executed the bronzes for the Mercury and Hercules fountains between 1597 and 1602, and in 1601 was appointed Court Sculptor to Rudolph II, moving to Prague the

following year. This portrait was recorded in the inventory of Rudolph's Cabinet of Curiosities at Prague by 1611, but before 1652 it had entered the collection of Queen Christina of Sweden, having been confiscated – together with many other sculptures by de Vries – as war booty during the Thirty Years' War (1618–48). (NJ)

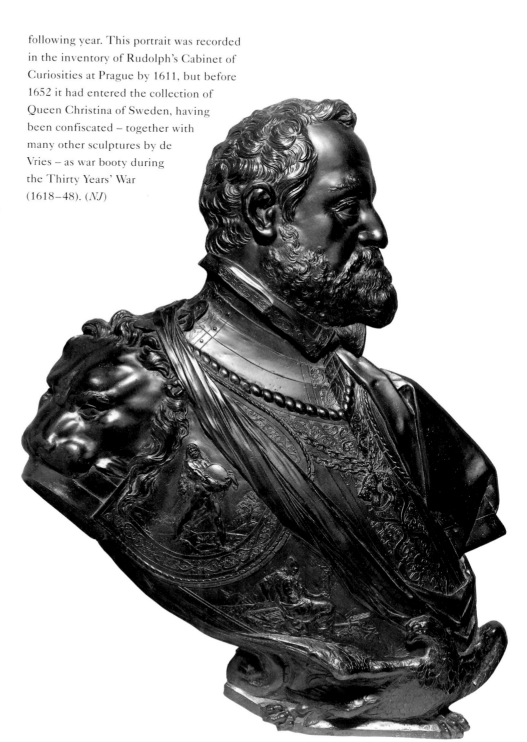

THE CHRISTOPH FUGGER ALTAR

By Hubert Gerhard
(about 1550–1620)
German (Augsburg); 1581–84

Gilt-bronze; relief h. 96.5 cm, w. 62.9 cm,
statuettes from 21.9 cm to 42.5 cm

A.20 to 28-1964; bequeathed by Mr George
Weldon

When Christoph Fugger, a member of the
great Augsburg banking family, died
unmarried in 1579 a large sum of money
was set aside from his estate for an
appropriately rich memorial. A site was
chosen in the Dominican church of St
Magdalena in Augsburg, and the work
entrusted to Hubert Gerhard. The altar
memorial consisted of a stone framework
of red and white marble, on to which
were set gilt-bronze sculptures: a large

relief of the Resurrection, a smaller relief
of the Ascension (missing since the
eighteenth century), two standing and
two seated figures of prophets, two small
angels holdings the Instruments of the
Passion and two large kneeling angels
who supported the framework above. In
addition to Gerhard, Paulus Mair was
employed to cut the marble, Carlo
Pallago (a Florentine stucco sculptor)
assisted with the casting, the Reisinger
brothers of Augsburg supervised the
technical side of the work and the
goldsmith Johann Müller was responsible
for the finishing, chasing and gilding.

The progress of the commission is
fortunately extremely well documented
in an account-book held in the Fugger
archives at Dillingen. Fascinating details
emerge from the accounts, such as the

fact that the casts of the two reliefs and
one of the large angels failed at the first
attempt, and it is of interest to note how
many people were involved in such a
collaborative exercise. In connection with
the final polishing, for instance, two
women were employed for a number of
weeks to rub at the bronzes with wire
brushes and tartar and to wash them
down with beer and water; and to
counteract the effects of mercury
poisoning the men working on the gilding
were given small amounts of butter. This
is unlikely to have been particularly
helpful.

The marble framework of the altar was
renewed in 1727 when the church was
remodelled in the Baroque taste, but the
bronzes – with the apparent exception of
the Ascension relief – remained *in situ*
until 1807, when the church was
secularised and the contents sold. The
history of the sculptures between the
early nineteenth century and 1964, when
they were bequeathed to the Museum, is
not known.

Hubert Gerhard was one of a number of
Northern sculptors trained in Italy in the
second half of the sixteenth century, all of
whom came under the considerable
influence of Giambologna (see page 123)
and carried the latest artistic
developments back to Germany and the
Netherlands. The Fugger altar was one of
the first manifestations of this mixture of
Italianate and Northern styles in South
Germany, and Gerhard – together with
Johann Gregor van der Schardt and
Adriaen de Vries (see page 125) – became
its leading exponent.

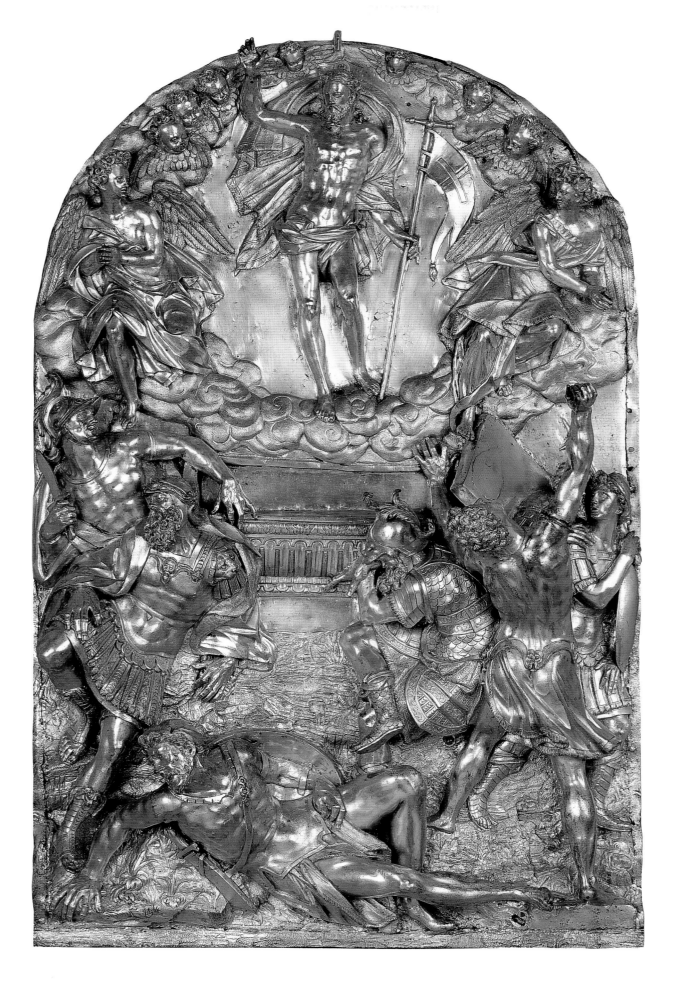

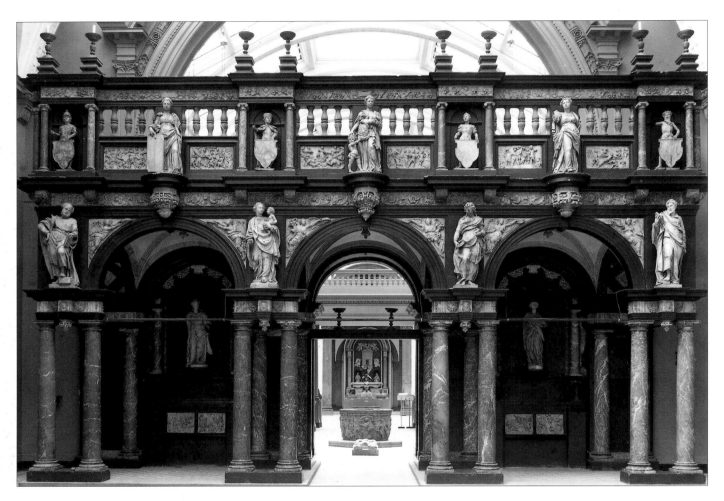

THE HERTOGENBOSCH ROODLOFT
Netherlandish; 1610–13

The structure red, black, and grey Belgian marble, the figure sculpture and decoration of alabaster; h. 780.1 cm, w. 1044 cm

1046-1871

The roodloft was erected between 1610 and 1613 across the choir arch of the cathedral of St John at 's-Hertogenbosch, replacing an earlier choirscreen which had been severely damaged in the Calvinist *beeldenstorm* (destruction of images) in 1566. After 1579, when the Calvinists failed to gain power over 's-Hertogenbosch, the city became a strong Catholic outpost of the Spanish Netherlands until 1621. During this time the authorities commissioned Coenraed van Norenberch

from Namur to build the roodloft after a design closely modelled on the example in Antwerp Cathedral, his workshop providing most of the statues, the spandrel figures, the reliefs and the architectural decoration for the loft. However, one of the most important of the figures – that of the patron saint, John the Evangelist – was sub-contracted out to the most distinguished Amsterdam sculptor of the day, Hendrik de Keyser, who is recorded as working on the

sculpture at the end of 1613. For doing this he incurred the wrath of the Protestant Reformed Church in Amsterdam, who insisted that he cease work on it immediately.

The four figures placed between the spandrels on the front (west side) of the structure are St Peter, the Virgin and Child, St John the Evangelist and St Paul, while above are four bearers of coats-of-arms and, centred over the arches, three statues of the Cardinal Virtues – Faith, Charity and Hope – flanked on either side with scenes from the Life of Christ. Two further figures of Justice and Peace and additional reliefs now placed under the arches were originally set on the north and south ends of the roodloft. The central niche of the back of the loft, facing the choir, was occupied by a statue of Christ (destroyed by the Protestants in 1629) and eight reliefs, the Seven Works of Mercy and the Last Judgement.

For more than 250 years this monument of the Catholic Counter-Reformation remained largely unmolested, even when the cathedral was in Protestant hands from 1629 to 1810. It was eventually taken down in 1866 during the mid nineteenth-century restoration of the building, ostensibly because it obstructed the congregation's view of the high altar but also because its style was inconsistent with the surrounding Gothic architecture. Shortly afterwards it was purchased by the art dealer Murray Marks, who sold it to the Museum in 1871 (see pages 13–15 and figure 4 on page 14). (*NJ*)

St John the Evangelist by Hendrik de Keyser

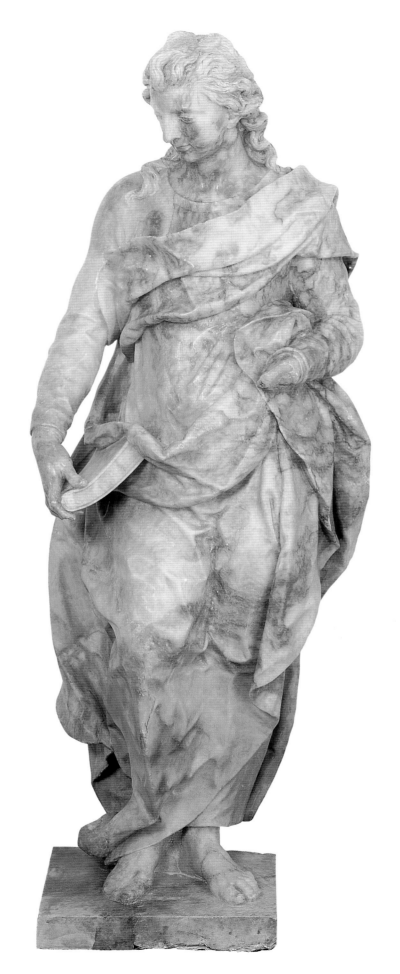

King Henry IV of France Overcoming his Enemy

By Hubert Le Sueur
(active 1602–58)
French (Paris); about 1615–20

Bronze; h. 85 cm

A.46-1951 (given by Dr W.L. Hildburgh) and
A.1-1992 (bought with the assistance of the
National Art Collections Fund, Sotheby's and an
anonymous benefactor)

This group, together with its pair showing Henry IV's son, King Louis XIII (A.47–1951), is attributed to the French sculptor-founder, Hubert Le Sueur, primarily because of its close relationship with a signed smaller statuette of Louis XIII also in the Museum (A.1-1994) and the life-size monument to King Charles I in Trafalgar Square, signed and dated 1633. Much of Henry IV's reign was spent fighting to establish a stable kingdom,

and he was frequently portrayed, as here, overcoming his enemies. The soldier cowering beneath the King's horse had been separated from the main part of the group before the latter entered the Museum's Collection in 1951, but was

reunited with it after being acquired at auction in 1992.

Hubert Le Sueur was sculptor to Louis XIII in Paris before coming to England in 1625 to work for the court of King Charles I. Although he also produced works in marble, including the Museum's signed bust of Charles I (A.35-1910), Le Sueur was a specialist in bronze casting. His equestrian statues were cast in separate pieces, the head, the body of the rider and the horse being bolted together. (*PE*)

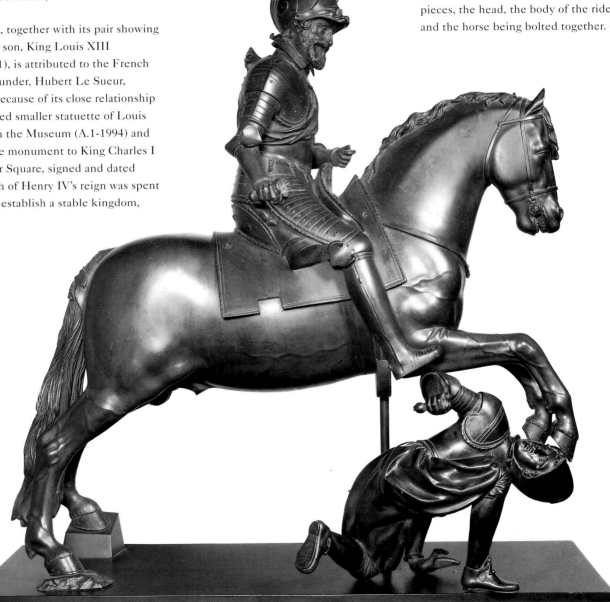

MONUMENT TO SIR MOYLE AND LADY ELIZABETH FINCH, COUNTESS OF WINCHILSEA

Attributed to Nicholas Stone
(1587–1647)
English; about 1630

Marble and alabaster; h. 172 cm, l. 469.9 cm,
w. 464.8 cm
A.186-1969; given by the Rector and
Churchwardens of the Parish of Eastwell with
Broughton Aluph

The monument was originally in the church of St Mary at Eastwell, Kent, but was given to the Museum, with other sculptures, when the church fell into disrepair after the Second World War. The effigies of Sir Moyle and Lady Elizabeth Finch lie on the top, and an inscription recording the names of their twelve children runs round the bier. When the tomb was first erected it had an elaborate canopy supported by columns, surmounted by a griffin holding a coat-of-arms. These were demolished in 1756, but a sketch dating from about 1628, now in the library of the Society of Antiquaries, shows the north side of the complete monument. Because the drawing differs in some respects from what survives of the monument, however, it is not clear whether the ensemble was actually complete at the time of the drawing, or whether the sketch was a hurried and slightly inaccurate reconstruction of what could then be seen in the church.

Lady Elizabeth Finch (d.1634) was the sole heiress of Sir Thomas Heneage, Chancellor of the Duchy of Lancaster under Elizabeth I. Sir Moyle Finch (d.1614), whom she married in 1572, was heir to the Finch and Moyle fortunes, so that on his death in 1614 she was an extremely wealthy woman. She pursued a peerage in her own right, becoming Viscountess Maidstone in 1623 and Countess of Winchilsea in 1628, and almost certainly commissioned this elaborate and costly tomb shortly after she was created Countess. At that date in England few sculptors were as sophisticated as their continental contemporaries, but Nicholas Stone, to whom this work is attributed, had trained in the Netherlands, and was the leading English sculptor of his time. The quality of carving is especially evident in the portrait of Elizabeth Finch, probably taken from the life. (*MT*)

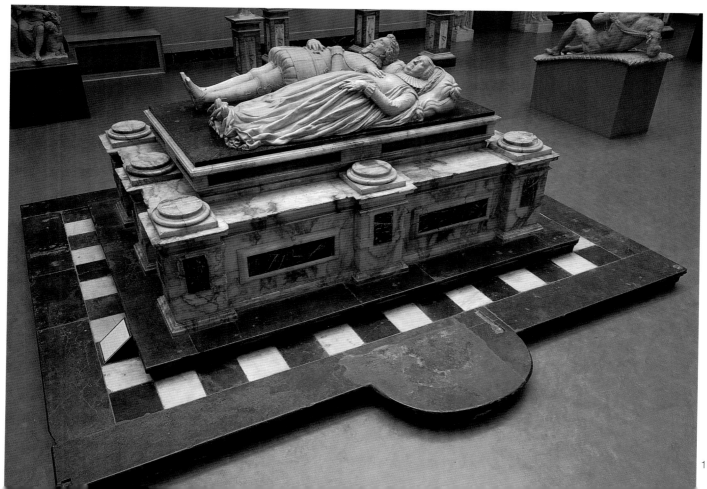

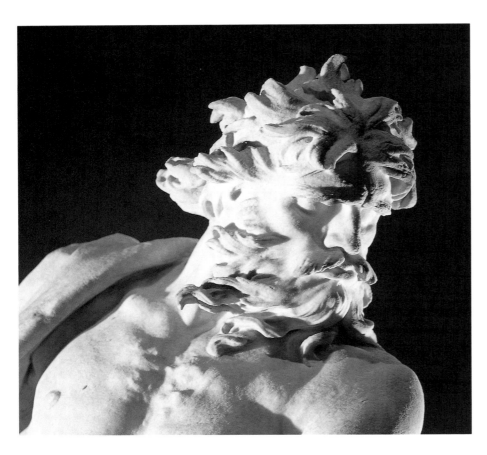

NEPTUNE AND TRITON

By Giovanni Lorenzo Bernini
(1598–1680)
Italian (Rome); about 1620–22

Marble; h. 182 cm

A.18-1950; purchased with the assistance of
the National Art Collections Fund and with
contributions from the John Webb Trust and the
Vallentin Bequest.

Commissioned in about 1620–22 by
Alessandro Peretti, Cardinal Montalto, for
the garden of his villa in Rome, this
impressive marble group originally
surmounted a fountain. Water flowed

from the conch-shell blown by Triton, the
piping still remaining inside the figure.
Triton was incorrectly identified by the
biographer Filippo Baldinucci as Glaucus,
a fisherman who, according to Greek
mythology, changed into a merman by
chewing magic blades of grass. The
composition in fact appears to be based
on Ovid's account of the Flood
(*Metamorphoses*, Book 1, 330-42), where
Triton is ordered by Neptune to blow his
conch-shell to summon the waters to
retreat.

Bernini, the most gifted and influential
sculptor of the Baroque, was renowned
for his marble groups of mythological
subjects, his portraits and his expressive
religious sculpture. Stylistically the
Neptune and Triton falls between the
Aeneas and Anchises (1618–19) and the
David (1623) in the Galleria Borghese in
Rome, anticipating the elaborate
compositions of the sculptor's mature
style. The group was one of the most
celebrated sights in Rome during the
seventeenth and eighteenth centuries,
remaining in its original position until
1786, when it was sold to the Englishman
Thomas Jenkins, from whom it was
purchased later that year by the painter
Sir Joshua Reynolds. Reynolds kept it in
his coach-house and after his death in
1792 it was sold again to Charles Pelham,
first Lord Yarborough, who placed it in
the Garden of Walpole House, Chelsea. It
was moved to Brocklesby Park in
Lincolnshire in 1906, from where it was
acquired by the Museum in 1950
(see page 22).
(*PE*)

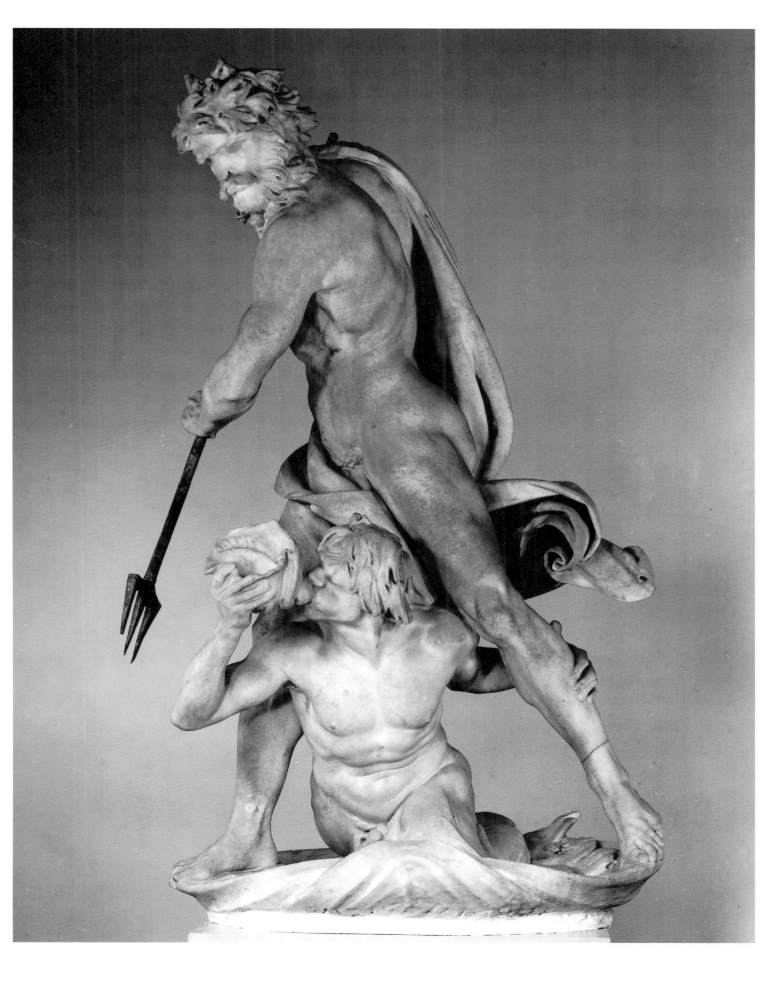

CARDINAL PAOLO EMILIO ZACCHIA

By Alessandro Algardi (1595–1654)
Italian (Rome); about 1650

Terracotta; h. 82.2 cm

A.78-1970; purchased with the assistance of
the National Art Collections Fund

This sketch-model was made in
preparation for a marble bust of the
Cardinal (1554–1605) now in the Museo
Nazionale del Bargello, Florence. The
marble version was unfinished at Algardi's
death, suggesting that the portrait was
one of the sculptor's last works. It was
subsequently completed by an assistant,
possibly Domenico Guidi, and is recorded
in the possession of the Cardinal's niece,

the Marchesa Rondanini. The marble
bust lacks the vivacity of the terracotta,
the handling of which is particularly
remarkable as the sitter had died nearly
50 years before it was modelled. Algardi
presumably based his work on an existing
portrait.

The Cardinal, who wears a *biretta* (a
three-cornered hat) and *mozetta* (a short
hooded cape), is shown turning the pages
of a book – a pose alluding to his written
works, which included a treatise on the
Immaculate Conception. Cracks are
clearly visible throughout the terracotta,
caused by firing the clay too quickly.
(*PE*)

KING CHARLES II

By Honoré Pelle (active 1672–1706)
Franco-Italian (Genoa); signed and
dated 1684

Marble; h. (with socle) 128.9 cm

239-1881; given by Mr Henry Durlacher

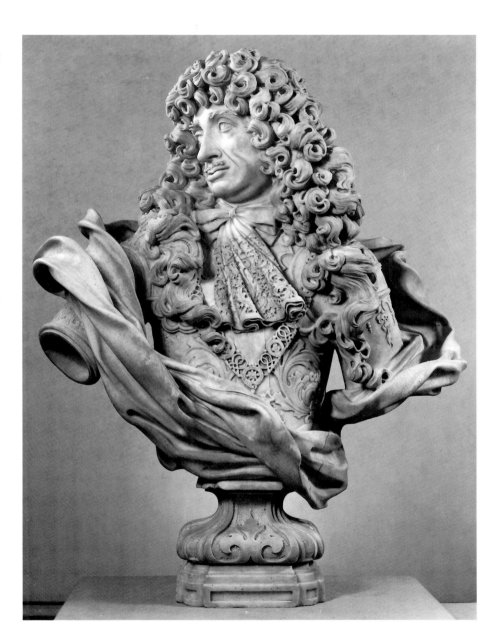

Charles II (1630–85) is portrayed in a
dramatic and animated fashion, his head
turned to one side, an elaborate wig
cascading down over his lace cravat and
billowing drapery. Such a grand Baroque
image was almost certainly originally
intended for an architectural setting, and
indeed another version dated two years
earlier is set on a balcony in a courtyard at
Burghley House near Stamford,
Lincolnshire. Such images of monarchs
and powerful aristocrats were more
common in seventeenth-century France
and Italy than England; Bernini is
especially renowned for such flamboyant
portraits, and the present sculpture may
have been inspired by such works as his
bust of *Louis XIV* at Versailles, carved in
1665.

Unfortunately nothing is known about
the circumstances of the original
commission; this version was completed
only the year before the King died. Little
is known of Pelle, who seems to have
spent his working life in Genoa, perhaps
after training in Rome. He almost
certainly never came to England, and the
bust was probably based on a painting, or
an engraving after a painting. This
sometimes occurred when the subject
could not sit for the artist, most famously
when Charles II's father, Charles I, was
sculpted by Bernini in Rome, the bust in
that instance being based on a painting
sent over by the Court Painter Van Dyck.
(*MT*)

TANKARD

By Bernhard Straus
(active 1640–81)
German (Augsburg); signed and
dated 1651

Ivory mounted in silver-gilt; h. 48.5 cm

4529-1858

This large lidded tankard is an
outstanding example of German Baroque
ivory carving, and would always have
been a luxury object for display rather
than used for drinking. The figure group
on the top depicts Hercules slaying a
centaur, and is based on Giambologna's
monumental marble group now in the
Loggia de' Lanzi in Florence. Straus
probably knew of this group from a
reduced bronze version, of which there
were many at the German courts. Around
the sides of the tankard mythological
subjects are shown, including Venus and
Cupid, Minerva, the drunken Silenus
supported by bacchantes and Neptune
and Amphitrite in a sea-chariot. Near the
figure of Minerva, under an archway, is a
male head and shoulders in contemporary
dress pointing to a figurine in a niche; this
may be a self-portrait of the artist.

This is one of the few signed works by
Bernhard Straus, described by his
contemporary Joachim von Sandrart in
1675 as a '*guten Bildkünstler in Helfenbein,
Edelgstein, Buxbäumen, Holz und Silber*' ('a
good sculptor in ivory, precious stone,
boxwood, wood and silver'). Two others
are in the Kunsthistorisches Museum in
Vienna and the Rijksmuseum in
Amsterdam. It is inscribed underneath
the lid: '*Anno. 1651. Bernard Straus,
Goldschmidgesel, Von Marckhdorf am
Bodensee, Fecit, A: Vinde:*' ('Bernhard
Straus, goldsmith from Markdorf am
Bodensee, made this at Augsburg'. 'A:
Vinde' is an abbreviation for the Latin
name for Augsburg, Augusta
Vindelicorum). The side of the tankard is
also signed on Neptune's chariot:
'BERNARD STRAVS GOLDSCHMID FEC.'
Further confirmation of the tankard's
provenance is given by the mounts, which
bear the Augsburg town-mark and the
master-mark 'AW', probably standing for
Andreas Wickert (1600–61). (*MT*)

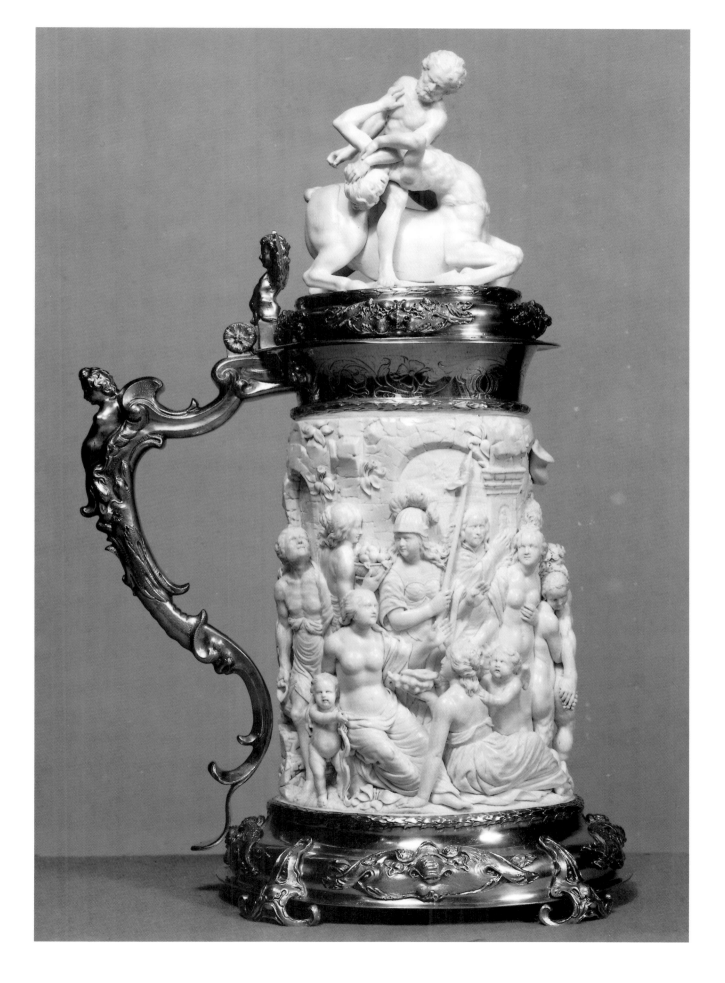

ARISTAEUS FETTERING PROTEUS

By Sébastian Slodtz (1655–1726),
after a model by François Girardon
(1628–1715)
French; about 1695–1700

Bronze; h. 87.6 cm

A.6-1963

As recounted in Virgil's *Georgics*, Aristaeus – the protector of cattle and fruit trees and patron of bee-keepers – had pursued Eurydice into the fields, where she was killed by a snake bite. The nymphs punished him by destroying his bees, so he sought the advice of the sea-god Proteus, shown here accompanied by two seals. Proteus had received the gift of prophecy from Neptune, but he often eluded enquirers by assuming different shapes or by vanishing. In order to obtain his answer, Aristaeus therefore had to fetter him, and this is the scene shown here. Proteus was to recommend that Aristaeus sacrifice cattle to the nymphs, which he did, and returning after nine days found the carcases swarming with bees.

This bronze is a reduced version of a colossal marble group made for the park at Versailles and completed in 1714. Several smaller bronze versions were made of the subject, which had originated in a wax model by François Girardon. The present bronze, which seems to be the only one in existence to reproduce the composition faithfully, almost certainly dates from the late seventeenth

century. Of the groups recorded, two were documented in the late seventeenth-century accounts of the French Royal Collection, one is known to have been in Girardon's own collection, and one was exhibited at the Salon in 1704. The present group is likely to be one of these.

Sébastian Slodtz was born in Antwerp, but had settled in Paris before 1685, and

there entered Girardon's studio. He carried out a number of commissions for the King, and much of his work is in Paris and Versailles. Three of his sons became sculptors, the most eminent of whom was Michel-Ange Slodtz. From 1699 he was given lodgings at the Louvre, where he remained until his death.

(*MT*)

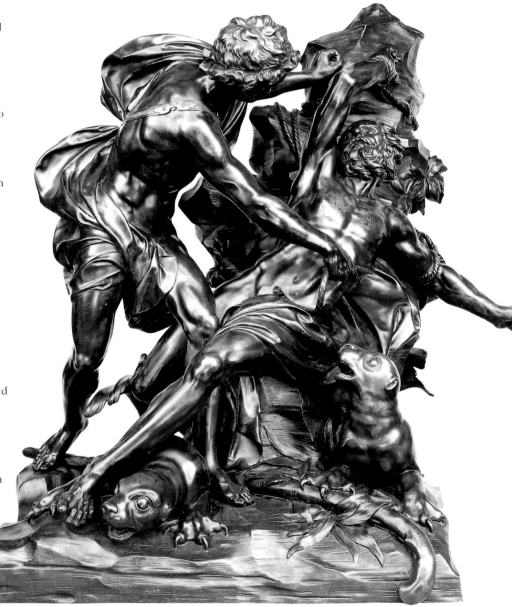

THE TRIUMPH OF CHASTITY

By Francesco Bertos
(active 1693–1739)
Italian; about 1700

Bronze; h. 90.2 cm

A.3-1949; given by Dr W.L. Hildburgh

The allegorical group is surmounted by a winged female nude, representing Chastity, holding palm leaves in her right hand and a wreath in her left. She is supported by a rearing unicorn, on which is seated a male figure wearing a lion's skin and holding a serpent in his left hand, and a female figure with a cornucopia (horn of plenty) of jewels seated on an altar. A group is ranged around the altar: a female figure holding a mirror (possibly *Vanitas*), a male warrior, a female holding ears of corn and a cornucopia (possibly *Fertility*) and a child holding a ring.

The origins of Bertos are unclear, but a reference of 1739 suggests either that he came from the village of Dolo, near Padua, or that he was then living there. He is also documented as working in Rome in 1693, Venice in 1710 and Padua in 1733–34. This is one of a number of related groups of allegorical subjects, some signed, in the immediately recognisable and idiosyncratic style of the artist. Although he also worked in marble, two examples of which can be seen in the Museum (*Hylonome attacked by the Lapiths*, A.5-1943, and *The Expulsion from Paradise*, A.69-1953), his compositions were more suited to bronze, as its tensile strength allows greater experimentation with sculptural form. His output was considerable, and examples of his work survive in collections throughout Europe and the United States.
(*PE*)

EWER

By Massimiliano Soldani
(1656–1740)
Italian (Florence); probably designed
about 1695
Bronze; h. 79.7 cm
A.18-1959

The ewer is decorated in high relief with figures of Neptune riding a pair of dolphins on one side and Triton with two seahorses on the other. It is one of a pair of decorative vases in the Museum, the other showing Galatea or Amphitrite, the wife of Neptune, and a nereid (or sea nymph). They are closely comparable in style with a Bacchanal relief made by Soldani for the Duke of Liechtenstein in 1695–97 (Liechtenstein Palace, Vienna), and are possibly the ewers referred to in correspondence with the artist in 1695. They may have belonged to the Scarlatti family in Florence, from whom the British Consul Sir Horace Mann attempted to acquire a pair of similar description for Bubb Doddington in 1759.

The moulds for the two ewers were probably those listed amongst the contents of Soldani's house after his death in 1740. They were clearly popular designs, being reproduced together with several of his other sculptures and those of his contemporary Giovanni Battista Foggini (1652–1725) in coloured porcelain by the Doccia factory in Florence, where wax versions survive. Other bronze versions of these ewers are known to exist, and these casts may be slightly later in date than the original models.

Massimiliano Soldani received his training as a sculptor and medallist in Rome and Paris before being recalled to Florence, where he worked for over 40 years as the Master of Coins and Custodian of the Mint for the Medici Grand-Dukes of Tuscany. He produced a wide range of objects, specialising in bronze casting, and this ewer illustrates the high-quality finish produced in his workshop. The body of the ewer is cast in one with the base, with the separate lid screwed into place by the knob.
(*PE*)

THE VIRGIN OF SORROWS

By José de Mora (1642–1724)
Spanish (Granada); about
1680–1700

Painted pinewood, glass and ivory;
h. 48.5 cm, w. 49 cm. 1284-1871

The subject, known in Spain as the *Virgen de la Soledad*, or *Dolorosa*, shows the mourning Virgin alone after Christ's entombment. Such pieces, perhaps deriving their form from reliquary busts, were widely produced in Granada and elsewhere in Andalusia during the seventeenth and early eighteenth centuries and were often paired with a bust or half-length figure of Christ as Man of Sorrows.

This bust is ingeniously made from a number of pieces of wood fitted together; x-rays have revealed that the head was carved separately from the neck and shoulders, and that the veil is separate from both. The face is carved as a mask, with glass eyes, teeth (probably made of ivory) and tongue inserted from behind, before the veil was fitted around it with small nails. The ringlets of hair are made from what are in effect corkscrews of wood-shavings.

Long attributed to the sculptor Pedro de Mena, the bust has recently been reassigned to another Andalusian artist, José de Mora. Like his father Bernardo and brother Diego, José de Mora specialised in wood sculpture. He seems also to have painted the works himself. He worked with his father in Granada for several years, but in about 1666 he left for Madrid, and was created Court Sculptor in 1672. He settled once again in Granada in 1680, and worked there until he declined in mental health following his wife's death in 1704. He died insane 20 years later. (*MT*)

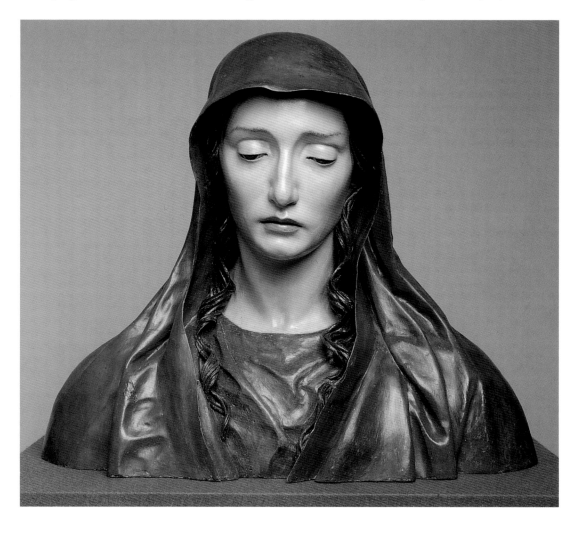

THE VIRGIN AND CHILD WITH ST DIEGO OF ALCALÁ

By Luisa Roldán (1652–1706)
Spanish (Madrid); about 1690–95

Painted terracotta on a painted and gilt wood base; h. 51 cm, w. 66 cm

250-1864

The Virgin and Child are shown presenting a cross to St Diego of Alcalá, a Franciscan saint, one of whose miracles occurred when he was accused by a fellow friar of stealing bread from the convent to give to the poor. When his robes were searched, the hidden bread was miraculously transformed into roses. Rose petals can be seen here in the folds of his habit.

Luisa Roldán, or *La Roldana*, was trained as a sculptor in wood and terracotta by her father, the Seville sculptor Pedro Roldán (1624–99). Exceptionally for a woman at that time, she set up her own workshop, initially in Cadiz, and from 1688 onwards in Madrid. Here she petitioned the King, Charles II, for the post of Court Sculptor, which was eventually granted in 1692. Roldán specialised in small polychromed terracotta groups, and although this piece is unsigned, it is typical of her work.

This was one of the works of Spanish sculpture purchased in Spain in 1863 by John Charles Robinson, whose acquisitions formed the foundation of the collection of Spanish sculpture at the Museum (see page 9).

(*MT*)

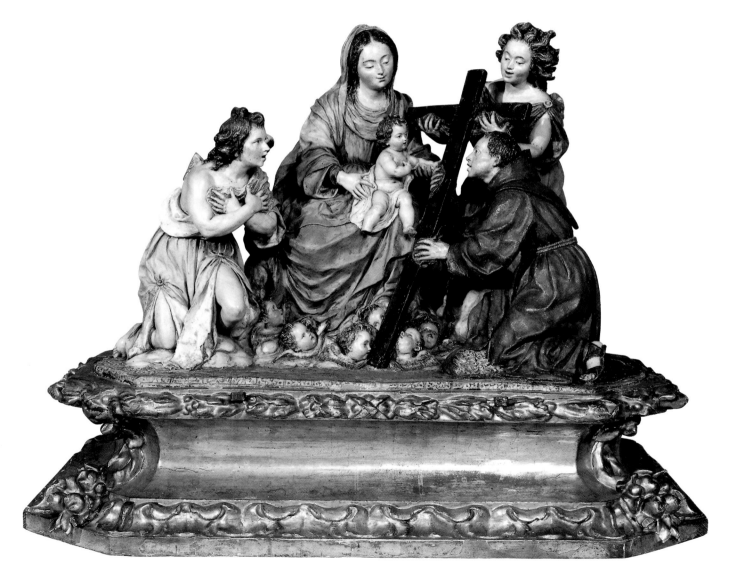

St Joseph and the Christ Child

By José Risueño (1665–1732)
Spanish (Granada); about 1720

Painted terracotta, pinewood and fabric; h. 50 cm, w. 32 cm

313-1864

In Spain during the seventeenth and eighteenth centuries, following the Counter-Reformation, St Joseph and the Christ Child were frequently depicted in painting and sculpture. Here the figure of the kneeling St Joseph embracing the Child and gazing towards Heaven suggests both his tenderness and awareness of Christ's deity. The Child himself is shown in contrast as a chubby baby, apparently oblivious of his future rôle as Saviour. The swirling drapery and twisting poses of the composition are typical of Risueño's dynamic and animated style.

Risueño was active as both a painter and sculptor, and appears to have spent his whole life in Granada, working in stone and wood as well as terracotta. This piece is largely terracotta, but fabric has been fixed around the base, over an added block of wood. These additions seem to be contemporary with the terracotta, and may have been made to adjust the angle at which the figures were to be seen, or possibly because the lower part of the terracotta had been damaged during firing.

(*MT*)

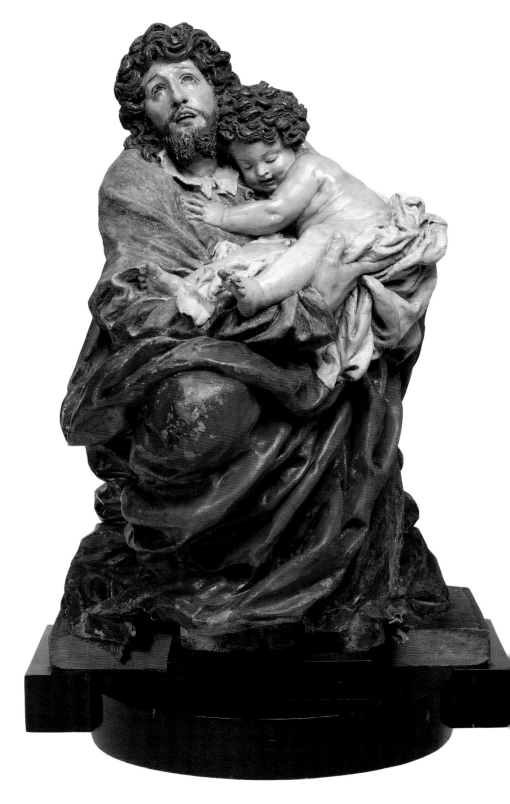

THE JUDGEMENT OF PARIS

By Christoph Maucher
(1642 – after 1701)
German (Danzig); about 1690–1700
Amber and ivory on a wooden core; h. 19.7 cm,
w. 19.5 cm
1059-1873

The peasant-like figure of Paris chooses
the similarly awkward Venus as the most
beautiful goddess by giving her the apple,
while Juno and Minerva, flanking
Mercury, look over their shoulders. The
main figure group is carved from amber,
set on a wooden socle encrusted with
amber panels. Some of the clear amber
panels have been carved on the reverse
with landscapes or floral designs, and
then placed over gold-coloured foil. This
combination of materials gives an exotic
shimmering effect not unlike oriental
lacquer work. The four main oval panels
are held in place by ivory-headed nails.
The shape of the base and signs of
previous fixings underneath suggest
that this piece once formed the
crowning group of an amber cabinet
or casket.

Amber is a fossilised
resin, and was highly
valued as a material
for small-scale
sculpture during
the seventeenth
and early

eighteenth centuries. Large deposits are
found along the Baltic coast, and centres
for amber carving evolved in this area,
notably at Königsberg (Kaliningrad) and
Danzig (Gdansk). Christoph

Maucher, who was based in Danzig,
worked in both amber and ivory, and
undertook commissions for the
Brandenburg court in Berlin and for
Emperor Leopold I in Vienna. (*MT*)

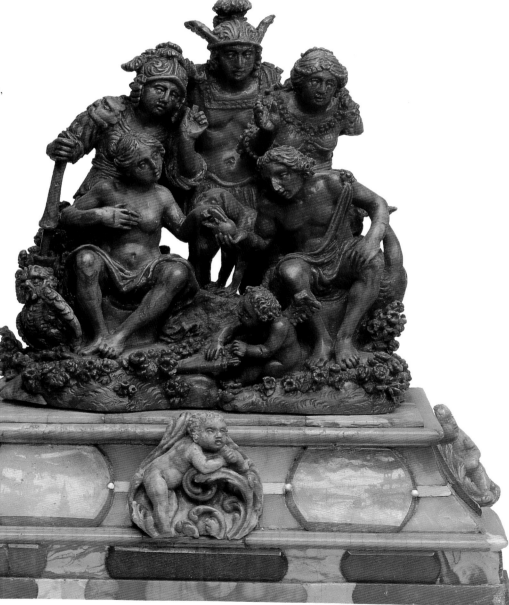

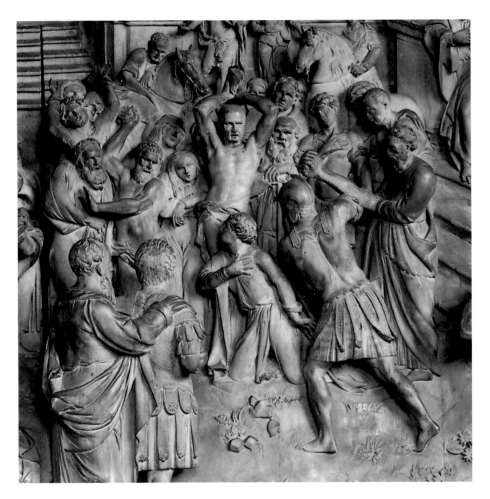

THE STONING OF ST STEPHEN
By Grinling Gibbons (1648–1721)
English; late seventeenth or early
eighteenth century
Limewood and lancewood (with some later
paint); h. 185 cm, w. 121 cm
446-1898

One of the most renowned sculptors in England during the second half of the seventeenth and early eighteenth centuries, Grinling Gibbons is famous for his intricate and fluent wood carving, of which this piece is an outstanding example. The subject is the stoning to death of the first Christian martyr, the scene shown in the centre foreground, but perhaps more dominant is the grand Italianate building rising up behind. Many of the diminutive figures are in classical poses and groupings, and although Gibbons never went to Rome himself, such elements show that he was familiar with both High Renaissance painting and antique sculpture.

Gibbons was actually born in Rotterdam, the son of an English merchant who had lived there for some years. The sculptor first came to England in 1667 at the age of 19, having almost certainly trained in one of the leading sculptors' workshops in the Netherlands, that of Artus Quellin in Amsterdam. His continental background helps explain the assured style and technical brilliance of this piece.

This panel was probably purchased by the Duke of Chandos at the sale of effects which took place in 1722 after Gibbons's death. It was at the Duke's seat, Canons in Middlesex, until the sale following its demolition in 1747, when it was bought by a Mr Gore; passing by descent through his family until 1839, it was in turn acquired by a Mr Rebow and taken to Wivenhoe Park near Colchester. It entered the Museum in 1898.
(*MT*)

THE JUDGEMENT OF SOLOMON

By Simon Troger (1683–1768)
South German (Munich); about
1741

Ivory, walnut and coloured glass; h. 122 cm,
w. 101.5 cm, d. 73 cm

1009-1873

The Judgement of Solomon was a subject
which both illustrated the wisdom of a
just ruler and allowed for a dramatic
scene with male and female figures.
According to the Biblical story, two
mothers went to Solomon to settle their
dispute. Each claimed that of two babies
– one alive and the other dead – the
living baby belonged to her. To
determine the truth, Solomon decreed
that the living baby should be cut into
two, and thus equally shared between the
two mothers; at this the real mother
revealed herself by renouncing her claim
to the child in order that its life might be
spared. Here the soldier on the left is
about to divide the living baby into two,
while the true mother kneels before
Solomon; the other mother points to her
dead baby. Solomon is enthroned under a
magnificent Baroque canopy, around
which angels hover, perhaps as part of the
decoration of the throne and canopy, or
perhaps intended as real angels endorsing
Solomon's wisdom. Another, even larger
version of this composition is in the
Museo Civico (the Palazzo Madama) in
Turin; that piece is signed and dated
1741, giving an approximate date for the
group here.

Simon Troger came originally from the
Tyrol; he worked in Meran and
Innsbruck, probably spending some time
in Italy, and from 1726 was based in
Munich. He specialised in figures and
groups made of ivory and wood in
combination, with inset glass eyes. The
technical accomplishment of this
imposing work epitomises the highly
sophisticated level of ivory and wood
carving in Germany at this date.
(*MT*)

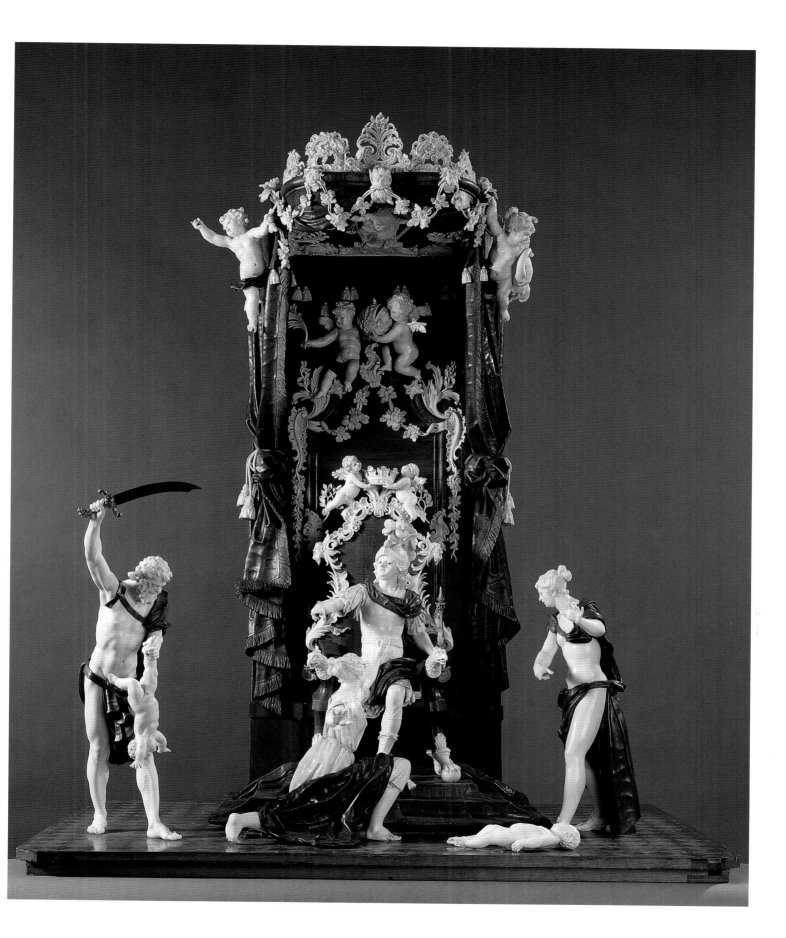

FROM 1720
TO 1920

Although the Museum's Collection of eighteenth- and nineteenth-century continental sculpture contains a representative sample of works by major artists, its holding of British sculpture is without parallel. To a great extent, the concerns of British sculptors and the wishes of their patrons were the same as those throughout Europe at this period, so that with the exception of religious commissions, generalisations about the circumstances of production hold good for England, France, Germany and the Netherlands. Northern European sculptors continued to travel to Italy for inspiration and the increasingly wealthy middle classes kept them fully employed with commissions for portraits and funeral monuments.

A great number of sculptors flourished in Britain in the eighteenth century, reflecting the good health of the economy as well as the desire of patrons to emulate monuments abroad. But although by the second half of the century these native-born sculptors were achieving renown, much of the work before 1750 was by immigrant continental artists, notably the Huguenot David Le Marchand, who trained in Dieppe, Louis-François Roubiliac, originally from Lyons, and John Michael Rysbrack, who came from Antwerp.

The two most common types of sculpture in Britain and elsewhere in Northern Europe in the eighteenth century were the portrait bust and

1. 'Poets' Corner', south transept, Westminster Abbey

2. The Sculpture Gallery at Woburn Abbey; engraving by Henry Moses after a drawing by J. G. Jackson, 1827 (from P. F. Robinson, *New Vitruvius Britannicus: A History of Woburn Abbey*, 1833)

the funeral monument, although there were occasions when the functions merged. Sometimes a bust made during a patron's lifetime would be installed as part of a commemorative monument after death, and conversely a copy of a posthumous bust erected on a tomb might be housed in the home of the deceased's family. As well as these two categories, sculpture of mythological, allegorical and historical subjects became more widespread for gardens and for interiors, especially at the great country houses of England, such as Stowe in Buckinghamshire and Wentworth Woodhouse in Yorkshire. Copies of classical statuary seen on the Grand Tour continued to be made – usually of lead, if they were to be placed outdoors, or plaster if indoors – but sculptors were now commissioned to make contemporary ideal works, such as Joseph Nollekens's Diana (page 163), although these were often also derived from classical prototypes.

Funerary monuments and even portrait busts could be expensive commissions, and aristocratic patronage was often vital if a sculptor was to be successful. By the 1730s, however, other patrons were emerging from the professional middle classes, such as James Gibbs the architect (page 155), and Jonathan Tyers the impresario (see page 158). In addition, writers, artists and composers were recognised and commemorated from this time, as epitomised by 'Poets' Corner' in Westminster Abbey, with its eighteenth-century monuments to Joseph Addison, David Garrick, George Frederick Handel and others (figure 1).

The dominant movement in European sculpture in the late eighteenth and early nineteenth centuries was Neo-classicism, a style which in sculpture is exemplified above all by the work of Antonio Canova (pages 168–71). Following the cessation of the Napoleonic Wars in 1815 more young artists than ever were able to travel to Rome. A community of sculptors, including of course Canova himself, was based there, and many patrons – especially the British – went to Italy, where they commissioned works from the resident artists to

be sent back to their homes. Sculpture galleries in country houses such as Petworth in Sussex, Chatsworth in Derbyshire and Woburn in Bedfordshire (page 170 and figure 2) were built in the early years of the nineteenth century for precisely this sort of acquisition, where the modern pieces were shown alongside classical marbles.

The Great Exhibition of 1851 in London was the first of a number of international exhibitions where three-dimensional work was shown, and sculptors thereby gained a large international audience. The purchasers of sculpture from the exhibitions included royalty and the aristocracy as usual, but the constituency for such works was ever-widening. French and Italian artists increasingly came to work in Britain during the nine-

teenth century, and Aimé-Jules Dalou in particular had an important – albeit brief – influence on British art students at the National Art Training School at South Kensington (later to become the Royal College of Art) between 1877 and 1880.

Towards the turn of the nineteenth century the work of Auguste Rodin had a tremendous impact on the work of his contemporaries, and countless French and British sculptors of the early years of the twentieth century were indebted to his freer style and deliberately incomplete or fragmented works (see page 178 and figure 3). This in turn prepared the way for the achievements of a new generation of British sculptors, foremost amongst them Henry Moore and Barbara Hepworth, and the subsequent rejection of the classical tradition. (*MT*)

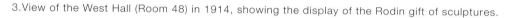
3.View of the West Hall (Room 48) in 1914, showing the display of the Rodin gift of sculptures.

MATTHEW RAPER

By David Le Marchand (1674–1726)
Anglo-French; signed and
dated 1720

Ivory; h. 20.1 cm, w. 15.7 cm

A.20-1959

It is unusual to find full-length portraits
in ivory, and this piece is additionally
exceptional in showing the young subject
in a library interior, his work table jutting
out, and bookshelves behind. Matthew
Raper (1705–78) was a gifted scholar,
here depicted demonstrating a
proposition in geometry; he later became
a Fellow of the Royal Society and the
author of a learned work on Greek and
Roman money. Matthew Raper's father
(also called Matthew), who presumably
ordered this portrait, was a silk merchant
who became Director of the Bank of
England in 1738. He commissioned other
works from Le Marchand, including a
bust of Newton in 1718, now in the
British Museum.

According to the incised inscription on
the back of this relief, the portrait was
carved from the life. The inscription
reads: 'Eff. Mathei RAPER juni. AEtat
suae 15° An. ad viu. Scul. D.L.M. 1720'
('The image of Matthew Raper the
Younger at the age of 15. Sculpted from
the life DLM 1720'). David Le Marchand
was a Huguenot originally from Dieppe.
It is not known when he initially came to
Britain, although he is first recorded
working as an ivory carver in Edinburgh
in 1696. He became one of the greatest
exponents of ivory carving in Britain,
specialising in relief portraits.

The Museum also possesses two other
works associated with the Raper family: a
silver medal with an inscription recording
that it had been presented to Matthew

Raper as a christening gift on his first
birthday from his uncle in 1706, and a
glass paste medallion by James Tassie of
Matthew Raper Senior, based on a lost
ivory portrait relief by Le Marchand.
(*MT*)

THE ARCHITECT JAMES GIBBS

By John Michael Rysbrack
(1694–1770)
Anglo-Flemish; signed and
dated 1726

Marble; h. (with original socle) 67.2 cm

A.6-1988; purchased with contributions from
the National Heritage Memorial Fund and
the National Art Collections Fund (Eugene
Cremetti Fund)

This portrait of the leading British architect of the early eighteenth century by the country's most distinguished contemporary sculptor was carved at a time when Rysbrack was working closely with James Gibbs (1682–1754) on a number of ambitious church monuments. The artists were living near each other on the estate north of Oxford Street owned by their common patron, Edward Harley, 2nd Earl of Oxford, by whom this bust may have been commissioned. Few portrait busts were commissioned in England before about 1730, and this is one of those exceptional pieces which were to prompt English patrons to commission further sculpted portraits in large numbers from that date onwards. It therefore occupies an important place in the development of one of the richest forms of eighteenth-century English art.

Rysbrack originated from Antwerp and came to London in 1720. He seems to have collaborated with Gibbs, whose reputation was already firmly established, soon after his arrival. Their contemporary George Vertue recorded that Gibbs, 'from the time of his [Rysbrack's] first comeing to England almost has much imployd him'. Rysbrack became one of the leading sculptors of his time in England, rivalled only by his slightly younger contemporary Roubiliac (page 158).

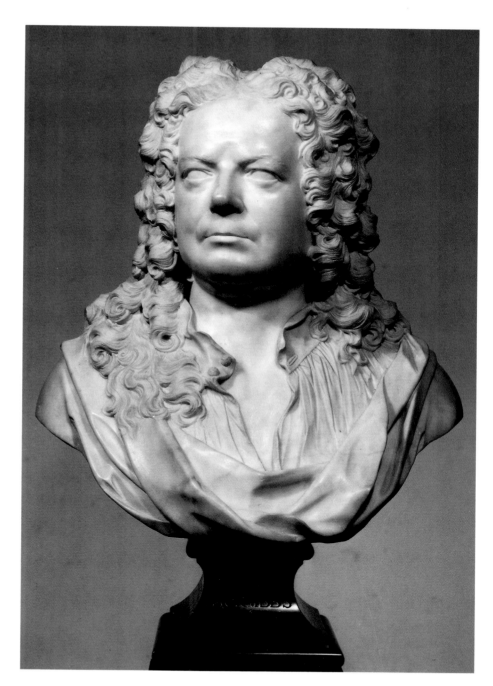

One of the early owners of this bust was probably George Bubbs Dodington, whose collection was sold in 1783; it is known to have been acquired by Horace Walpole by 1784 and was displayed at Strawberry Hill. It was sold at the Strawberry Hill Sale in 1842, and later on in the nineteenth century was presented to the Gibbs-designed church of St Martin-in-the-Fields; the Museum purchased it from the Parish of St Martin-in-the-Fields in 1988. (*MT*)

THUNER

By John Michael Rysbrack
(1694 –1770)
Anglo-Flemish; about 1726 – 30
Portland stone; h. 165.1 cm, w. (of base)
90.8 cm
A.10-1985; purchased with the assistance of
the National Art Collections Fund

Thuner was one of seven statues of Saxon
deities, each associated with a day of the
week, executed by Rysbrack for Lord
Cobham's garden at Stowe in
Buckinghamshire. The garden at Stowe,
now owned by the National Trust, is an
outstanding example of eighteenth-
century landscape gardening, peopled by
statues and adorned with temples, lakes,
groves and valleys. The Saxon gods were
commissioned during the first phase of
Lord Cobham's improvement
programme, and formed an integral part
of the Whig political iconography
propounded through the garden. They
were originally placed round an altar in an
open grove, known as the Saxon temple;
by 1744 they were set in the Gothic
Temple designed by James Gibbs (see
page 155) and by 1773 they had moved
again, to stand in a grove nearby.

All the works of art and other
furnishings from the house were
dispersed in two sales held at Stowe in
1848 and 1921. The Saxon gods were sold
as separate lots in the latter sale, and
Thuner re-appeared on the London art
market in 1984 after over 60 years in a
Hampshire garden; the Museum acquired
it the following year. (*MT*)

MODEL FOR THE MONUMENT TO THE DUKE OF ARGYLL

By Louis-François Roubiliac
(1702/5 –1762)
Anglo-French; signed and dated
1745

Terracotta; h. 89.5 cm, w. 50.2 cm
21-1888

This is one of the most important of the extensive collection of sculptors' models in the Museum. It was made in connection with Roubiliac's monument to John, 2nd Duke of Argyll and Greenwich (d.1743) in the south transept of Westminster Abbey. This sketch, which differs from the finished monument in some respects, must have formed part of the contract for the commission between the widowed Duchess of Argyll and Roubiliac: it is prominently and fully signed and dated, and the scale at the bottom was almost certainly used to make a full-scale plaster model which the monument would have copied. The Duke is shown reclining against the allegorical figure of Fame, who is writing an inscription which breaks off in the middle, as the title became extinct on the Duke's death. Below, *Eloquence* and *Pallas* exemplify the Duke's oratorical and military achievements. His contemporary Alexander Pope spoke of him as 'destined to share alike the Senate & the Field'. The Duke served under Marlborough in Flanders, and later helped to ensure Scotland resisted Jacobite plotting.

The finished memorial was Roubiliac's first major monument, and added greatly to his growing reputation. George Vertue wrote soon after its erection that it outshone 'for nobleness & skill all those before done, by the best sculptors, this fifty years past'. The dramatic figure of

Eloquence stepping forward received the greatest praise, and was later admired by Canova during his visit to London in 1815. (*MT*)

GEORGE FREDERICK HANDEL

By Louis-François Roubiliac
(1702/5–1762)
Anglo-French; 1738

Marble; h. 135.3 cm

A.3-1965; purchased with the assistance of the
National Art Collections Fund

Roubiliac's *Handel* was commissioned by
the impresario Jonathan Tyers for his
pleasure gardens at Vauxhall. The
composer George Frederick Handel
(1685–1759) is shown in the guise of
Orpheus, holding Apollo's lyre. Yet
despite the classical allusion, he wears
informal contemporary dress: a soft cap, a
long shirt open at the neck, a full loose
gown, and slippers, one of which has
been discarded and lies beneath his right
foot. His pose too is casual, being seated
cross-legged, and leaning his elbow on a
pile of bound scores of his works; this
includes *Alexander's Feast*, completed the
same month as the statue was finished.
The statue was unprecedented, not only
because the sitter was portrayed with
such startling informality, but because it
was the first life-size marble depicting a
living artist; such public statues were
until this date erected only for monarchs,
noblemen or military leaders.

Roubiliac was a French sculptor –
originally from Lyons – who had trained
in Dresden, but all his known surviving
work was executed in England. He was
here by 1735, and *Handel* (which is signed
at the back) is his earliest known
independent work. Its originality and
accessibility – in the sense both of its
being in a public setting, and easy to
appreciate, since it was of a famous
contemporary – helped establish
Roubiliac as one of the leading sculptors
in England.

The figure remained in the Vauxhall
Pleasure Gardens for nearly 80 years until
about 1813, when it was removed by a
descendant of Jonathan Tyers and
eventually bought by the Sacred
Harmonic Society. It was then acquired
by the music publishers Novello and
Company in about 1900, who sold it to
the Museum in 1965.

(*MT*)

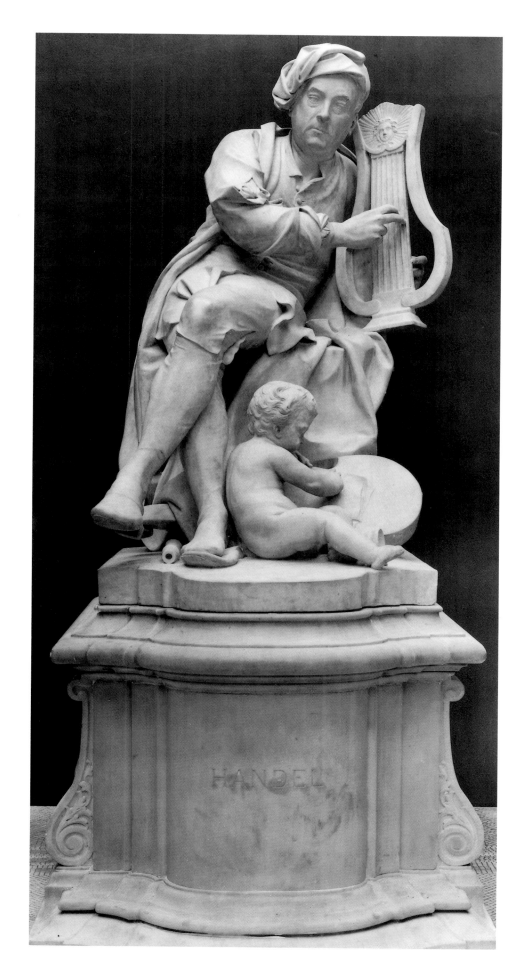

JOSHUA WARD

By Agostino Carlini (c.1718–90)
Anglo-Italian; about 1761–64

Marble; h. 213 cm

A.2-1991; purchased with the assistance of
funds from the Bequest of Hugh Phillips Esq.

Joshua Ward (1685–1761) was a renowned quack-doctor who manufactured and sold patent medicines known as 'Ward's Drop and Pill'. Although this statue may have been intended as part of a monument to him to be erected in Westminster Abbey, the project was never brought to fruition. Writing a biographical sketch of the sculptor some 60 years after the figure was carved, J.T. Smith noted in 1828 that Ward

employed his old friend Carlini ... to produce a statue of him, as large as life, in his usual dress and pompous wig; and in order to make the statue talked of, and seen at the Sculptor's studio, he proposed to allow Carlini two hundred guineas per annum, to enable him to work at it occasionally till it was finished; and this sum the Artist continued annually to receive till his death.

Whether Carlini did indeed receive this large annuity is not known, but the story indicates that Ward's desire for publicity during his lifetime was perhaps another motive behind the commission.

Agostino Carlini was renowned for 'the skill and grace with which he executed drapery'. Here, Ward's voluminous cloak and half-unbuttoned waistcoat, his stance and outstretched hand have an assurance and Baroque movement reflecting Carlini's virtuoso handling of marble. Nothing is known of the sculptor's early life or training, but he was apparently a native of Genoa and he almost certainly trained in Italy. All his known works, of which this is the first, were executed in England. He was a founder member of the Royal Academy in 1768, and became Keeper in 1783. His other principal sculptures include a bust of George III, now in the Royal Academy, a number of church monuments and some of the architectural sculpture for the north front of Somerset House.

The statue was not included in the sale of Carlini's studio contents after his death, and it is unclear where it was housed in the years following Ward's demise. In 1793 however, three years after Carlini had died, one of Ward's original executors, his great-nephew Ralph Ward, presented it to the Society for the Encouragement of Arts, Manufactures and Commerce (the Royal Society of Arts). It was purchased by the Museum from the Society in 1991. (*MT*)

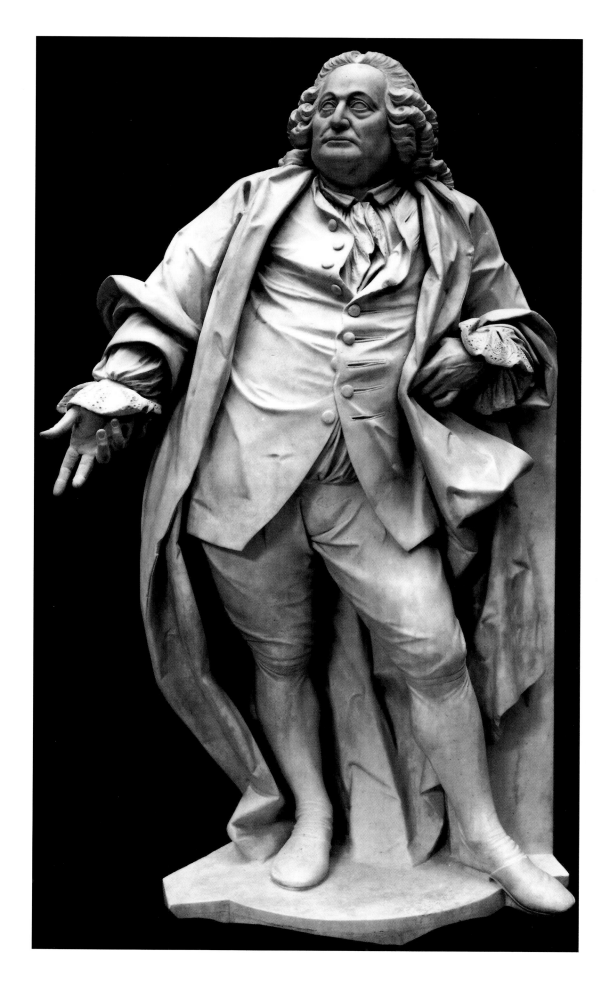

THETIS DIPPING ACHILLES IN THE RIVER STYX

By Thomas Banks (1735 – 1805)
English; about 1788

Marble; h. 85.4 cm, l. 97.8 cm

A.101-1937; given by Mr C.F. Bell

The subject is taken from Homer's *Iliad*. The sea nymph Thetis dips her son Achilles in the River Styx to ensure his immortality; she holds him by the right heel, which does not enter the water, and through which he was eventually to be wounded and killed. The base of the group is decorated with monsters from the Styx fighting one another. This marble group was commissioned by Colonel Thomas Johnes of Hafod, one of Banks's best patrons, and the heads of the two figures are those of Johnes's wife and infant daughter. It was exhibited at the Royal Academy in 1790. For a heroic group it is on a relatively small scale, comparable with contemporary French academic sculpture.

Thomas Banks trained in London, but in 1772 gained a travelling studentship to Rome from the Royal Academy; by then he had married into money, and was able to stay in Rome for seven years. He was greatly admired by his contemporaries, Reynolds regarding him as 'the first British sculptor who had produced works of classic grace', and whose 'mind was ever dwelling on subjects worthy of an ancient Greek'.

Colonel Johnes installed the group at Hafod in Mid-Glamorgan, where it escaped a disastrous fire in 1807, and it was later bought with the house by the Duke of Newcastle in 1833. It remained in his family until 1937, when it was bought by Charles Bell, a descendant of the artist, who presented it to the Museum. (*MT*)

DIANA

By Joseph Nollekens (1737–1823)
English; signed and dated 1778

Marble; h. 94 cm

A.5-1986

The marble statue of Diana the Huntress was intended for the sculpture gallery at the 2nd Marquess of Rockingham's country seat, Wentworth Woodhouse in Yorkshire, but seems not to have been taken there until after his death in 1782 and was never actually displayed. Diana is shown in the act of shooting her bow. Her dramatic pose, running forward and twisting her head round to take aim, is actually derived from an early seventeenth-century bronze statuette of Cupid, of which Nollekens made four drawings.

Joseph Nollekens was one of the most successful sculptors in England in the late eighteenth and early nineteenth centuries, particularly of portrait busts and church monuments. This figure is unusual in being an ideal work intended for a sculpture gallery, a new type of setting for sculpture in England probably partly inspired by the displays of antique marbles in Rome. Nollekens had spent the 1760s in Rome, where he had not only studied ancient sculpture but had also built up his own reputation as an artist, acquiring a number of English patrons such as Charles Townley and Lord Yarborough. On his return to England he became the leading sculptor in London, and was quickly overwhelmed with commissions. One of his former studio assistants, J.T. Smith, was to write

a vituperative biography of the sculptor after his death, in which he condemned him as a miser, ridiculing his odd personal habits and the squalor in which he lived.

However he admitted that Nollekens worked exceptionally hard, and that his portrait busts in particular were unrivalled. (*MT*)

163

SELF-PORTRAIT OF JOHN FLAXMAN

By John Flaxman (1755 – 1826)
English; signed and dated 1778

Terracotta; diam. 18.7 cm

294-1864

This self-portrait is a youthful image of John Flaxman, one of the most important English sculptors of his time. The Latin inscription around the rim identifies Flaxman as the artist, and can be translated as follows: 'John Flaxman the Younger, artist, sculptor and craftsman, a pupil of the Royal Academy, at the age of 24 made this image of himself in the year 1778' (in fact Flaxman could only have been 22 or 23 in 1778). The image corresponds to a later description of Flaxman by Allan Cunningham, a friend and writer: '... His forehead was fine: his large eyes seemed to emit light while he spoke: and the uncommon sweetness of his smile softened a certain proud expression of his mouth and some coarseness of physiognomy'. The relief was exhibited at the Royal Academy in 1779, and by 1789 was in Naples, in the possession of the scholar and collector Sir William Hamilton, who is known to have been in contact with Flaxman when the artist was in Italy.

John Flaxman was the son of a sculptor, and having trained at the Royal Academy Schools, joined his father in 1775 in working for Josiah Wedgwood, for whom he provided models for cameos, ceramic friezes and portrait medallions. In 1787 Flaxman went to Rome, where he was to stay for seven years, although he continued to carry out commissions for monuments in England. Flaxman is also famed as a designer of engravings, and during these years made illustrations for the works of Homer, Dante and Aeschylus. When he returned to England in 1794 he devoted himself primarily to sculpting church monuments, and produced comparatively few portrait busts and statues. In 1810 he was elected Professor of Sculpture at the Royal Academy, and delivered a series of lectures which were published after his death. A good number of Flaxman's plaster models for monuments survive, and many of these were presented to University College London in 1851 by his sister-in-law, who was the beneficiary of his will.

(*MT*)

THE MARQUIS DE MIROMESNIL
By Jean-Antoine Houdon
(1741–1828)
French; signed and dated 1775
Marble; h. 87.1 cm
A.19-1963; purchased under the Bequest of
Captain H.B. Murray

Armand-Thomas Hue de Miromesnil
(1723–96) is shown in the robes of a
magistrate, so the bust probably
commemorates his appointment as *Garde
des sceaux* (Minister of Justice). Despite
the official dress and wig, the portrait is
highly individualised – the sitter's eyes
looking to his left, the face animated – as
if he were about to speak. The bust was
exhibited in the Salon of 1775, and
another marble version dated 1777 is in
the Frick Collection in New York.

Jean-Antoine Houdon was unrivalled as
a portrait-sculptor in France in the late
eighteenth century. His subjects included
his fellow-countrymen Voltaire, Rousseau
and Diderot, and the eminent
contemporary Americans Franklin,
Jefferson and Washington. Houdon was
not from a family of artists, but because
his father was the caretaker of a building
where the élite students of the Académie
Royale were preparing to take up the *Prix
de Rome*, he grew up surrounded by
artists, and himself enrolled as a student
at the Académie in 1756; he won a
scholarship to Rome in 1764, returning to
Paris in 1768. From that date onwards he
regularly exhibited at the Salon. Although
specialising in acutely observed portrait
busts, he also executed monuments and
some ideal figures, such as the famous

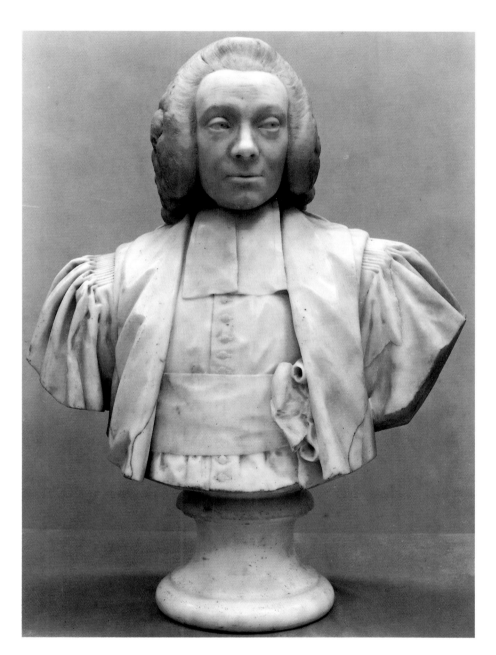

Diana, versions of which are in the
Gulbenkian Museum in Lisbon, the
Huntington Collection in San Marino,
California, and the Frick Collection. (*MT*)

CUPID AND PSYCHE

By Claude Michel, called Clodion
(1738–1814)
French; about 1797–1800

Terracotta, signed; h. 59 cm

A.23-1958; given by Sir Chester Beatty

Clodion is particularly renowned for his handling of terracotta, a material which he used for finished works rather than models, although he also worked in marble. Here the swooning Psyche is taken by Cupid, assisted by putti, above the clouds. The episode derives from classical legend, and is presumably an allegory of the Soul's search for union with Desire.

Clodion trained in Paris under his uncle Lambert-Sigisbert Adam and, after Adam's death in 1759, with Jean-Baptiste Pigalle. In 1762 the sculptor won the *Prix de Rome* from the Académie Royale. In the event he stayed in Italy for nine years, only returning when he was ordered back to Paris in 1771 by the *Directeur des Bâtiments du Roi* (the Surveyor of the King's Buildings), for the King expected winners of the prize to return after three or four years to work for the Crown. On his arrival in Paris Clodion found his works, both small terracottas and large monuments, to be in great demand. His workshop produced decorative reliefs and statues for the interiors of the aristocratic houses of Paris, but such commissions diminished with the coming of the Revolution, and Clodion left the capital for his home town of Nancy in Lorraine in 1794. He went back to Paris in 1797, however, and after this time produced a number of highly accomplished terracotta groups, such as the present example. He may have decided to specialise in these pieces partly to win new patrons under Napoleon. A group listed as an *Enlèvement de Psyche* ('The Taking of Psyche') was included in the sale of Clodion's effects after his death, and was described by his executor as 'admirable in its composition and execution'. The version now in the Museum may be that group, although another contemporary example also survives. (*MT*)

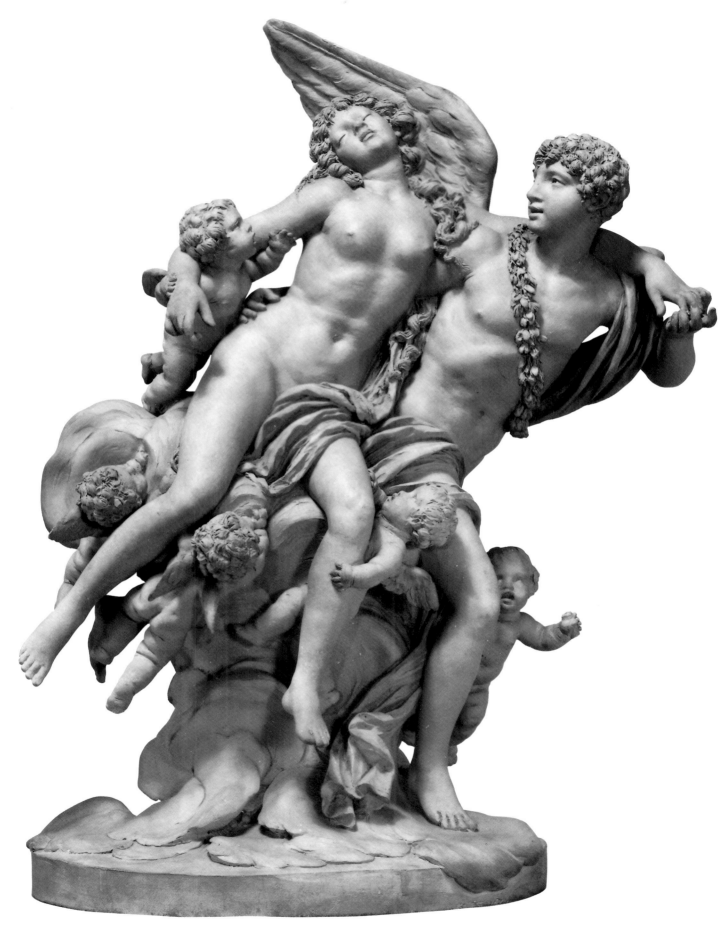

THESEUS AND THE MINOTAUR

By Antonio Canova (1757–1822)
Italian (Rome); 1782

Marble; h. 145.4 cm, l. 158.7 cm, w. 91.4 cm

A.5-1962; purchased with the assistance of the
National Art Collections Fund

Theseus is shown seated triumphant on
the body of the dead minotaur, half-man
and half-bull. Coils of the thread which
enabled Theseus to escape from the
labyrinth are visible by the minotaur's left
leg. This is the first major work the young
Canova undertook. In 1780 he had settled
in Rome, where he lived at the expense
of his patron, Girolamo Zulian, the
Venetian ambassador. Zulian
commissioned him to execute a statue,
giving him a marble block and allowing
him free choice of subject: Canova chose
the scene from Ovid's *Metamorphoses*,
which he had read in translation. His
friend the painter Gavin Hamilton, who
was also living in Rome, apparently
advised him to represent Theseus and
the Minotaur after their struggle was
finished, as his reputation would gain
more from a static group than from one
showing violent movement.

By the time the sculpture was
completed in 1782, Zulian had been
transferred to Constantinople, and gave
the group to Canova. He soon sold it to
Josef Johann Graf Fries, who transported
it to Vienna. It was acquired there by the
Marquess of Londonderry and probably
installed in Londonderry House at Hyde
Park Corner in the 1820s. The Museum
was able to buy the piece shortly before
the house was demolished in 1962.

Antonio Canova was considered by his
contemporaries to be the greatest living
artist. After training under a local sculptor
at his birthplace, Possagno, and then in
Venice, he went at the age of 23 to Rome.
Here he studied the Antique to create a
new style of revolutionary severity and
idealistic purity. He was invited to the
courts of Russia, Austria and France, but
said he could work only in Rome –
although many of his patrons were from
elsewhere in Europe and America. His
work was particularly prized for the
surface finish of the marble, as well as for
his understanding of the importance of
multiple viewpoints, and gained
unprecedented international popularity.
(*MT*)

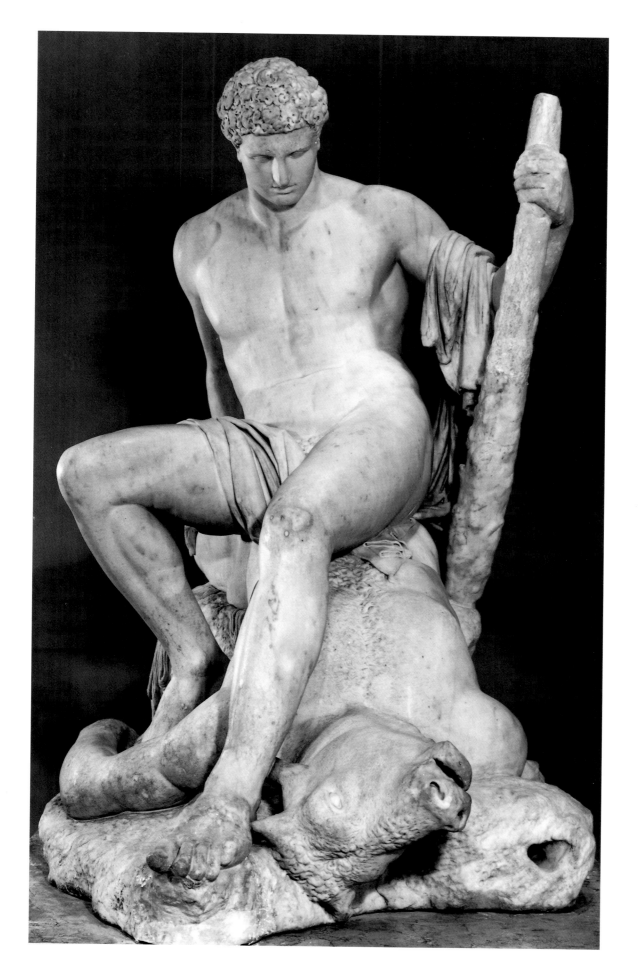

THE THREE GRACES

By Antonio Canova (1757–1822)
Italian (Rome); 1814–17

Marble; h. 173 cm

A.4-1994; purchased jointly with the National
Galleries of Scotland, with the assistance of the
National Heritage Memorial Fund, the National
Art Collections Fund, and with donations from
John Paul Getty II, Baron Hans Heinrich
Thyssen-Bornemisza and public subscription

The Three Graces, celebrated in classical literature and art, were daughters of Zeus and companions to the Muses. Thalia (youth and beauty) is accompanied by Euphrosyne (mirth) and Aglaia (elegance). This group is one of two marbles of the subject executed by Canova while at the height of his fame. In 1812 the Empress Josephine had commissioned a version, which was nearly completed at the time of her death in 1814. John Russell, 6th Duke of Bedford, offered to buy the group when he saw it at the sculptor's studio in Rome, but Josephine's son claimed it, and this piece is now in the Hermitage in St Petersburg. Canova agreed to carve a second version with variations for the Duke, and worked on it from 1814 to 1817. It had arrived at Woburn Abbey by 1819, and was there placed in the specially constructed Temple of the Graces at one end of the Duke's sculpture gallery.

The group descended through the family of the Dukes of Bedford until it was sold in 1985. Following a long fund-raising campaign it was purchased jointly by the Victoria and Albert Museum and the National Galleries of Scotland in 1994 and will be displayed alternately at the two institutions. (*MT*)

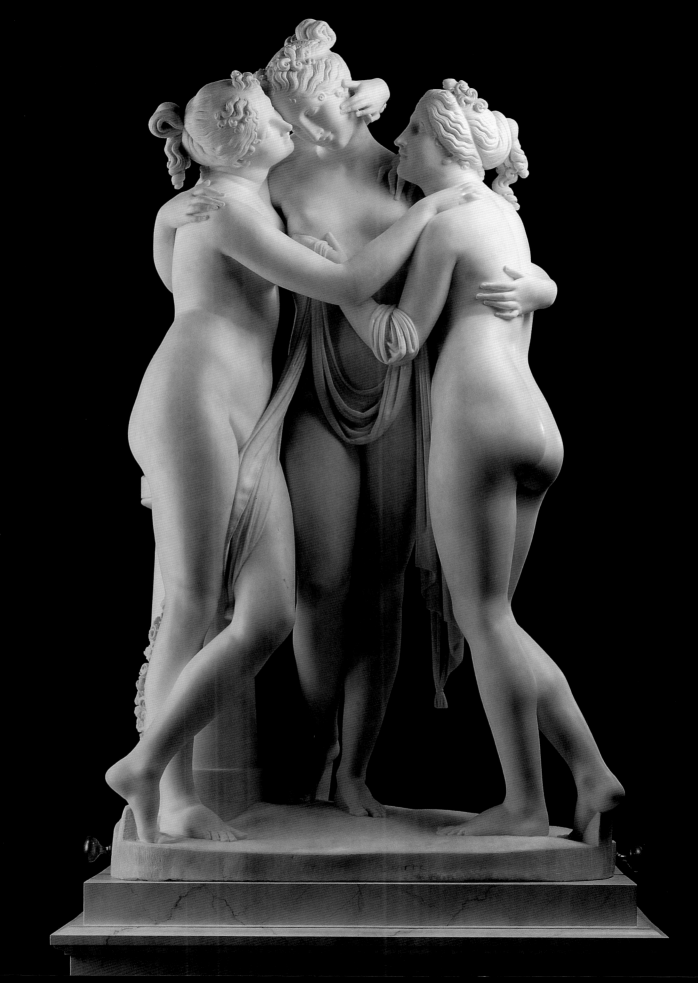

THE DEATH OF VOLTAIRE

By Samuel Percy (1750–1820)
English; late eighteenth or early
nineteenth century

Coloured wax, signed; h. (including frame) 49
cm, w. 55.5 cm

A.19-1932; given by Miss J.M. Duncombe

The *tableau* portrays the discovery by a
member of his household of the
philosopher and writer Voltaire
(1694–1778) on his death-bed. Voltaire
lies in a pose of physical abandonment,
eyes rolled upwards, mouth agape and
hands limp, on his draped and canopied
bed, and the elderly woman approaches
with the first gesture of shock and sorrow
– her hands held up and out before her.
The room is left bare of any decorations
except those of the bed hangings and
linen and of the garments of the two
figures. Drama is thus concentrated on
the central scene.

The wax modeller Samuel Percy was
born in Dublin but settled and worked in
London. He executed many portraits of
his contemporaries in both public and
private life together with *tableaux* of rustic
life. He developed techniques for the
realistic representation of flesh, jewels
and different fabrics which set his work
apart from that of other wax modellers of
the time. The subject for Percy's *Death of
Voltaire* appears to derive from a similar
wax group attributed to the Swiss
modeller Philippe Curtius (1737–94)
which exists in several versions and
includes a third, younger female figure.
Similarities between the two
compositions are many, but equally

striking are the differences. Curtius
worked in Paris before and after the
French Revolution with his niece – the
future Madame Tussaud. His version of
the scene is dramatic in pose and gesture
but lacks fine detail and expressiveness.
Percy's, in comparison, is a virtuoso piece
of wax modelling. Dispensing with
Curtius's third figure, he concentrates the
drama and poignancy of the scene
between two figures and displays some of
his finest work in the treatment of flesh
and fabrics, in particular the lace cap and
dress trimmings of the lady, her face, arms
and hands.

The Museum's collection of waxes is
second to none, ranging in date from the
Renaissance to the twentieth century, and
was augmented in 1996 by the bequest of
part of the collection of the late E.J.
Pyke, the pre-eminent authority on the
subject.

(*LC*)

PANDORA

By John Gibson (1790–1866)
British; about 1856

Marble; h. 172.7 cm

A.3-1922; given by Mrs Penn

John Gibson was born in Wales and originally trained in Liverpool, but in 1817 he left Britain for Rome, where he was to spend virtually the rest of his life. He greatly admired the Neo-classical sculpture of Antonio Canova, as well as the work of the Danish sculptor Bertel Thorwaldsen. Both these artists were established in Rome at the time of Gibson's arrival, and gave him advice and assistance. Gibson settled there as a sculptor, while nevertheless continuing to exhibit work at the Royal Academy in London, being elected a Royal Academician in 1838. During the late eighteenth and early nineteenth centuries many British artists lived in Rome, and visiting dignitaries on the Grand Tour often commissioned or bought works from them there.

The *Pandora* epitomises Gibson's Neo-classical purity of style. The classical subject, posture and dress, as well as the smooth surface of the marble are all typical of his work, and reveal his indebtedness to Canova and Thorwaldsen. Pandora is about to open the box, which according to the Greek myth released the sorrows of the world. The gravity of her expression seems to express a foreboding of what she is about to do. Gibson made more than one version of this sculpture; the Museum's example – signed 'IOANNES GIBSON ME FECIT ROMAE' – was given by a Mrs Penn, and it must therefore be the one formerly owned by a '—- Penn Esq', mentioned in a biography of Gibson by Lady Eastlake in 1870. Another is at the Lady Lever Art Gallery at Port Sunlight on Merseyside. (*MT*)

THE SLEEP OF SORROW AND THE DREAM OF JOY

By Raffaelle Monti (1818 – 81)
Italian; signed and dated 1861

Marble; h. 175.3 cm

A.3-1964

This group was acclaimed by contemporary critics as one of the masterpieces of the 1862 International Exhibition held in London. Raffaelle Monti, a Milanese exile in London since 1848, carved it as a poignant political allegory on the foundation of the new Kingdom of Italy in March 1861. The sleeping figure represents Italy just emerged from Austrian domination: above her roses bloom and a veiled figure symbolising her dream of the future united country rises upwards.

The Sleep of Sorrow and the Dream of Joy is the culmination of Monti's work as a sculptor of large ideal marble statues which established his reputation in England; after the 1860s he concentrated on designs for reproduction in silver, Parian porcelain and bronze. This group is one of great technical virtuosity, and is remarkable for two features in particular: the veiled face of the rising figure, and the illusion of weightlessness as she appears to float upwards. The representation of veiled women became a hallmark of Monti's work and derives from a tradition in Venetian eighteenth-century sculpture, exemplified by the sculptor Antonio Corradini (1668–1752). The illusion of unsupported movement is indicative of the stylistic development away from Neo-classicism towards a re-assimilation of the Baroque and, more specifically, the work of Bernini, whose *Apollo and Daphne* in the Galleria Borghese in Rome was one of the main sources of inspiration for Monti's group. (*AK*)

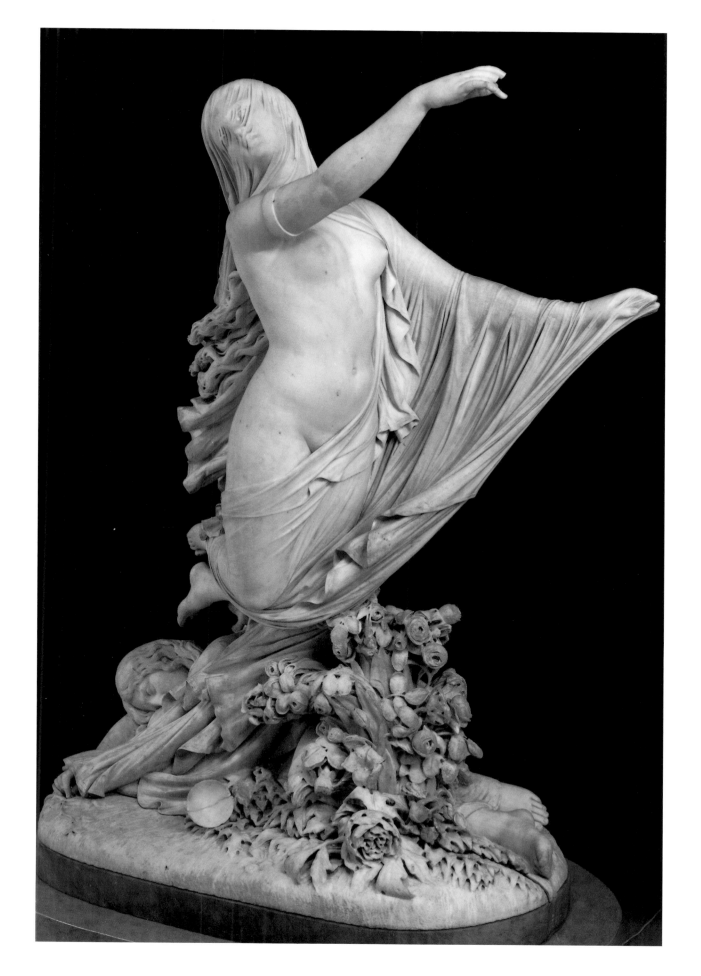

VALOUR AND COWARDICE
By Alfred Stevens (1817–75)
English; about 1866
(designed 1857)

Plaster; h. 236 cm

321B-1878

This is a full-scale model for one of the bronze groups on the monument to the Duke of Wellington in St Paul's Cathedral, designed by Stevens in 1857. The Duke of Wellington had died in 1852, and soon afterwards it was decided that he should be commemorated as a hero by a monument in St Paul's, to be paid for by the nation. The selection of the sculptor became a long process, however, and only after two competitions was the relatively unknown Alfred Stevens given the commission. Having made a reduced model for the competition (now also in the Museum, 44-1878), Stevens then agreed to submit a full-size plaster model, although this was not completed until nearly ten years later in 1866. The present group is from this large model, which closely resembles the finished monument, comprising an architectural structure reminiscent of a

triumphal arch, with the bier of the Duke beneath, and his equestrian portrait surmounting it. The allegorical group of *Valour and Cowardice*, and another representing *Truth and Falsehood* (also in the Museum, 321A-1878) were placed at either side.

As well as illustrating part of the sculptor's process in designing and constructing a large monument, this plaster model vividly embodies Stevens's remarkable powers as an artist, calling to mind Italian High Renaissance sculpture, especially that of Michelangelo. Stevens was the son of a house and sign painter in Dorset, but in 1833 the local parson noticed his talent and sent him to study in Italy, where he remained until 1847, at one time becoming the pupil of Bertel Thorwaldsen. On his return he became a teacher at the Government School of Design at Somerset House, and later undertook a variety of work, including designing medals and fittings for stoves. His monument to Wellington was his supreme achievement, although the finished work was not installed in St Paul's until 1912, many years after the sculptor's death. (*MT*)

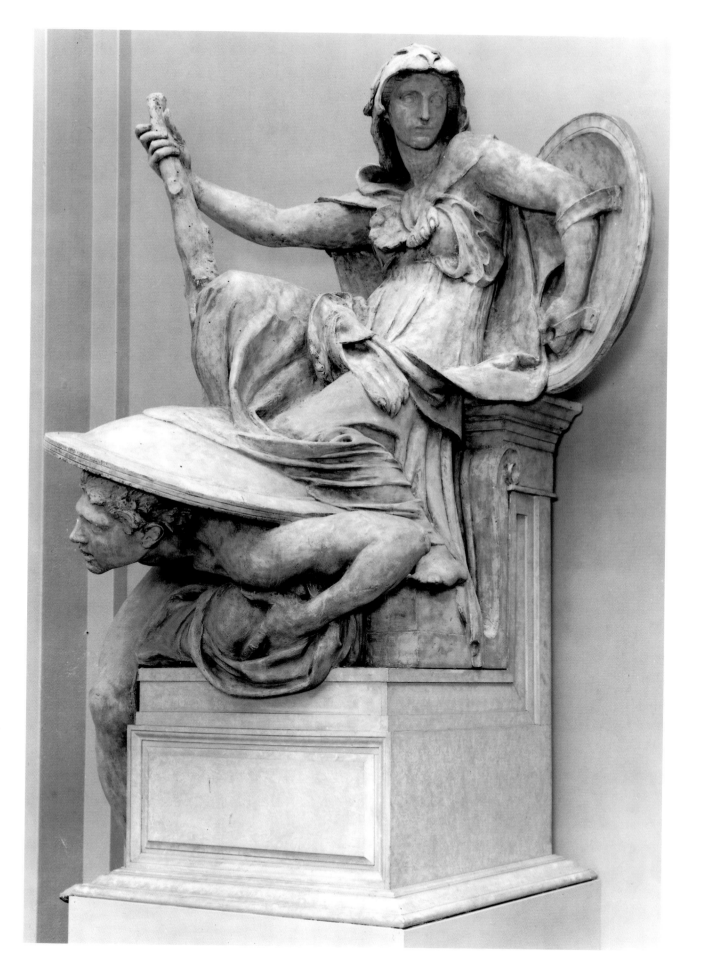

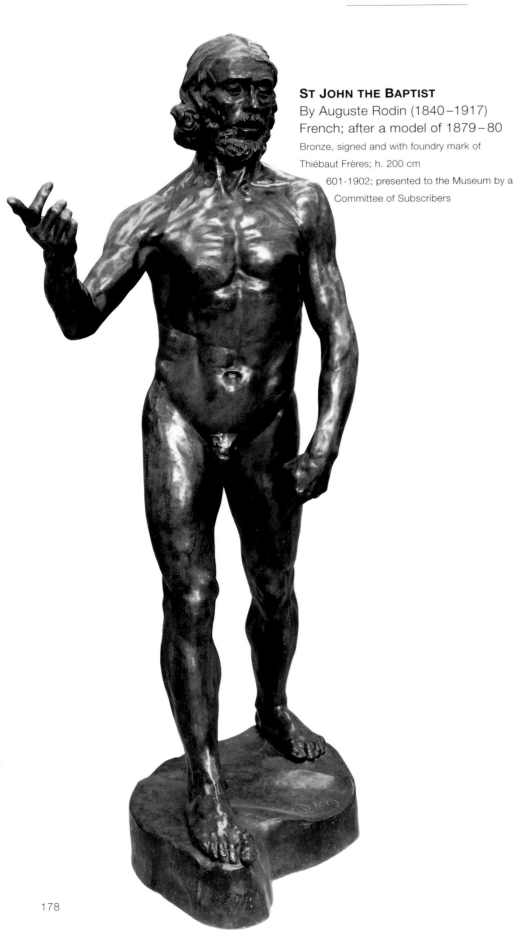

ST JOHN THE BAPTIST

By Auguste Rodin (1840–1917)
French; after a model of 1879–80

Bronze, signed and with foundry mark of
Thiébaut Frères; h. 200 cm

601-1902; presented to the Museum by a
Committee of Subscribers

St John the Baptist is Rodin's second large bronze figure study. Begun in 1878, the head was exhibited independently in the Paris Salon of 1879, followed by the whole figure in plaster in 1880 (with a cross, later abandoned) and in bronze the following year. It was acquired by the state in 1884 for the Luxembourg Gardens. An early model for the figure, lacking the head and arms, was later exhibited as the *Walking Man*.

To counteract the damning criticism of casting from the live model which surrounded his first figure, *The Age of Bronze*, the figure of *St John the Baptist* was made slightly over life-size. Rodin did not set out to make a religious subject, but the naturally awkward yet forceful pose of his untrained model, an Italian peasant from the Abruzzi named Pignatelli (the head was taken from a separate model), suggested to him a raw mystical character appropriate to the Baptist. This bronze, the first work by Rodin to enter an English public collection, was presented to the Museum in 1902 by a committee of the sculptor's supporters who had set up a subscription to acquire one of his pieces for the nation. To acknowledge the successful campaign Rodin was invited to a celebration at the Café Royal, after which students from the Slade and South Kensington Art Schools pulled Rodin's carriage through the streets of London in homage to the artist. *St John the Baptist* thus became the official symbol of Rodin's dominant influence on establishment sculpture of the early twentieth century. The Museum's collection of Rodin's sculpture was later substantially increased by the gift of 18 works from the artist himself in 1914 (see pages 19 and 153). (*AK*)

PRIMAVERA

By Richard Garbe (1867–1957)

English; signed and dated 1926

Ivory, mounted on wood painted gold; h. 105 cm

Circ.592-1976; given by Mr F.A. Palmer on behalf

of Arthur George Palmer

Primavera (Spring) is probably Garbe's most ambitious work in ivory. It combines free-standing figures with low reliefs, pierced panels and architectural elements. In the centre the semi-clad Flora, holding a bunch of flowers, is flanked by two smaller figures on slender columns of a man with a lute and a woman singing. At the top, in high relief, the personification of the Sun is shown emerging through clouds above a frieze of naked boys carrying flowers. At the bottom two reliefs depict, on the left, Zephyr (the west wind of Spring) pursuing Flora and, on the right, a shepherd listening to Pan perched in a tree. The ensemble is completed by pierced and low relief decoration of animals in foliate scrollwork and a gold painted background.

By the early twentieth century the art of ivory carving was held in low esteem, the *Studio* magazine in 1906 considering it suitable only for 'billiard balls, false teeth and cutlery'. Garbe was instrumental in reviving the use of the material for both decorative objects and independent sculptures. From around 1924 his ivory sculptures were regularly exhibited at the Royal Academy, *Primavera* being shown there in 1926. These works contributed to the gradual acceptance in establishment circles of direct carving and truth to materials, aims associated with the Modern Movement. Garbe taught at the Central School between 1901 and 1929 and at the Royal College of Art from 1929 to 1946, and his versatile style and technique were influential on many younger sculptors. (*AK*)

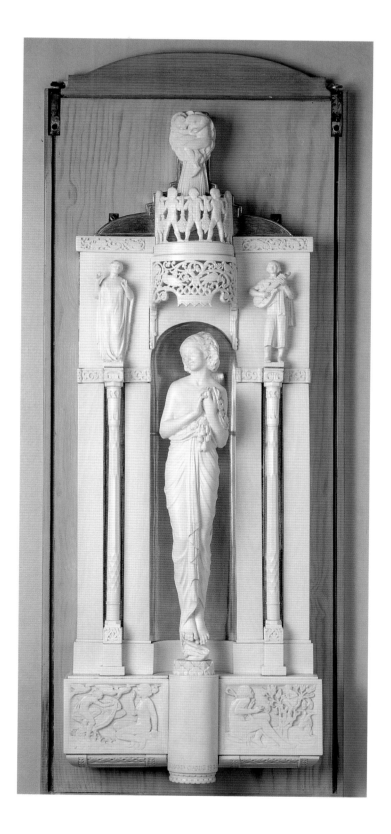

MOTHER AND CHILD

By Sir George Frampton
(1860–1928)
English; 1894–95
Silvered bronze; h. 102 cm
A.8-1985; given by the late Meredith Frampton
Esq.

The *Mother and Child* group was made at the height of Frampton's early career. He was elected an Associate Member of the Royal Academy in 1894 and exhibited regularly across Europe, contributing to the Munich and Vienna Secession. This group was first shown at the Royal Academy in 1895 and subsequently at the Venice Biennale in 1897 and the Paris Exposition Universelle in 1900, where Frampton won the *Grand Prix* with four works. The sculptor's wife Christabel, whom he married in 1893, and his son, Meredith (born 17 March 1894, who later became a painter and gave this bronze and a plaster model of the group (A.9-1985) to the Museum), were the models. As a portrait group of Frampton's young family this work is an intimate and fond expression of motherhood.

Like the best works of the so-called 'New Sculpture' produced in England in the last quarter of the nineteenth century, *Mother and Child* also has more subtle layers of meaning. The Mother supports the child by leaning her right arm on a shaped ledge, recalling a recognised type of Renaissance portrait, and her baggy sleeves and the child's full robe and cap also suggest a former era. This sense of an ideal group would have been further emphasised by a bright copper plaque with a white enamelled disc in the centre which Frampton originally designed to form a backing to the sculpture. This Symbolist format connects it with Frampton's masterpiece of 1892, *Mysteriach*, now in the Walker Art Gallery in Liverpool. *Mother and Child* is a notable example of Frampton's experiments with colour in sculpture, combining as it did the coppery backboard, white disc and silvered bronze.

(*AK*)

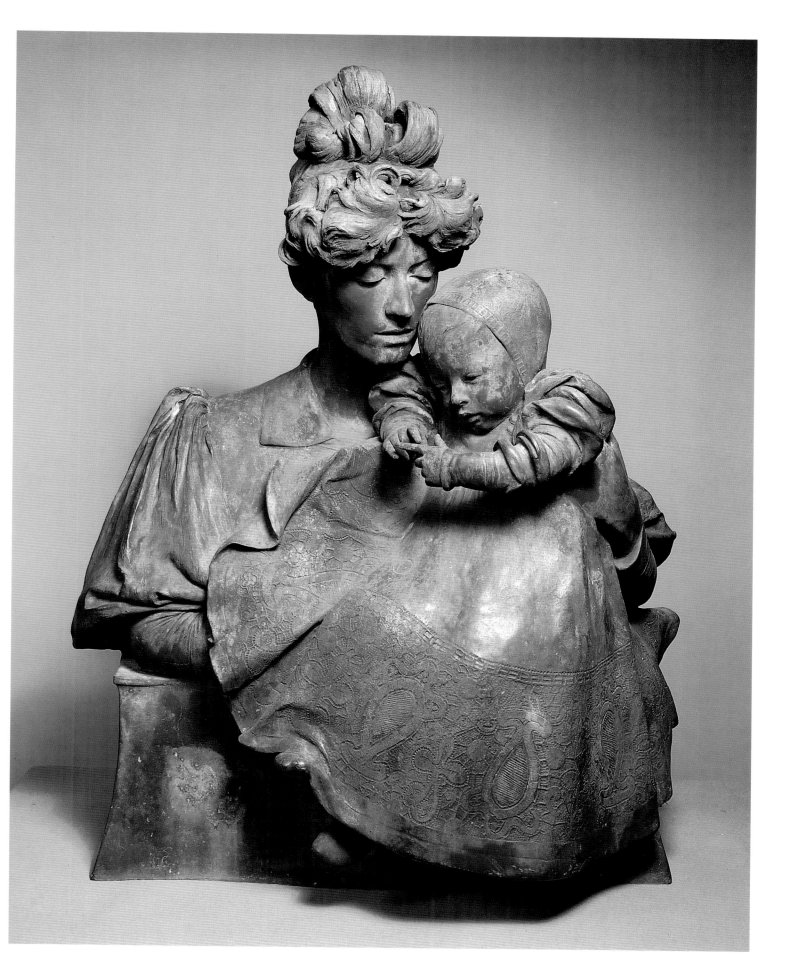

THE CAST COURTS

'The new court is indeed a novelty of construction, and it may safely be said that the world does not possess such another'.

(*Building News*, 25 April 1873)

The Cast Courts, or Architectural Courts as they were originally called, were opened in October 1873 to provide a permanent home for the Museum's growing collection of plaster casts. The rooms' massive proportions made possible the display of large monuments not able to be accommodated in galleries of normal dimensions, such as casts of Trajan's Column (shown in two sections) and the Pórtico de la Gloria of the Cathedral of Santiago de Compostela (figure 1). The creation of these galleries reflected the widespread educational fervour of the mid-nineteenth century, which coupled with the limited opportunities for students to travel widely, encouraged the establishment of cast collections across Europe. The South Kensington Museum was very much in the forefront in the acquisition of plaster casts, however, and quickly amassed the unrivalled collection now on display.

Today the Cast Courts contain reproductions only. This was not originally the case, as architectural models as well as large-scale monuments were also displayed, including the roodloft from 's-Hertogenbosch, now displayed elsewhere in the Museum (see page 14). The reaction of the critics to the new arrangement was largely favourable, the Art Journal remarking that the displays of original sculpture 'contrast well with the reproductions', and that 'the boldness of the area, the height of the apart-

1. The west Cast Court, showing the plaster casts of Trajan's Column and the Pórtico de la Gloria in the background

ments, the magnitude of many of the objects with which they are filled, and the beauty of others, all concur to produce a lasting effect'. That original objects and reproductions were displayed together at this time illustrated the desire for a comprehensive display to 'show the student how great masters have decorated architecture with sculpture'.

Many years before the opening of these purpose-built galleries, plaster casts were seen as a fundamental aspect of the Museum's collections. The forerunner of the South Kensington Museum – the Government School of Design, established in 1837 – had amassed substantial cast collections for the instruction of students, and these were incorporated into the collection when it was installed at Marlborough House. In 1862, over 2,000 casts of decorative woodcarvings used as examples for the craftsmen working on the Palace of Westminster were transferred to the Museum from the Board of Works, although the majority of these were subsequently transferred to the Edinburgh Museum. Other pieces were acquired less conventionally. The cast of Michelangelo's *David* (figure 2), for example, was originally presented to Queen Victoria by the Grand-Duke Ferdinand III of Tuscany in 1856 as a peace-offering for the veto he had imposed on the export of a painting by Ghirlandaio which the National Gallery had sought to acquire, and was forwarded to the South Kensington Museum the following year. The 1860s heralded a more systematic approach to the collecting of casts, with such major acquisitions as the Pisa pulpits of Nicola and Giovanni Pisano – the casting being carried out specially for the Museum by the London-based Franchi workshop – and Trajan's Column. As with the collection of original sculptures, this was primarily the work of Henry Cole and John Charles Robinson (see pages 11–12). In 1865 Robinson visited Santiago de Compostela, and on seeing the cathedral urged for a cast to be made of the doorway. It was commissioned from another firm, that of Domenico Brucciani & Company, who subsequently operated what amounted to a franchise of the Museum's cast service, supplying plaster casts to students and the general public until the early 1920s.

In order to gain access to monuments and sculptures held in museums outside Britain, Henry Cole initiated an International Exchange Scheme for the promotion of art, intended to facilitate the exchange of reproductions between institutions across Europe. The document which concluded this agreement, The International Convention, was signed by the 15 crowned Princes of Europe in 1867 at the Paris Exhibition, and this undoubtedly helped the South Kensington Museum to amass a collection of casts of unrivalled diversity, creating the need for the present galleries. The great collection of original Italian sculpture was subsequently complemented by casts and electrotypes of the most important monuments still *in situ*, including Ghiberti's *Gates of Paradise*, the central doorway of San Petronio in Bologna, the *cantorie* (singing galleries) of Luca della Robbia and Donatello, and numerous other sculptures by the masters of the Italian Renaissance. Many of these pieces were actually purchased, rather than exchanged, in the 1880s from the plaster cast workshops of Ottavio Lelli in Florence. The Northern European collection was also augmented by reproductions of important German monuments such as the St Sebaldus Shrine and Schreyer Monument in Nuremberg, and the eleventh-century bronze doors of Hildesheim Cathedral.

By the beginning of the twentieth century the acquisition of casts had gradually slowed. Significant additions to the collection were made around this time, but most of the casts were now received as gifts instead of being commissioned, most notably almost 4,000 pieces – principally architectural details – which were transferred from the Royal Architectural Museum of the Architectural Association in 1916. From about 1920 the value of reproductions began to be questioned. The idea that a small fragment of an original was of more aesthetic worth than a complete reproduction of a masterpiece, combined with the prevailing belief in 'truth to materials' among contemporary artists, led to a decline in interest. In 1928, when discussions within the Museum centred around the lack of space for display, it was suggested that the cast collection be removed to the Crystal Palace, where a large collection

of plaster casts was also housed. The proposal was wisely rejected by the Director, Sir Eric Maclagan, a decision further justified when in 1936 fire gutted the Crystal Palace. Instead, by an ironic twist of fate 23 casts – mainly effigies – were transferred to the Museum by the Trustees of the Crystal Palace two years later; they represent the last major additions to the collection.

The value of the Museum's plaster cast collection is self-evident. Because other European museums during the nineteenth century limited their collecting of reproductions to local examples, the Victoria and Albert Museum collection has remained unrivalled in its coverage. Environmental damage to monumental sculpture has ensured that casts made in the nineteenth century often retain more detail than may now be found on the originals, as is sadly the case with Trajan's Column in Rome; and in some cases casts exist where original objects have been altered or lost altogether, such as the female bust by Francesco Laurana, formerly in Berlin but destroyed in 1945.

The Cast Courts are of interest today not just for the three-dimensional record they provide of widely-separated amd sometimes damaged monuments. They remain an eloquent and outstanding expression of Victorian taste and a testament to the ambition and learning of the earliest curators of the Victoria and Albert Museum. (*DB*)

2. Detail of the Italian (east) Cast Court, showing plaster casts of sculptures by Michelangelo in the foreground

BIBLIOGRAPHY

THE FORMATION OF THE COLLECTION

M. Baker, 'Spain and South Kensington. John Charles Robinson and the collecting of Spanish sculpture in the 1860s', *The V&A Album*, 3 (1984), pp.341–49.

A. Burton, 'The image of the curator', *The V&A Album*, 4 (1985), pp.373–87.

J. Pope-Hennessy, 'Sculpture for the Victoria & Albert Museum', *Apollo*, LXXX (1964), pp.458–65.

J. Pope-Hennessy, 'The Gherardini Collection of Italian Sculpture', *Victoria and Albert Museum Yearbook*, 2 (1970), pp.7–26.

J. Pope-Hennessy, *Learning to Look* (London, 1991), pp.92–119.

Review of the Principal Acquisitions during the years 1911–38 (Victoria and Albert Museum, London, 1912–39, annual).

J.C. Robinson, *Catalogue of the Soulages Collection; being a descriptive inventory of a collection of works of decorative art, formerly in the possession of M.Jules Soulages of Toulouse* (London, 1856).

A. Somers Cocks, *The Victoria and Albert Museum: The Making of the Collection* (Leicester, 1980), pp.3–15, 61–75.

P. Williamson, 'The NACF and the National Collection of Sculpture', *National Art-Collections Fund Review 1986*, pp.77–85.

P. Williamson, 'John Gordon Beckwith 1918–1991', *Proceedings of the British Academy*, LXXX (1993), pp.233–43.

CATALOGUES AND HANDBOOKS OF THE SCULPTURE COLLECTION

M. Baxandall, *German Wood Statuettes 1500–1800* (London, 1967).

M. Baxandall, *South German Sculpture 1480–1530* (London, 1974).

J. Beckwith, *Caskets from Cordoba* (London, 1960).

F. Cheetham, *English Medieval Alabasters, with a catalogue of the collection in the Victoria and Albert Museum* (Oxford, 1984).

C.D.E. Fortnum, *A Descriptive Catalogue of the Bronzes of European Origin in the South Kensington Museum* (London, 1876).

J. Hawkins, *Rodin Sculptures* (London, 1975).

Catalogue of the Jones Collection, II (London, 1924).

M.H. Longhurst, *Catalogue of Carvings in Ivory*, 2 vols (London, 1927–29).

E. Maclagan, *Catalogue of Italian Plaquettes* (London, 1924).

E. Maclagan and M.H. Longhurst, *Catalogue of Italian Sculpture*, 2 vols (London, 1932).

J. Pope-Hennessy, assisted by R. Lightbown, *Catalogue of Italian Sculpture in the Victoria and Albert Museum*, London, 1964.

J.C. Robinson, *Italian Sculpture of the Middle Ages and Period of the Revival of Art. A descriptive catalogue of the works forming the above Section of the Museum, with additional illustrative notices* (London, 1862).

A Guide to the Salting Collection (London, 1911).

M. Trusted, *Catalogue of European Ambers in the Victoria and Albert Museum* (London, 1985).

M. Trusted, *German Renaissance Medals: A Catalogue of the Collection in the Victoria and Albert Museum* (London, 1990).

M. Trusted, *Catalogue of Spanish Sculpture in the Victoria and Albert Museum* (London, 1996).

J.O. Westwood, *Fictile Ivories in the South Kensington Museum* (London, 1876).

M. Whinney, *English Sculpture 1720–1830* (London, 1971).

P. Williamson, *An Introduction to Medieval Ivory Carvings* (London, 1982).

P. Williamson, *Catalogue of Romanesque Sculpture* (London, 1983).

P. Williamson, assisted by P. Evelyn, *Northern Gothic Sculpture 1200–1450* (London, 1988).

P. Williamson (ed.), *The Medieval Treasury: The Art of the Middle Ages in the Victoria and Albert Museum* (2nd edition, London, 1996).

SELECTED FURTHER READING ON SCULPTURE, BY PERIOD

N. Penny, *The Materials of Sculpture* (New Haven and London, 1993)

F. Haskell and N. Penny, *Taste and the Antique: The lure of classical sculpture* (New Haven and London, 1981).

J. Beckwith, *Coptic Sculpture 300–1300* (London, 1963).

R. Salvini, *Medieval Sculpture* (London, 1969).

L. Stone, *Sculpture in Britain: The Middle Ages* (Pelican History of Art, 2nd edition, Harmondsworth, 1972).

J. Beckwith, *Ivory Carvings in Early Medieval England* (London, 1972).

P. Williamson, *Gothic Sculpture 1140–1300* (Pelican History of Art, New Haven and London, 1995).

J. Pope-Hennessy, *Italian Gothic Sculpture* (3rd edition, Oxford, 1986).

T. Müller, *Sculpture in the Netherlands, Germany, France, and Spain 1400–1500* (Pelican History of Art, Harmondsworth, 1966).

J.W. Steyaert (ed.), *Late Gothic Sculpture: The Burgundian Netherlands* (exhibition catalogue, Ghent and New York, 1994).

M. Baxandall, *The Limewood Sculptors of Renaissance Germany* (New Haven and London, 1980).

G. von der Osten and H. Vey, *Painting and Sculpture in Germany and the Netherlands 1500–1600* (Pelican History of Art, Harmondsworth, 1969).

J. Chipps Smith, *German Sculpture of the later Renaissance c.1520–1580: Art in an age of uncertainty* (Princeton, 1994).

J. Pope-Hennessy, *Italian Renaissance Sculpture* (2nd edition, London, 1971).

J. Pope-Hennessy, *Essays on Italian Sculpture* (London and New York, 1968).

J. Pope-Hennessy, *The Study and Criticism of Italian Sculpture* (New York and Princeton, 1980).

C. Avery, *Florentine Renaissance Sculpture* (London, 1970).

C. Seymour, *Sculpture in Italy 1400–1500* (Pelican History of Art, Harmondsworth, 1966).

J. Pope-Hennessy, *Italian High Renaissance and Baroque Sculpture* (2nd edition, London, 1970).

A. Radcliffe, *European Bronze Statuettes* (London, 1966).

J. Montagu, *Roman Baroque Sculpture: The Industry of Art* (New Haven and London, 1989).

M. Whinney, *Sculpture in Britain 1530–1830* (Pelican History of Art, 2nd edition, revised by J.Physick, Harmondsworth, 1988).

R. Gunnis, *Dictionary of British Sculptors 1660–1851* (revised edition, London, 1968).

M. Levey, *Painting and Sculpture in France 1700–1789* (Pelican History of Art, New Haven and London, 1993).

F. Souchal, *French Sculptors of the 17th and 18th centuries: The reign of Louis XIV* (3 vols, Oxford, 1977–87; supplementary vol., London, 1993).

H.W. Janson, *Nineteenth-century Sculpture* (London, 1985).

B. Read, *Victorian Sculpture* (New Haven and London, 1982).

B. Read and J. Barnes (eds), *Pre-Raphaelite Sculpture: Nature and Imagination in British Sculpture 1848–1914* (London, 1991).

P. Fusco and H.W. Janson (eds), *The Romantics to Rodin: French nineteenth-century sculpture from North American collections* (exhibition catalogue, Los Angeles, 1980).

S. Beattie, *The New Sculpture* (New Haven and London, 1983).

INDEX